DATE DUE			
Dec3 80			
JUNE 16 '86			

An Artist's Notebook
Techniques and Materials

Holt, Rinehart and Winston
New York Chicago San Francisco Atlanta
Dallas Montreal Toronto London Sydney

Bernard
Chaet *Yale*
University

An Artist's Notebook

Techniques and Materials

As work on this volume progressed, it became clear that one cannot divorce techniques from aesthetics. A "cookbook" full of recipes would be meaningless without theory firmly spliced into its roots. In order to use materials and methods with authority, the artist must have a broad visual culture. To write about the handling of oil paint, for example, without guiding the novice through illustrations of masterly handling and the ideas that surround it (the kind of discussion one hears in artists' studios) is to remove the frame of reference that gives meaning to factual information. But with this frame of reference intact, a thorough knowledge of techniques is indispensable in an artist's quest to fulfill his or her own image.

Acknowledgments

Having taught a technical course for so many years, my debts to responsive students are many. I want to cite some here and apologize to those I have neglected. I am grateful to the late George Lockwood for research into distemper; to Arthur Hoerner for the initial research into acrylic emulsion; to Guynemer Giguère for research in studio-made stretchers; to Anne Litke and Paul Devries for finding various papers, and to Irwin Rubin, whose investigations into the making and testing of paper provided ample material for Chapter 1; to John M. Hull, whose experiments with acrylic gesso and the aluminum nails drypoint technique are used here; and to Nabil Nahas for his experiments with acrylic gesso grounds.

Thanks are also due to several people—artists and teachers—who read the first draft of the manuscript and offered many critical suggestions. These include Peter and Mary Moak; Marlene Rothkin Vine; Robert Gronendyke of Sonoma State College; Floyd Bettiga of College of the Redwoods; Nicholas von Bujdoss of Smith College; and Jerry Clappsaddle of the University of Maryland.

I want also to express my appreciation to Dwight W. Webb of Webb Books for giving permission to quote from my book, *Artists at Work,* 1960. Finally, my thanks go to those who typed the manuscript, Patricia Forsythe and Leah E. Chaet.

New Haven, Connecticut B.C.
December 1978

Contents

An Artist's Notebook
Techniques and Materials

Introduction

There are two schools of thought about the relationship between knowledge of artistic techniques and the creative impulse. One argues that artists cannot be taken seriously unless they have mastered the finest points of technical competence. In this approach, the studio becomes a laboratory, with the artist surrounded by paint specimens, chemicals, and machines.

The other camp maintains that technical expertise actually inhibits creativeness. The artist is depicted as a totally free spirit—one who, wholly ignorant of materials, can create on impulse works of art out of whatever lies at hand.

Somewhere between these two extremes lies a compromise: facility with methods and materials becomes the servant of inspiration. Artists know their materials, but they do not make a fetish out of them.

If creativeness and understanding of materials go hand in hand, then one must ask whether magic formulas exist. Are there media and surface treatments that, in themselves, make the difference between good and bad painting? Another question inevitably follows: To what *extent* does an artist need this kind of technical expertise? There are almost as many answers to these questions as there are artists and art experts, with the solutions ranging from an exclusive emphasis on "craftsmanship" to a total rejection of it.

Among those who have stressed a mastery of materials, Jacques Maroger, former Technical Director of the Laboratory at the Louvre, took an extreme position. In his book, *The Secret Formulas and Techniques of the Masters,** Maroger claimed to have found the secret oil medium of the Old Masters. He listed the formulas used by

*New York and London: The Studio Publications, Inc., 1948.

Leonardo, Titian, Rubens, and Rembrandt. The implication is that the artist-reader can simply choose one and proceed. Maroger further stated that the secrets he rediscovered had been lost toward the end of the 18th century. "The decadence that followed," he continued, "was inevitable, and a certain drama lies in the fact that this decadence was due simply to the loss of a secret technique—that is to say, to a cause that was entirely material."

Despite Maroger's assertions, there is today no consensus among experts about the nature of the media used by many of the Old Masters. Even if we assume that a more accurate analysis of such media will reveal the actual components, we do not know how much influence this discovery will have on painters. Maroger attempted to answer this question: "Only the knowledge of technical means, which he had lacked until this day, will enable the painter of tomorrow to take part successfully in the many still unknown possibilities."

1. Vincent van Gogh. *The Night Café.* 1888. Oil on canvas, 28½ × 36¼" (72 × 92 cm). Yale University Art Gallery, New Haven, Conn. (bequest of Stephen Carlton Clark).

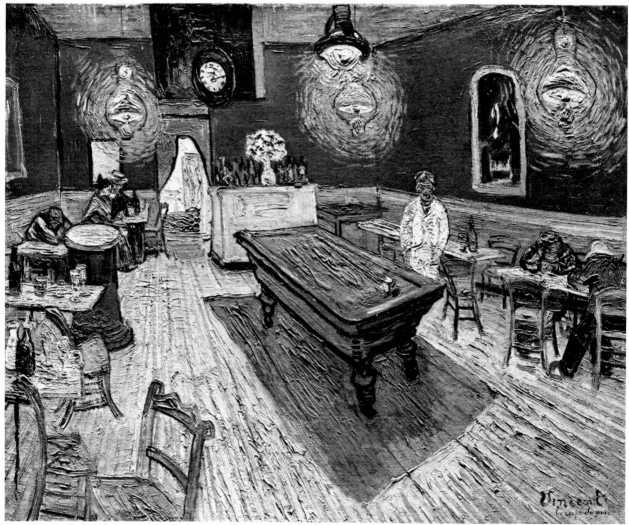

Since the publication of Maroger's book, other "magic formulas" have become popular. During the 1950s many artists and critics felt that textural qualities should be the painter's primary concern. A heavily textured canvas was seen as the most potent vehicle of visual expression, as if impasto itself would guarantee a certain "quality" or "richness."

But in the 1960s, perhaps as a reaction against this movement, artists began to eliminate all trace of texture in an attempt to reduce the image to the inherently flat surface of the support. These later painters perhaps understood that a preoccupation with texture overemphasized the way in which the paint was laid down and, in the process, undercut a consideration of what was actually painted. Carried to an extreme, this would mean that Van Gogh, for example, first invented his brushstokes and then trusted inspiration to put them to creative use (Fig. 1). Both the "textural school" and the "minimalists" forget that all painters accommodate the individual surface of their canvases to an original plastic conception. Simply stated, they put the cart before the horse. *It is the artist's conception that determines the choice of textural expression,* not the other way around.

Opposed to the texturists, the minimalists, and Maroger are a number of contemporary artists who reject technical formulas of all kinds. Some have deliberately abandoned "sound practice," choosing instead to paint with the quickest and cheapest materials available. For these artists, permanence is irrelevant. They are given to saying, "I would rather paint a good picture that falls apart than a bad one that lasts forever." This point of view ignores the obvious fact that one can just as easily paint a good picture that *will* last forever.

It is true, of course, that an exaggerated concern with technique may lead to a sterile approach. Artists who insist that choice of medium and other didactic rules hold the key to mastery belittle their own visual realization. For the zealot of this technical viewpoint, artists can be classified according to their craft alone, and Cézanne becomes simply the man whose paint cracked when he used too much Prussian blue.

The other extreme—the belief that technical knowledge hampers expression—is equally untenable. Those who take this position fail to recall that the term "painter" itself implies knowledge of a craft, of the nature of materials, their characteristics, and their permanence. Moreover, if the painter has a responsibility to the collector, matters of craft cannot be ignored. Paintings that crack, warp, or otherwise deteriorate, drawings that fade or even crumble—these do not inspire confidence.

The anticraft attitude may be a response to the mystery that has been made of technical practice. But there is no basis to the idea that technical knowledge is so difficult to obtain, nor that its acquisition will inhibit the creative impulse. On the contrary, there exists a close interrelation between the freshness of creation and a new utilization of media. Some of the most prominent—and dynamic—artists today are those who have explored new territory in techniques and methods of expression.

Fortunately, the pitfalls of both the technical and the antitechnical extremes can be avoided. Those who yearn for the secrets of the Old Masters should remember that more than twenty colors available today were unknown before the 18th century. Yet the existence of these colors does not make contemporary art superior to that of previous eras. Conversely, the artist fearful of craft knowledge should realize that the concepts of artist-as-genius and artist-as-craftsman are not in the least incompatible. Knowledge of technique is not inhibiting, nor is it a guarantee of achievement. At best, mastery of craft supplies a working vocabulary—one that opens possibilities to be fulfilled by the individual vision of the artist.

Drawing: Instrument and Instrumentation

All artists develop their own personal drawing language. By trial and error, they examine each mode of graphic thinking, from pure line to heavily modeled forms, seeking the manner that most directly connects to their pictorial vision. Yet whatever language is eventually adopted—whatever style, in other words, is developed—every drawing has a self-sufficient function that requires an individual solution. These functions may range from idle sketching, to preparatory studies, to experimenting with the arrangement of forms, to a finished drawing that is a work of art in its own right. It is the demands of the theme and the practical task at hand that dictate how a drawing will look. As the following illustrations suggest, technique is transformed by the special function of each drawing, even where the same artist is at work.

The Uses of Drawing

A Study for Another Medium Signorelli produced his *Head of a Man* as an underdrawing for a mural painting (Fig. 2). He pricked the contours with a needle,

held the drawing up to the wall, and then literally traced the forms' boundaries through the holes.

To Design or Arrange Forms Many artists have used drawing to design—to arrange or rearrange forms and try out various solutions. During the 1930s, Picasso executed many rapid pen-and-ink sketches in which he manipulated a series of conceived forms in an extraordinary variety of combinations (Figs. 3, 4).

2. Luca Signorelli. *Head of a Man.* c. 1500. Black chalk on paper, 11⅝ × 9½″ (30 × 25 cm). Metropolitan Museum of Art, New York (Lehman Collection).

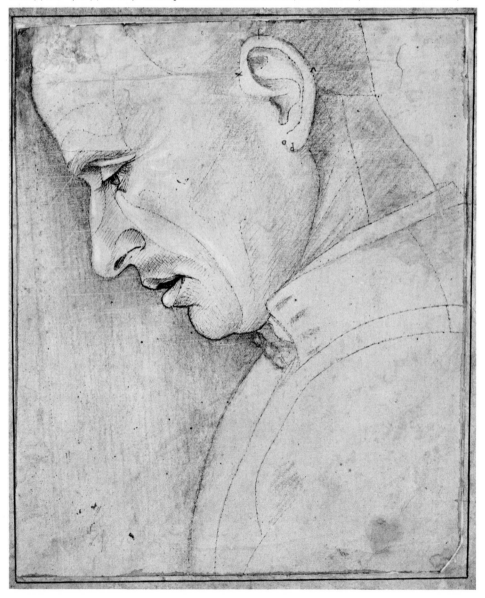

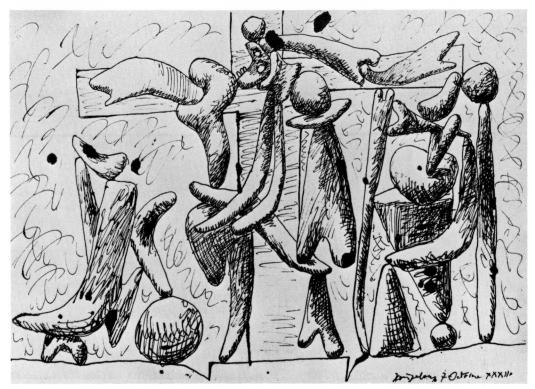

above: 3. Pablo Picasso. *Boisgeloup, 7 octobre 1932.* 1932. Pen and ink, 13½ × 19½″ (35 × 50 cm).

below: 4. Pablo Picasso. *Boisgeloup, 19 septembre 1932.* 1932. Pen and ink, 13½ × 19½″ (35 × 50 cm).

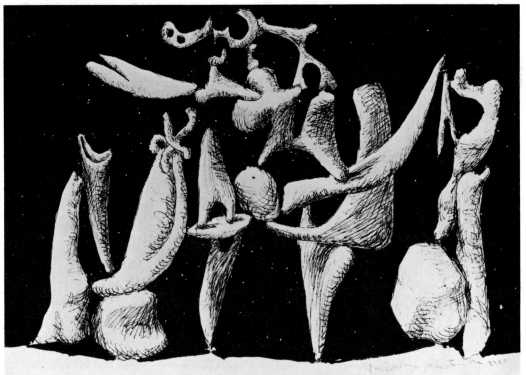

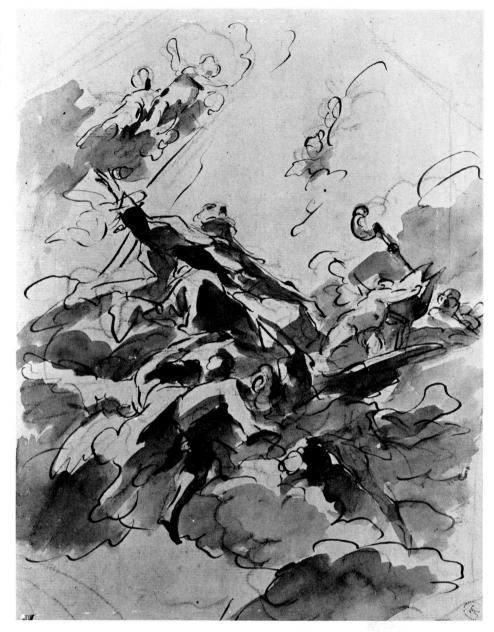

To Construct an Imaginary Space Giovanni Pellegrini in his *Apotheosis of a Saint* (Fig. 5), used his memory of art and nature to invent from imagination an upwardly spiraling space with tipping planes in opposition.

To Study Forms from Art and Nature In a pen-and-ink study, Rubens interpreted the composition of an earlier artist's bronze relief (Fig. 6), while in a study executed in red and black chalk and ultimately incorporated into a painting, he transcribed nature itself (Fig. 7). Note that Rubens changed both his medium and his technique to accommodate different themes.

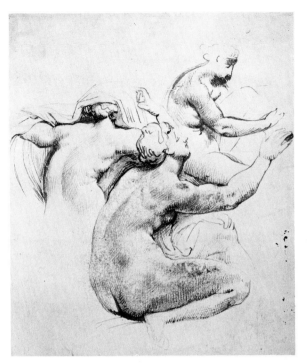

**left: 6. Peter Paul Rubens,
after Jacob Cornelisz Cobaert.**
Three of the Nymphs of Diana Undressing.
Pen and brown ink over black chalk,
6⅞ × 5⅞″ (17 × 15 cm).
British Museum, London
(reproduced by courtesy of the Trustees).

below: 7. Peter Paul Rubens.
Tree Trunk and Brambles. 1615–20.
Chalk, pen and ink, with touches of color;
14 × 12″ (35 × 30 cm).
Devonshire Collection,
Chatsworth (reproduced by permission
of the Chatsworth Settlement).

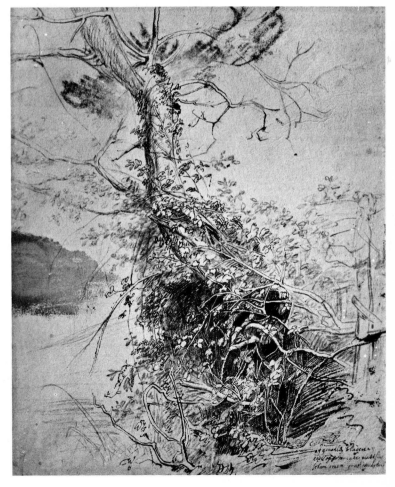

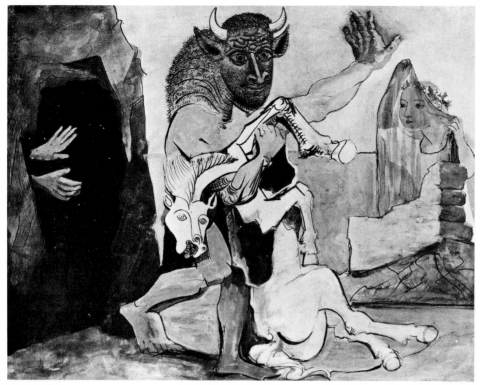

above: 8. Pablo Picasso.
Minotaur Carrying a Dying Horse.
1936. Gouache, pen and ink,
19¾ × 25¾″ (50 × 65 cm).

right: 9. Jean Auguste Dominique Ingres.
Esclave Musicienne. 19th century.
Graphite pencil. Ingres Museum, Montauban.

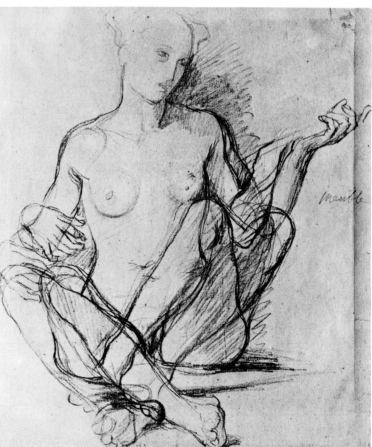

The Drawing as a Work of Art In *Minotaur Carrying a Dying Horse* (Fig. 8), Picasso, having found his pictorial conception and the medium that best expressed it, created a unique image, a work of art in its own right.

These are some of the functions that drawings can perform—functions that have been and will be defined by the individual artist's need to fulfill a particular idea. The same idea governs the way in which drawing tools are employed. This chapter illustrates what each tool in the drawing arsenal is capable of and how each *instrument* produces a different *instrumentation*, depending upon the artist's hand and individual purpose.

Drawing Tools

Ingres, a master of the graphite pencil, handled this tool in a preliminary sketch for a painting (Fig. 9) in a broad, loose manner as he searched for the leg position. And yet the same artist uses the pencil, this time with a harder graphite, to delineate clearly and sharply the portrait of *Madame Reiset and Her Daughter* (Fig. 10).

As Ingres' drawings reveal, graphite pencil, the most common drawing instrument, comes in degrees of hardness and softness—the hardest, 6H (Fig. 10), and the

Pencil

10. Jean Auguste Dominique Ingres. *Madame Reiset and Her Daughter.* 1844. Graphite pencil, 12 × 10½″ (31 × 25 cm). Museum Boymans-van Beuningen, Rotterdam.

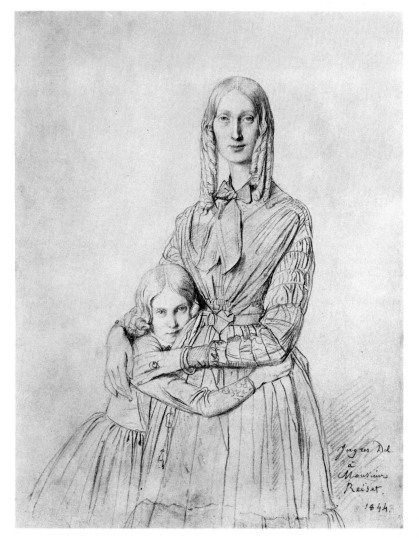

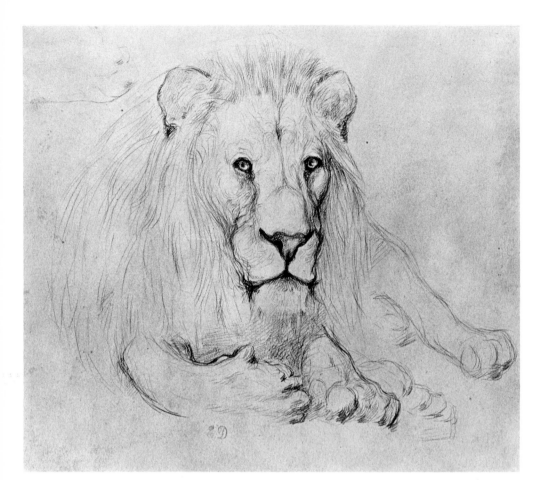

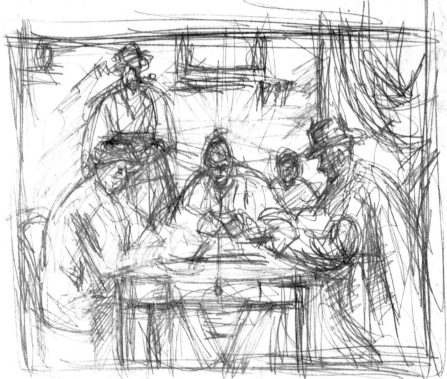

above: 11.
Eugène Delacroix
Lion Reclining, Front.
Graphite pencil, 8 × 9½″ (20 × 23 cm).
Collection Dr. Esmond B. Martin.

right: 12.
Alberto Giacometti,
after Paul Cézanne.
Study of *The Card Players.*
Graphite pencil,
12¾ × 15″ (32 × 38 cm).

softest, 6B (Fig. 9). It is important to buy pencils in all varieties in order to see what their touch produces. Saying "It makes no difference," or that "It isn't the pencil, it's the person behind the pencil," is only partly true, for the person who understands all the gradations of graphite pencil will work with greater skill. Ingres selected two grades of graphite to best fulfill the particular requirements of each subject.

Delacroix's drawing, *Lion Reclining, Front* (Fig. 11), illustrates how soft to medium gradations of graphite can be used to produce direct, smooth strokes. Leaving the contours open, Delacroix punctuated the rhythmic flow with just a few darks in the face of the lion. By contrast, in Giacometti's furiously scribbled transcription of Cézanne's *The Card Players* (Fig. 12), individual strokes merge as if the pencil (with only one grade of graphite throughout) never paused or left the page.

Picasso's 1915 portrait of *Ambroise Vollard* (Fig. 13) reveals a brilliant use of the various grades of graphite pencil, as well as the strong influence of Ingres. Picasso

13. Pablo Picasso.
Ambroise Vollard. 1915.
Graphite pencil, 18⅜ × 12⅝″ (47 × 32 cm).
Metropolitan Museum of Art, New York
(Elisha Whittelsey Collection, 1947).

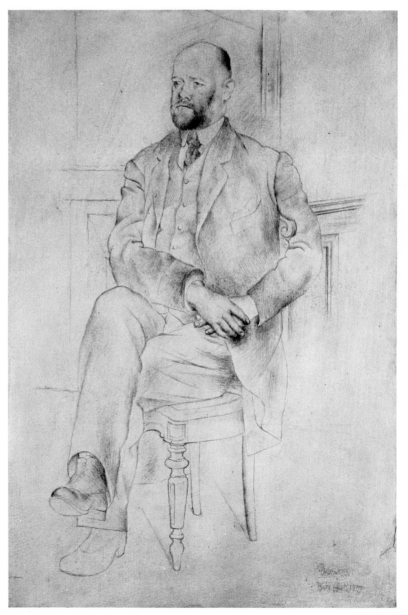

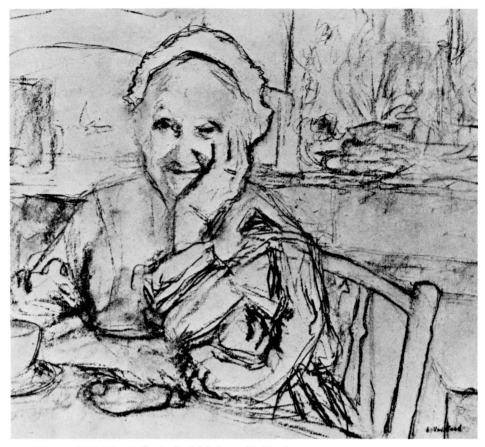

14. Edouard Vuillard. *Portrait of Madame Vuillard.*
Before 1928. Graphite pencil.

appropriated Ingres' concept of linear clarity with beautifully soft gradations of graphite pencil. Within this subtle modulation, everything is clear and precise, from the way the necktie is knotted to the exact description of the design on the chair's leg. And although Picasso leaves the strongest focus for the hair, beard, and hands, these darks blur into the allover softness of the whole page.

Vuillard, his friends report, used only a very soft (5B) pencil. But he did not maintain a uniform pressure. Thus, in the portrait of his mother (Fig. 14), this variation of pressure, plus a little gentle rubbing with the finger, resulted in a wide range of values. Corot's *Città Castellana* (Fig. 15), on the other hand, discloses a wide variety of graphite gradations here employed to create a drawing constructed with all the energy and attention he gave to his finished paintings. Indeed, *Città Castellana* is not just a sketch, but one of Corot's finest works.

Colored Pencils Many contemporary artists draw with colored pencils. Before you use these, however, you should test each one for color permanence. Put marks on a piece of paper, cut the paper in half. Keep one half in a closed book and expose the other half to strong light for two weeks; compare. Some colors are light-fast, but others are produced from dyes that fade.

Colored wax crayons, actually made from paraffin, not wax, and manufactured for *Wax Crayons*
children's use, are sometimes employed by professional artists. Once again, these
colors are produced from dyes and should be tested in light (as above), since many, if
not all of them, fade.

Chalk refers to conté crayon, a hard chalk that comes in shades of black, brown, and *Chalk-Conté*
red. (Chalk may also refer to the softer pastel sticks, pp. 137–140.) Conté provides an
excellent opportunity to demonstrate that the same drawing tool can be handled in
different ways: the instrument remains the same, the instrumentation changes.
Limiting the subject to heads makes the comparison all the more striking.

 The artist coaxes the simplified, idealized, egg-shape volume of the head from
the paper, because the paper's rough surface tooth catches the gradual build-up of

15. Jean Baptiste Camille Corot. *Cività Castellana.* 1826.
Graphite pencil on beige paper, 12¼ × 15⅜″ (31 × 39 cm). Louvre, Paris.

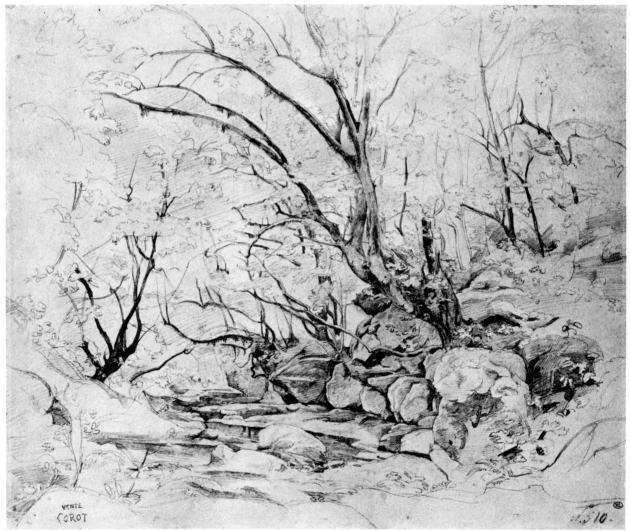

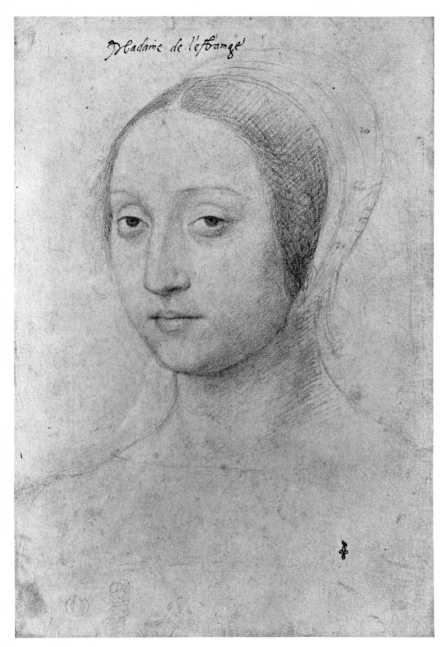

16. School of Jean Clouet.
Marie de Langeac,
Madame de Lestrange.
c. 1535. Black and red conté.
Musée Condé, Chantilly.

strokes—a build-up hidden, however, by the rough texture (Fig. 16). Hans Holbein did not idealize his models. Using a harder paper surface, he reveals every stroke that produced the *Portrait of Bürgermeister Jakob Meyer* (Fig. 17). Although every small and large bulge of the flesh is blended, the conté marks are clearly visible and ultimately merge with the volumetric projection of the turned head. Notice, too, the textural contrast between the flowing hair and the head.

In Andrea del Sarto's *Head of a Young Man* (Fig. 18), deft, flowing, relaxed strokes produce a circular rhythm from the top down that locates the hair into a defined space. The solidly built head underneath, executed with the same light touch,

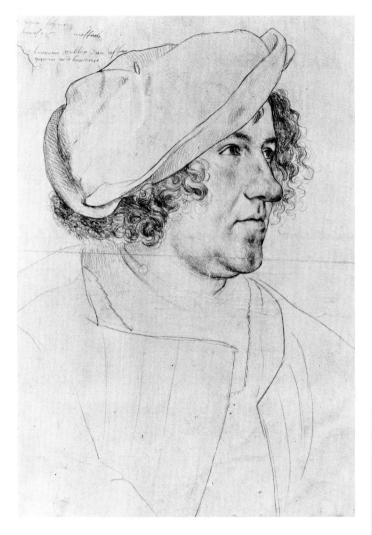

above: 17. Hans Holbein the Younger.
Portrait of Bürgermeister Jakob Meyer.
1516. Silverpoint and red conté,
10½ × 7½″ (27 × 19 cm).
Kupferstichkabinett, Kunstmuseum, Basel.

right: 18. Andrea del Sarto. *Head of a Young Man.*
c. 1500. Red conté. Louvre, Paris.

echoes this circular movement. In Picasso's *Head of a Woman* (Fig. 19) the sharp, angular distortions of the forms are duplicated by the handling of the black conté. The crayon's broad, loose, heavy strokes match the visual drama created by the break-up of thrusting planes.

Seurat's delicate handling of conté results in a beautifully orchestrated textural density (Figs. 20, 21). Very loose, uneven cross-hatched strokes, which stay on the surface, create an atmosphere that engulfs sky, ground, buildings, and people in a unified whole. Goya seems to force his dark brown conté strokes into the open weave

19. Pablo Picasso.
Head of a Woman. 1909.
Black conté and gouache,
24 × 18⅝″ (62 × 48 cm).
Art Institute of Chicago
(Charles L. Hutchinson
Memorial Collection).

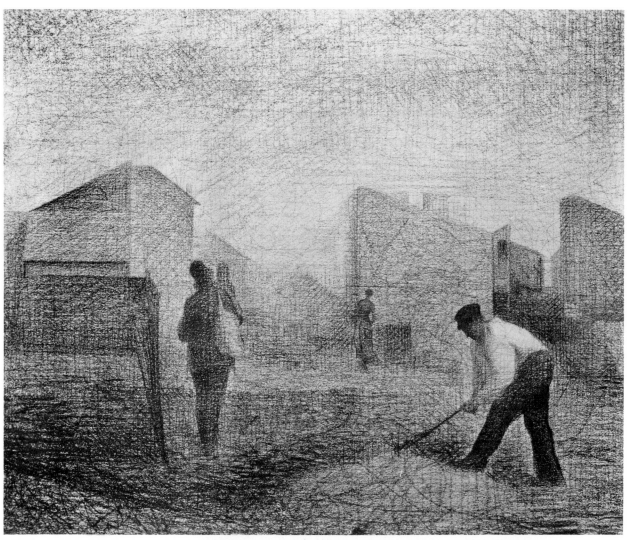

above: 20. Georges Seurat.
Stone Breakers, Le Raincy.
c. 1881. Black conté,
11⅞ × 14¾″ (30 × 38 cm).
Museum of Modern Art, New York
(Lillie P. Bliss Collection).

right: 21. Detail of Figure 20.

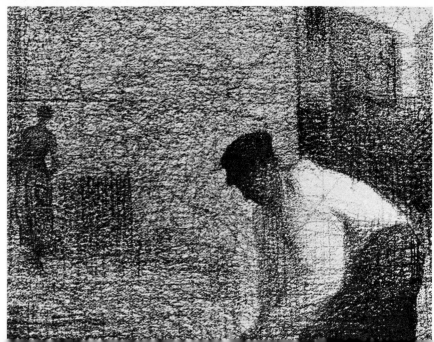

of the rough paper to make them appear as if they had already been there when he started to draw the looser, lighter strokes (Fig. 22).

Each artist in this series finds a distinct way of adapting the conté to his own themes. All, however, work with a sharp point. Students often use a blunt point, seldom sharpening it on the sandpaper blocks manufactured for this purpose. But the blunt point limits the precision of strokes; a sharp point assures full control.

Lithographic Crayon

Lithographic *pencils,* manufactured in modulated grades from hard to soft, can be sharpened to long points to produce delicate tones. The lithographic *crayon,* also available in gradations, is harder to keep sharpened. It is, rather, a short, blunt, square-edged tool, whose stiff wax base makes flowing marks difficult to execute. Hartley uses the soft varieties of the lithographic crayon (Fig. 23). Working within the limitations of the crayon's flexibility, he employs the front end of the tool in short jabs, accompanied by additional marks made by the side of the crayon.

The method of working with lithographic crayon on paper is similar to its use on a lithographic stone for printmaking, except that on the stone tones must be built up slowly, gradually filling the stone's pores.

Charcoal

Manufactured in sticks about 6 inches long, charcoal comes in hard, medium, and soft grades. Grumbacher also makes longer and thicker sticks. In addition, charcoal can be purchased in compressed form—shorter square-ended sticks that produce a darker, richer tone. Like graphite pencil and conté crayon, it facilitates countless effects.

Camille Pisarro used a medium grade of charcoal to record swiftly, in a broad yet distinctly linear manner, a study of the various positions of a peasant's *Baskets* (Fig. 24). Arshile Gorky, by contrast, incorporated all grades from hard to soft in his

22. Francisco Goya. *Banderillas de Fuego.* 1815. Brown conté. Prado, Madrid.

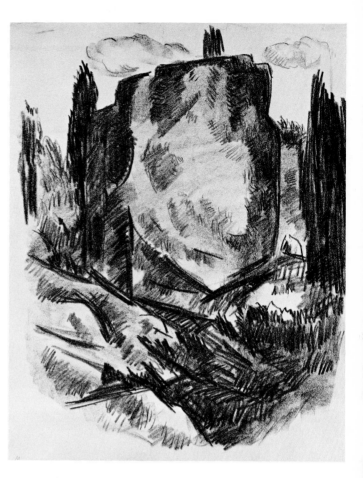

right: **23. Marsden Hartley.** *Landscape.*
First half 20th century.
Lithographic crayon, 16⅛ × 12½″ (41 × 32 cm).
Yale University Art Gallery, New Haven, Conn.
(gift of Walter Bareiss).

below: **24. Camille Pisarro.** *Baskets.* 1889.
Charcoal, 8⅞ × 12″ (23 × 31 cm).
Collection Henry P. McIlhenny, Philadelphia.

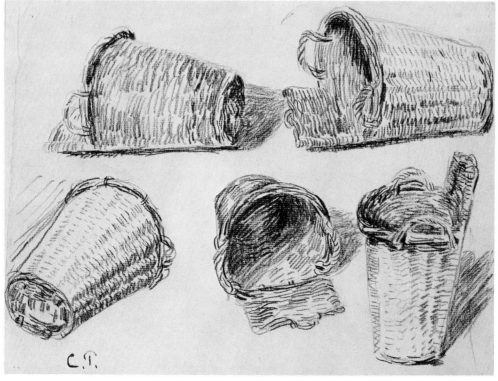

portrait *The Artist's Mother* (Fig. 25). There is no rubbing in, just individual strokes that build tonal masses. This building process lends an allover energy to the surface, an energy that is sometimes lost in reproduction.

The rich, velvety tone of charcoal—today produced with the compressed variety—is best exemplified by a detail of Redon's *Crucifixion* (Fig. 26). The broad sweeps of light and dark in the background create a dramatic atmosphere for the linear forms of the Christ figure.

Mixed Dry Media No artist is limited to one drawing medium alone. Piet Mondrian combines charcoal and conté crayon in a manner that exploits the inherent characteristics of each tool (Fig. 27). In this very large drawing, he blends the media to build up the heavy masses. But Mondrian renders the details and accents in the harder conté, the softer atmospheric sections in charcoal. The two media, in other words, work in unison.

25. Arshile Gorky.
The Artist's Mother. 1930.
Charcoal drawing,
24 × 18½″ (61 × 47 cm).
Art Institute of Chicago
(Worcester Sketch Fund Income).

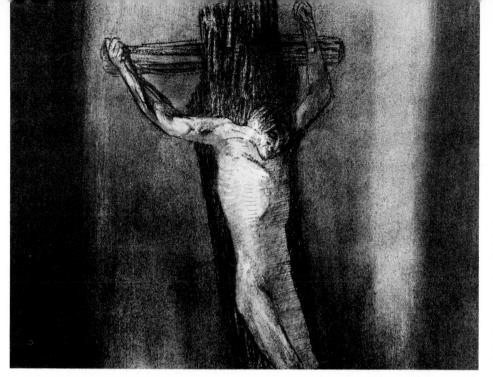

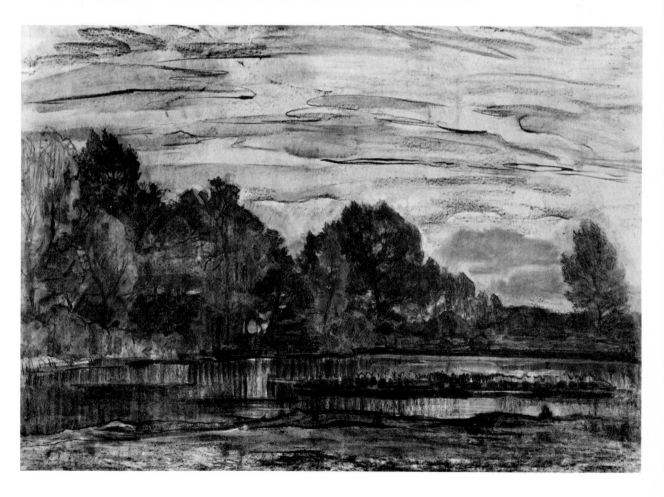

left: **26. Odilon Redon.**
Crucifixion, detail.
c. 1903. Charcoal drawing,
19½ × 13½″ (49 × 34 cm).
Yale University Art Gallery,
New Haven, Conn.

below: **27. Piet Mondrian.**
*A Shallow Pond at Saasveld
in Twente.* 1907-08.
Charcoal with chalk
and red crayon,
3′1¾″ × 4′6¾″ (.96 × 1.39 m).
Yale University Art Gallery,
New Haven, Conn.
(gift of Bruce B. Dayton).

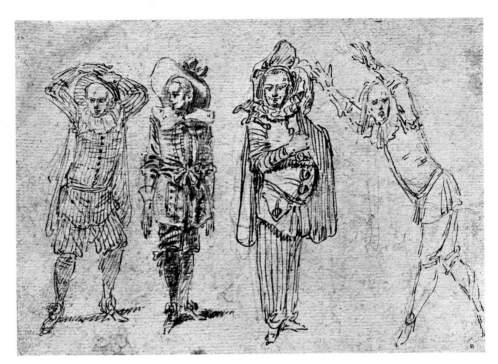

28. Claude Gillot.
*Four Figures
in Theatrical Costumes.*
Pen and brown ink
with red chalk,
5½ × 7⅞″ (14 × 20 cm).
Metropolitan Museum
of Art, New York
(Rogers Fund, 1909).

Spraying Fixatives

The modern spray-can fixatives for dry media work well if you follow directions. Keep the spray can 12 inches away from the drawing, and do not flood it. Remember that these fixatives are dangerous. The solvents are deadly. There are instances of artists who have contracted a blood disease and ultimately died from using spray-can fixatives improperly. The chemicals must be used in well-ventilated rooms—better still, out of doors. (See p. 141, for another fixative that works well for all dry media.)

Ink

Pens and brushes with ink and/or wash (ink diluted with water) comprise the wet media, the other broad category of drawing media. Of course, wet and dry media can be mixed, as in Figure 19, where Picasso's black conté crayon drawing has touches of gouache. Similarly, Claude Gillot's pen-and-ink costume studies (Fig. 28) reveals a red chalk underdrawing below the rapid, economical pen-and-ink lines.

Modern drawing inks are made from dyestuff (usually particles of a carbon pigment), shellac, and water. If you are curious enough about the quality of other types to try to make your own carbon ink, use the following recipe:*

1. Take 8 ounces of water, and heat it almost to the boiling point.
2. Remove the water from hotplate, and add 1 ounce of rabbitskin glue, stirring until the glue is completely dissolved.
3. Into a mortar place 1 level tablespoon of lampblack dry color of good quality.
4. Add 2 teaspoons of the hot glue size, and work the lampblack into the glue with a pestle. Although the two ingredients do not seem miscible at first, vigorous circular grinding will produce a smooth paste within one or two minutes.

* James Watrous, *The Craft of Old-Master Drawings* (Madison: University of Wisconsin Press, © 1957 by Board of Regents of University of Wisconsin System), p. 86. This book also contains information about making crayons and chalks from raw ingredients.

5. Continue the grinding until the mixture is well worked, then add 1 teaspoon of the hot glue size, and work it well into the paste.
6. You can then follow one of two procedures in forming the stick or cake of ink:
 a. Pour the mixture into a shallow porcelain or glass receptacle to dry. Although it will not affect the quality of the ink, the stick or cake will crack or warp during the drying process.
 b. Pour the cream-thick ink into a receptacle, stirring and working it as the moisture evaporates until it can be pressed into a semisolid stick form. Then cover or wrap the stick in wax paper, and allow it to dry slowly.
7. As in the case of Chinese ink sticks, the liquid can be brought to the proper consistency and intensity by rubbing the sticks with a proper amount of water, in a porcelain dish or a slate ink-saucer.

Pens

Having bought or made your ink, it is time to experiment with different pens. Figure 29 illustrates the marks produced from four different steel pen points, three lettering pens, the smaller crow-quill steelpoint, and pens made from bamboo, reed, and turkey

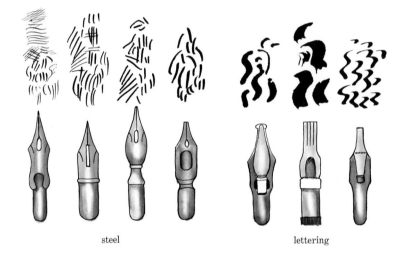

steel lettering

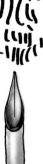

crow-quill

bamboo

reed
left- right-
handed handed

turkey quill
left- right-
handed handed

29. Various types of pen points and their drawing characteristics.

quill. You may not be able to get these specific examples, but the equivalents are readily available. Try as many as possible in order to find one that feels natural. The illustrations that follow begin with the finest points and gradually work up to the thickest points.

Steelpoints Feininger's *In the City at the End of the World* (Fig. 30) is executed with the crow-quill steel pen. It is a point that produces this kind of scratchy line as well as a very thin, textureless straight line. Feininger used the instrument often, obviously favoring such fine textural vibration.

Botticelli varied the pressure of a fine steelpoint, and may even have added a little water to the ink in places to make the line lighter (Fig. 31). The result is a beautiful parade of interlocking forms executed in a linear style. Using the same kind of steelpoint, Raphael develops a far more sculptural effect (Fig. 32). His contours

30. Lyonel Feininger.
In the City at the End of the World. 1912. Pen and ink, 12½ × 9½″ (32 × 24 cm). Museum of Modern Art, New York (gift of Julia Feininger).

above: 31. Sandro Botticelli.
Paradiso XXVIII
(Ninth Sphere of Heaven),
illustration for Dante's *Divine Comedy.*
c. 1482–92. Pen and ink.
Staatliche Museen, East Berlin.

left: 32. Raphael. *Enfants.*
Early 16th century. Pen and ink,
5″ (13 cm) square.
Louvre, Paris.

dissolve into the forming lines that are cross-hatched around the simplified volumes. Once again, each vision finds a different technical means to fulfill its need. Leonardo took up a heavier steelpoint in order to produce firmer contours that undulate slightly (Fig. 33). He drew the thinner, parallel lines behind the flowers with a finer pen point. Notice how these parallel lines form a spreading film that weaves the flowers to the page, rather than keeping them strictly on top of the ground.

Sisley's landscape, *Moret-sur-Loing* (Fig. 34) illustrates both another form language and another technical effect possible with a flexible steelpoint. Line and contour do not seem to exist in the tree forms. Lines dance on the surface, and their flowing patterns hardly reveal where the artist paused to dip the pen into ink. Landscape themes do tend to suggest this kind of flow. But it is Sisley's habit as an Impressionist to apply paint directly and in the correct color-value combination. He pursues the same idea in the pen drawing, where a loose flow of lines group to form a sense of water, of trees moving slightly from wind pressure, and then change to create a solidly built church that anchors the whole composition. There is enough information

33. Leonardo da Vinci. *Studies of Flowers.* c. 1483.
Pen and ink over metalpoint, 7 × 8″ (18 × 20 cm).
Accademia, Venice.

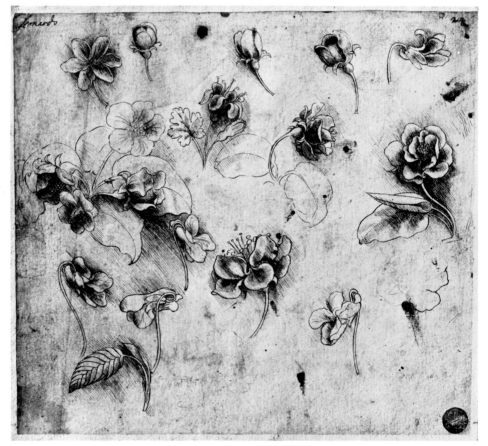

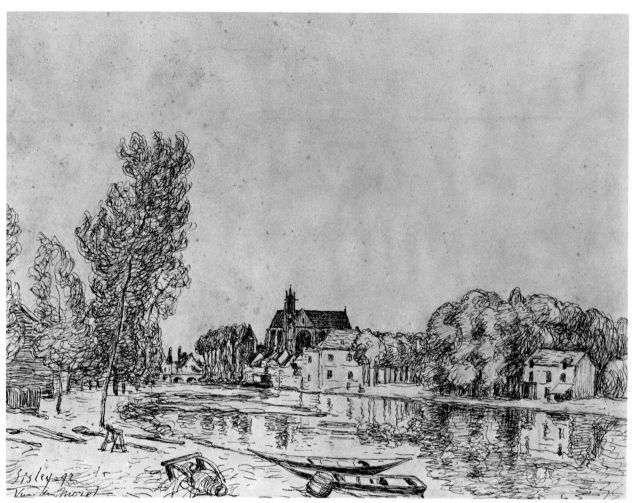

34. Alfred Sisley. *Moret-sur-Loing.* 1892.
Pen and ink, 9⅜ × 12½″ (24 × 32 cm). Courtesy Wildenstein & Co., New York.

in this steel pen drawing, which at first appears to be a casual sketch, to produce a detailed painting.

Sisley's handling of the pen resembles the ballpoint pen. However, you must be aware that a ballpoint pen does not yield permanent results. A drawing in ballpoint can literally fade into nothingness as a result of indirect light, as opposed to direct sunlight, for the dye in the ink is impermanent.

The contemporary American painter-draftsman Hyman Bloom has made unique technical experiments with steel pen, experiments prompted by the desire to keep pen drawing open to change. In his own words, he can "make changes with absolute precision." He achieves this with a water-soluble white ink, of which there are many on the market, including Grumbacher's "Write White." This white ink can be "picked up" with a wet sponge. Of course, you must not disturb the ground, which must be dark to show up the white ink. And it follows that the ground must be waterproof. Use 12 parts rabbitskin glue to 1 part water, plus some dry pigments as a colorant. Heat in

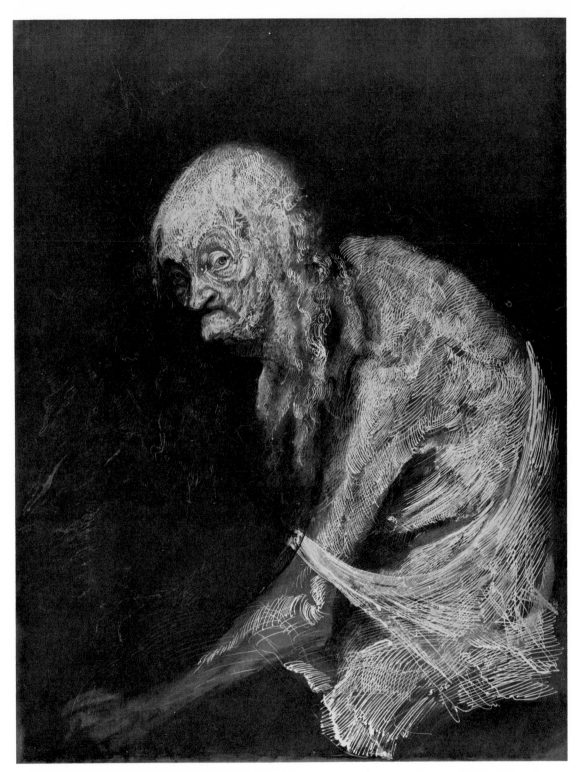

35. Hyman Bloom. *Old Woman.* 1956.
White ink and charcoal, 23 × 17″ (58 × 43 cm).
Collection Mrs. Herbert D. Kahn.

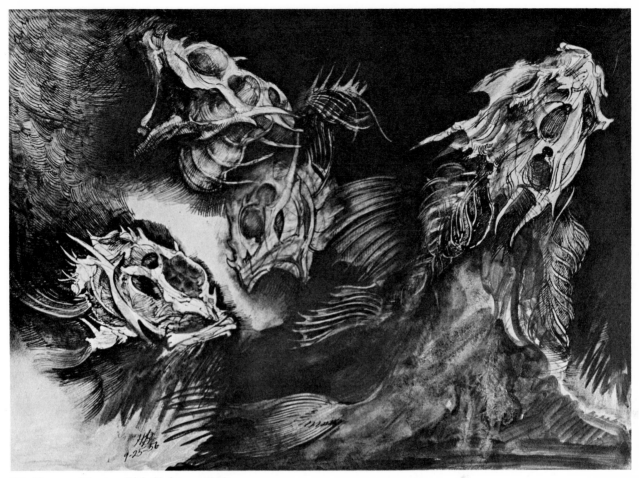

36. Hyman Bloom. *Fish Skeletons.* 1956.
Dissolved conté applied with brush and pen, 13 × 20″ (33 × 51 cm).
Courtesy the artist.

double boiler, stirring constantly. Apply warm. Make sure that you tape the paper to a board before applying the ground.

Old Woman (Fig. 35) reveals Bloom's method with all its revisions. The top of her back and her arm seem blended, but it is in reality a "ghost" of one of Bloom's fluid, yet surgeonlike operations.

Toned or tinted paper is generally employed with light and dark accents, the background tone assuming the role of the middle value. But Bloom prefers to use white ink alone "and work from the tone of the paper up." Optical grays, however, are produced by the grouping or clotting of the white strokes. And darks surrounded by white ink strokes appear darker than the toned background.

Bloom also invented another use for steel points. With fine particles of conté and water he made an "ink," so that he could include fine lines in conté crayon drawings (Fig. 36). (Conté itself cannot produce such fine lines.) These lines, like conté, can be erased, thus giving him the desired freedom. Why not simply use red or brown ink that matches the color of conté? Because ink has a shiny surface that will divorce itself from the allover mat quality of conté.

37. Albrecht Dürer. *Grotesque Head of a Man.* 1505.
Pen and ink, 8 × 6″ (21 × 15 cm).
British Museum, London (reproduced by courtesy of the Trustees).

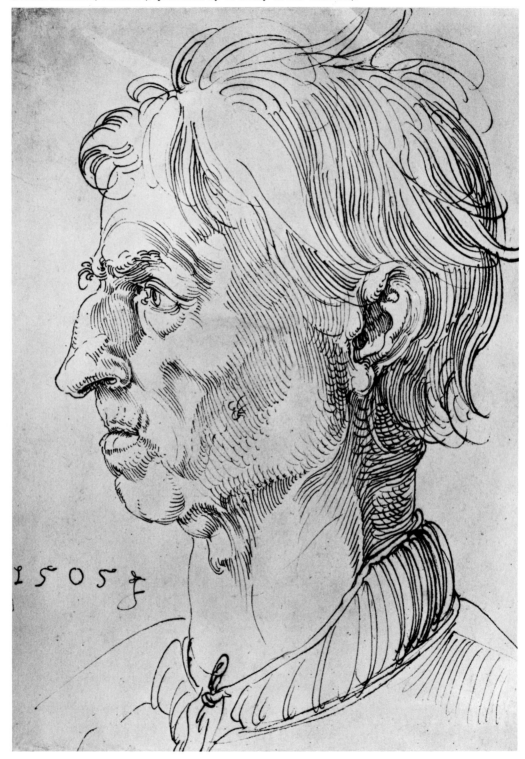

With Dürer, we return to steel pen points (Fig. 37), this time to a heavier point, as illustrated in Figure 29. In the master's hand, even the heavy point seems flexible, for he can use it broadly and fluidly. Dürer instinctively knows when to release the pressure for a lighter tone (around the cheeks), when to make short, delicate strokes (around the mouth and eyebrows), and when to increase the pressure for larger, flowing strokes (the hair and collar).

The last steelpoint example demonstrates the use of two heavy points; both kinds of line can be achieved with lettering pens (Fig. 29). In bold strokes, Kokoschka swiftly captures the volume of the skull underneath the facial mask (Fig. 38). The eyeglasses, with their round frames, accent and repeat the heavy contours.

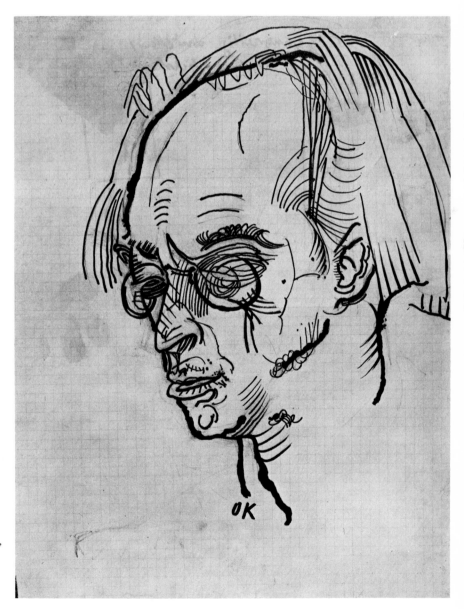

38. Oskar Kokoschka.
*Portrait of the Poet
Herwath Walden.* 1910.
Pen and ink, 11¼ × 8¾″
(29 × 22 cm). Fogg Art Museum,
Harvard University,
Cambridge, Mass.
(purchase, Friends of Art
and Music at Harvard).

Reed and Quill Pens As Figure 29 indicates, reed and quill pens should be cut so that a line varying from thick to thin can be drawn. Notice that the comparatively blunt point is cut convex on one side and concave on the other. If, however, you want only a fairly straight line that does not undulate, cut the reed or quill point to resemble a traditional steelpoint.

Reeds grow wild in many, if not all, parts of the country. Make sure the reed is thoroughly dry before you cut the point. A bamboo pen makes an excellent substitute.

The vibration of black and white marks, Van Gogh remarks in his letters, is equivalent to the vibration of complementary colors. *A Peasant of the Camargue*

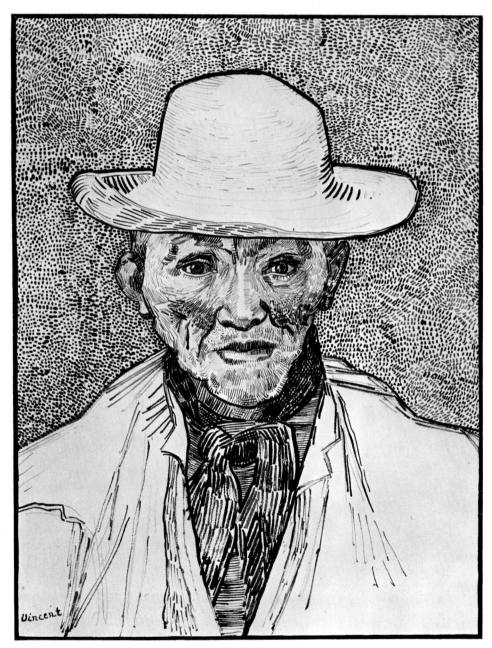

39. Vincent van Gogh.
A Peasant of the Camargue.
1888. Quill and reed pen
and ink over soft graphite,
19½ × 15″ (50 × 38 cm).
Fogg Art Museum,
Harvard University,
Cambridge, Mass.
(Grenville L. Winthrop
Bequest).

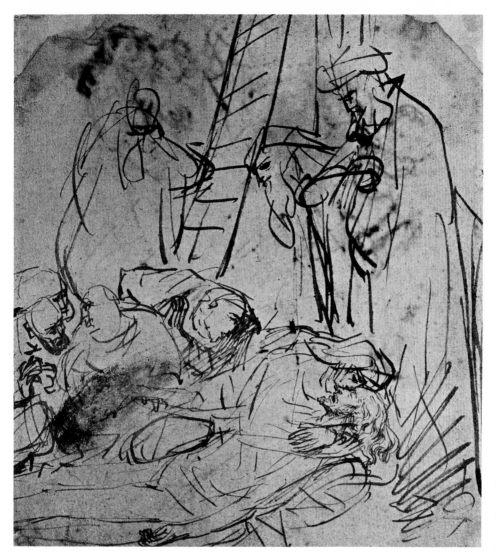

40. Rembrandt.
*Lamentation over the
Body of Christ.* c. 1635.
Quill pen and ink,
6¾ × 6″ (17 × 15 cm).
Kupferstichkabinett,
West Berlin.

(Fig. 39) is a study for a painting (Pl. 8, p. 212) in which the opposing colors do clash.
In the drawing, therefore, the textures representing background, hat, face, and shirt
are all different. These black-and-white textures, although stand-ins for the various
color vibrations, also play against each other as self-sustained contrasts.

The first question to answer about quill pens is, where to get a quill? Or a turkey
feather? Sea gulls along ocean beaches provide one source, and a visit to a turkey farm
provides another. One student found a reasonable supply of turkey feathers from a
manufacturer of children's Indian hats. Feathers are also available from commercial
suppliers, such as Finnysports. If you find a quill and use Figure 29 as a guide, your
quill will be able to produce a line that acts like Rembrandt's (Fig. 40). But his
handwriting is the natural product of his energies and experience, so do not try to
imitate it, or that of any other master. Pick a theme you are already working on, and
concentrate on it. Through familiar thematic material your handwriting (with this or
any other instrument) will find its own personality.

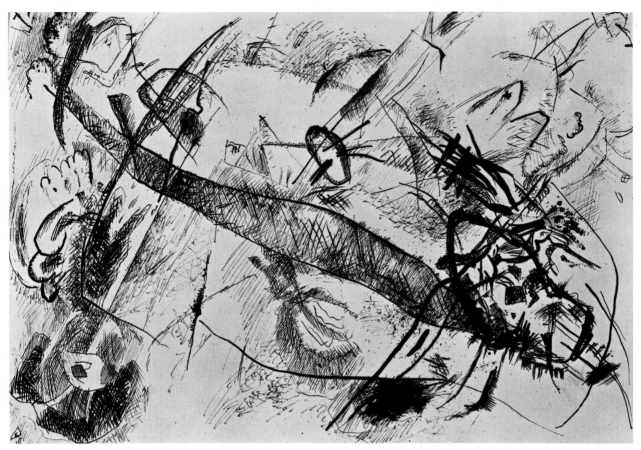

41. Wassily Kandinsky. *Untitled.* 1915. Pen and ink, 9 × 13¼″ (23 × 34 cm).
Museum of Modern Art, New York (purchase).

Kandinsky's pen drawing (Fig. 41) is a sort of grand finale of pen points, for to create the drawing's tensions—its spatial pulling and stretching—Kandinsky employed at least two, perhaps three, different pen points that in his hands produced a rich orchestration of texture.

Pen, Ink, and Wash The combination of pen, ink, and wash, like all other techniques, is open to a wide variety of instrumentation. Poussin, for example, used a fine steelpoint with a visual vibrato effect, along with a wash—that is, a watercolor brush with watered-down ink (Fig. 42). He applied the wash very delicately with light and medium values that do not overpower the line. By suppressing heavy darks he kept the pen lines and wash in the same tonal range and created a special soft light that permeates the whole work.

For the drawing in Figure 43 the artist used a quill pen thinner than the one employed in Figure 40. He combined the pen strokes with a wash to produce a wet cloud of atmosphere over the figure, throwing the upper torso into semidarkness. The wash also sharply defines the planes of the platform on which the figure rests.

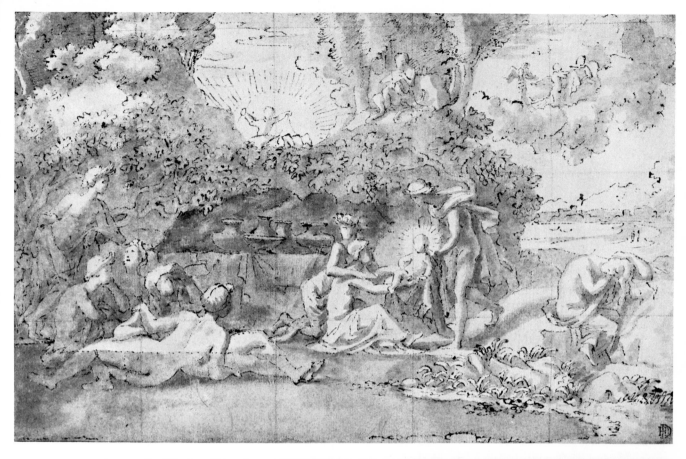

above: 42. Nicolas Poussin.
The Infant Bacchus Entrusted to the Nymphs.
1657. Pen, ink, and wash;
9 × 14¾″ (23 × 37 cm).
Fogg Art Museum,
Harvard University, Cambridge, Mass.
(gift of Mr. and Mrs. Donald S. Stralem).

right: 43. School of Rembrandt.
Study of a Nude Youth Seated on a Cushion.
1650-60. Pen and ink with wash,
heightened with white;
7⅞ × 8½″ (20 × 22 cm).
Victoria & Albert Museum, London
(Crown Copyright).

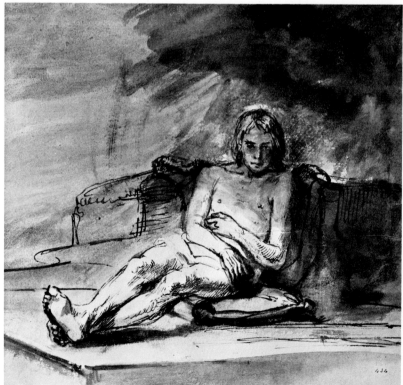

44. Claude Lorrain. *A Road Under a Wooded Slope.* Pen and brush in brown ink and wash, 9 × 12⅜″ (23 × 32 cm). British Museum, London (reproduced by courtesy of the Trustees).

Claude Lorrain worked with many tones of watered ink (Fig. 44), ranging from the very dark brushstrokes for the foliage at the center, to the middle-range layers in the foreground (with a few dry brushstrokes), to the more watered-down distant planes. Brush, ink, and water are the principal tools, and the pen is used sparingly. In the final analysis, this is a watercolor technique, but because it is produced from one color of ink (rather than watercolor material), it is called a wash drawing.

Silverpoint Before going into brush drawing and monotype—the boundary between drawing and painting—let us study silverpoint, a drawing technique related to both pencil and pen-and-ink, and drypoint, a process that technically speaking is a printmaking technique, but can also be classified as part of the drawing experience.

Silverpoint is a dry drawing medium, but because of its firm, sharp point, it feels like a steel pen. The silverpoint process produces a very delicate gray drawing. Exposure to air in a month's time gradually changes the silver deposit to a mellow brown color. Although silver is the usual metal, copper can also be employed, and this substance turns a dull green; similarly, lead turns a blue-gray.

To work with silverpoint, place a long silver wire in a modern mechanical pencil, and shape it to a fine point. You will be handling what appears to be an ordinary tool. Moreover, you do not need any special skill to prepare the ground. Take a sheet of rag paper (not too rough), tape it to a board with tan paper tape, and coat it smoothly, using a large watercolor brush and Chinese white watercolor diluted with just enough water to keep it fluid. Two or three smooth coats will do. There exist older formulas—for example, rabbitskin glue and bone dust or another abrasive material—but Chinese white works just as well. You may want to mix the white ground with some neutral watercolor paint. In doing so, keep the ground light, because silverpoint produces gray tones.

You can practice the silverpoint technique on some inexpensive clay-coated paper called "cameo." Although this takes the silverpoint well, it does not "skate" on the surface, nor are the lines as clear as on the Chinese (zinc) white. You can coat cardboard or paper with acrylic gesso and "draw" with aluminum nails. In general, do not try to gouge the surface to make darks, since the drawing will produce darks when it gradually turns. To make corrections, you can erase lightly and·recoat here and there with the white ground, but silverpoint is essentially a "one-chance" performance.

Even though the silverpoint medium is usually associated with a packed, tight handling such as Van Eyck's (Fig. 45), your style of drawing need not change to

45. Jan van Eyck.
Portrait of Cardinal Albergati. c. 1431.
Silverpoint on grayish-white
prepared paper, 8¼ × 7″ (21 × 18 cm).
Kupferstichkabinett,
Staatliche Kunstsammlungen, Dresden.

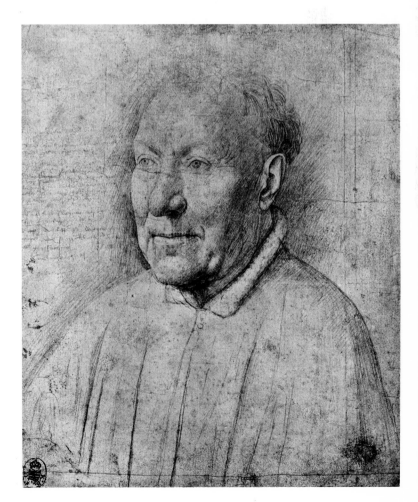

46. Leonardo da Vinci. *Study for the Sforza Monument.* c. 1488–90.
Silverpoint on blue prepared paper, 6 × 7¼″ (15 × 19 cm).
Royal Library, Windsor (copyright reserved).

accommodate it. Leonardo da Vinci, after all, used silverpoint with a loose, sketchy line (Fig. 46). Remember, too, that while silverpoint bears some resemblance to graphite pencil, it gives off a special soft light like no other medium.

Drypoint Drypoint is essentially a printmaking process. To employ it properly, you must learn the complicated technique of inking and printing the plate, and of using an etching press. Such a discussion is beyond the scope of this book. But you should understand the fundamentals of drypoint, for it most closely duplicates the act of drawing.

Like silverpoint, drypoint also involves drawing with a sharp point, in this case an etching needle—a pencil-shape metal tool, used directly on a copper or a zinc plate. The rough metal edge produced by the drawing strokes is called a burr. And this burr, once inked and printed, creates a soft-edged, rich, dark line on the paper. If the tool is held upright during the drawing process, the burr produced in its wake is double-edged; when drawn at a slant, the normal writing position, the burr leans in that particular direction. Drypoint prints, therefore, have a particular blurred edge on each line that gives them their unique appearance.

The drypoint effects vary from very soft, subtle edges to very heavy blurred edges depending upon the width of the etching needle, the pressure exerted during the drawing, and the method of wiping the ink. Three examples illustrate some of these possibilities. Jacques Villon uses drypoint to weave a horizontal-vertical screened surface in which the fuzzy burrs produce a frontal soft film of light (Figs. 47, 48). Lovis

47. Jacques Villon.
Seated Draughtsman. 1935.
Drypoint printed in black,
10⅝ × 8″ (27 × 20 cm).
Museum of Modern Art, New York
(purchase).

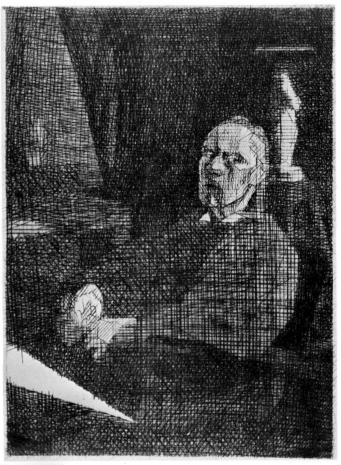

48. Detail of Figure 47.

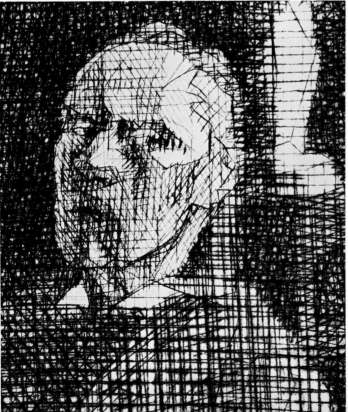

Corinth works with a finer needle to execute a delicate drawing (Fig. 49). You can see each line catching its own soft, drypoint echo. And, finally, Max Beckmann employs a thicker drawing point to create bold contours that more clearly reveal the soft edges of his work (Fig. 50).

Electric Drypoint　　An electric engraver or marking tool, made for industrial use, can create a variety of rich soft darks—in fact, five variations, each one an increase in darkness and width. This tool is the Drexel Electric Engraver. Although it vibrates slightly and makes a buzzing noise, it is easy to control. The higher the number at which you set it, the darker and wider the mark, and the more vibrating and noisy the tool. The blurred edges soften the allover energy in Gabor Peterdi's *Kahulu Reef I*

49. Lovis Corinth. *Nude with Arms Raised.* Early 20th century.
Drypoint, 9½ × 11½″ (24 × 29 cm). Private collection.

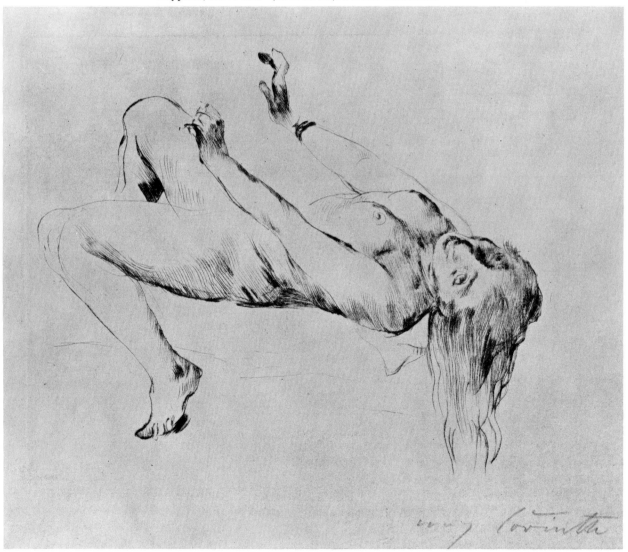

50. Max Beckmann. *Women's Bath.* 1922.
Drypoint, 17¼″ × 11⅜″ (43 × 28 cm). Private collection.

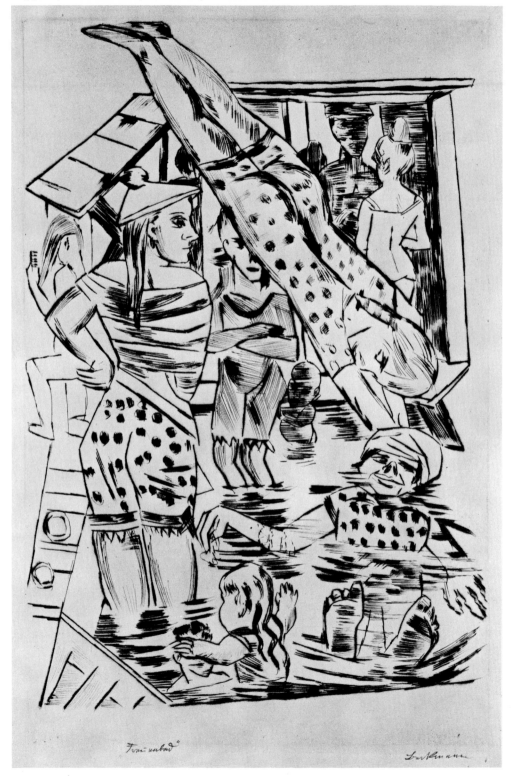

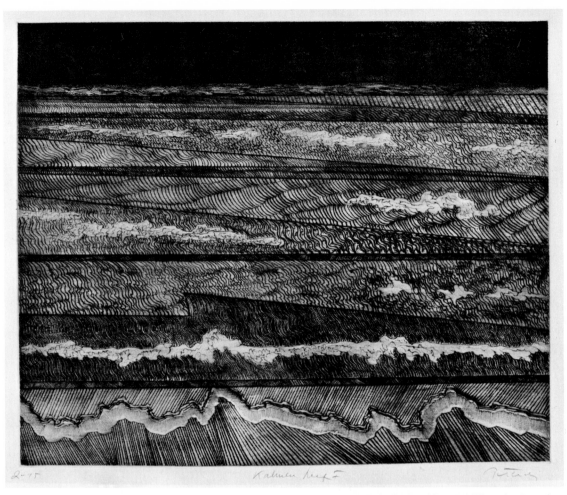

51. Gabor Peterdi. *Kahulu Reef I.* 1968. Electric drypoint, 20 × 24″ (51 × 61 cm). Courtesy the artist.

(Fig. 51), a skillful and imaginative work that illustrates the expressive potential of this commercial tool.

Brush The wash techniques mentioned earlier were all executed with the brush, either as an adjunct to pen drawings or, in the case of Claude Lorrain, as the principal component of the design. The Japanese excel at brushwork. However, their virtuoso handling, as the following illustrations suggest, is not standardized to conform to one tradition or model, but is adaptable to many.

Hokusai, with a slow-moving, firm control of contour, traces the pattern of clothing, pausing only to change to a smaller brush to depict head, hands, and feet (Fig. 52). Yet, this play between widths of brushes is incidental to the overall feeling of the weight and line.

Kuniyoshi seems to carve the air with one thin, long-haired brush in order to outline the volume that the figure occupies in space (Fig. 53). This breathtaking performance, seemingly accomplished in an instant, recalls the flashlight drawings Picasso executed a hundred years later in a darkened room in front of a camera.

below: 52. Katsushika Hokusai.
Self-Portrait. 1839.
Brush and ink.
Musée Guimet, Paris.

right: 53. Ichiyūsai Kuniyoshi.
Sketch for kakemono-e of Tokiwa Gozen.
Brush and ink,
22½ × 9⅞″ (57 × 25 cm).
Rijksmuseum voor Volkenkunde,
Leiden, Netherlands.

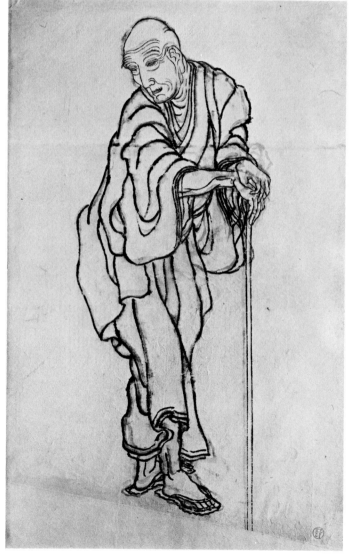

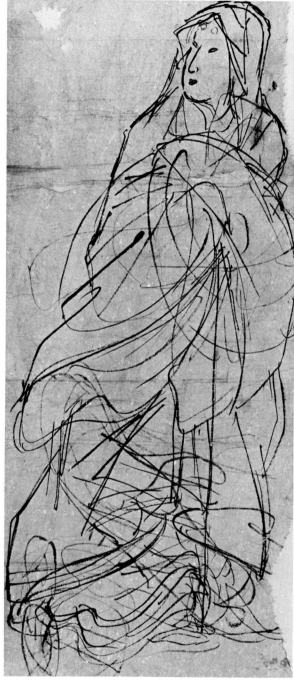

54. Kitagawa Utamaro. Study for color print,
Okubi-e, "Large Head" of Courtesan. 18th century.
Brush and ink, 14⅝ × 10⅝" (37 × 27 cm).
Rijksmuseum voor Volkenkunde, Leiden, Netherlands.

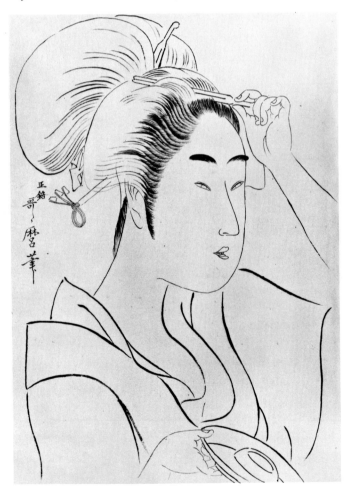

above: 55. Anonymous Japanese. *The Drinkers.*
19th century. Brush and ink.
Rijksmuseum Kröller-Müller, Otterlo, Netherlands.

Utamaro, using a totally distinct mode of instrumentation, carefully gives us a lesson in texture—and from two aspects (Fig. 54). First, he varies the brushes and the brushstrokes so as to differ the lengths, weights, and characters of the marks. Second, each change in brushstroke and brush represents another texture: flowing cloth, delicate eyebrows, fine hair, and with a softer line, flesh. Yet, the effect of these mixed textures is harmonious, for each one cooperates with the others to form one unified vision. Lastly, another completely different use of the brush from a Japanese artist (Fig. 55) here provides a full, rich scale of values in a remarkably fluid manner.

In the West, graphite pencils or pens are the everyday writing tools, but in the East it is brushes. Each culture marvels at the other's use of its native instrument. Nevertheless, Western artists' particular handling of the brush derives from a set of visual traditions distinct from those that characterize the East. In a study for *The Raft of the Medusa* (Fig. 56) Géricault explores possible chiaroscuro effects for the final

56. Théodore Géricault.
Study for *The Raft of the Medusa*. c. 1818.
Brush and ink, 8 × 11″ (20 × 29 cm).
Rouen Museum.

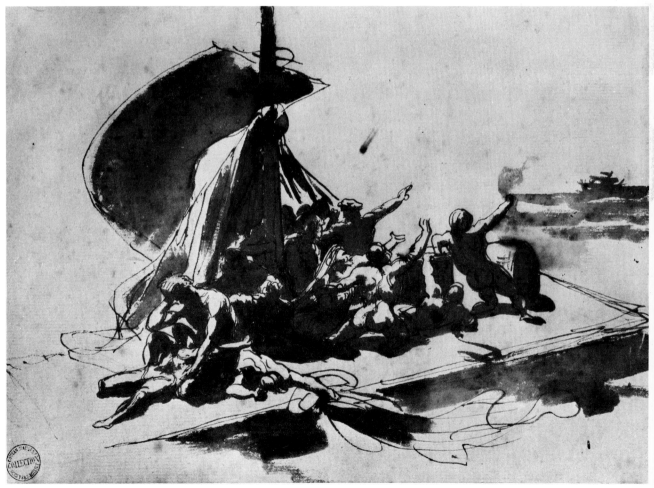

57. Henri Matisse. *Head of a Girl.* 1946.
Brush and ink, 17¼ × 11″ (44 × 28 cm).
Phillips Collection, Washington, D.C.

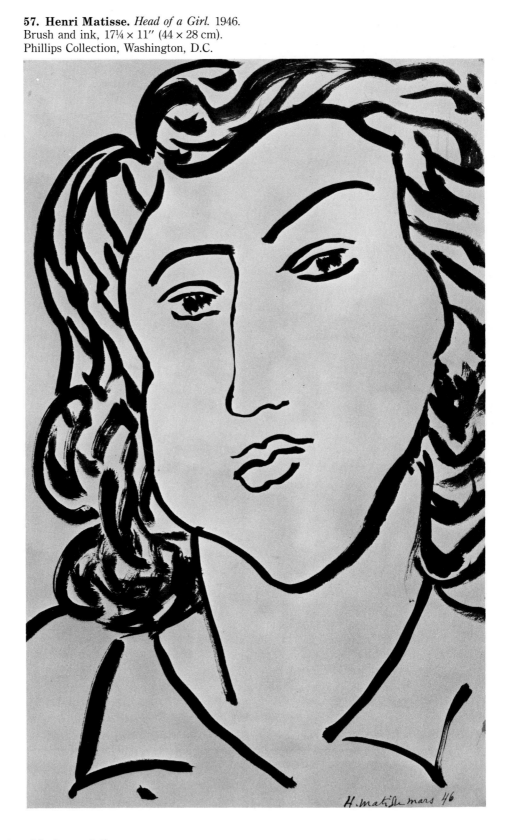

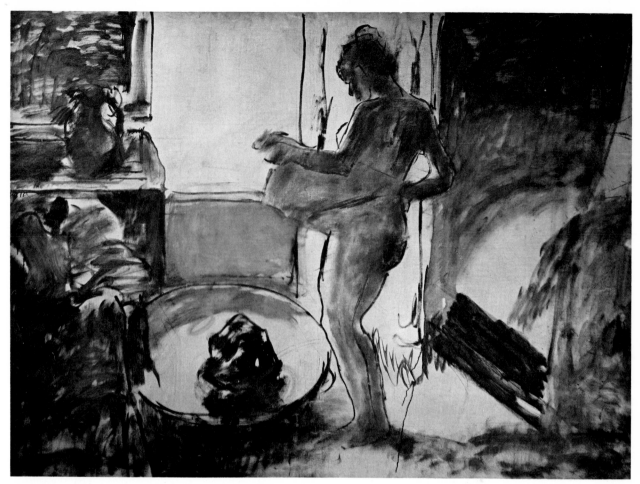

58. Edgar Degas. *Femme au Tub* (*After the Bath*). c. 1880.
Oil on canvas, 4'11⅛" × 7'⅜" (1.5 × 2.14 m).
Brooklyn Museum (Carll H. De Silver Fund).

painting (Fig. 181). Even though the brushwork makes large dark shapes, it is still used in the tradition of wash with accompanying line. In Matisse' *Head of a Girl* large, looping, free-flowing brushstrokes fill the entire surface of the picture plane and seem to extend beyond it (Fig. 57).

Degas' *Femme au Tub* (Fig. 58) at first appears to be a beautiful brush, ink, and wash drawing. But it is actually a monochrome oil sketch, probably burnt umber with turpentine on a primed white canvas. Thus, one medium (painting) acts like another (drawing). For Degas, however, who often crossed the formal line between media, this is both a logical and a personal step. Indeed, he also worked with pastel as if he were layering painted color over painted color—a technique held to be so impossible that experts still warn that it will lead to mud.

Drawing and Painting

In monotype the distinction between media is further blurred. You draw on a metal etching plate with printing ink or oil paint. You can thin with turpentine, use a brush

Monotype

to make tones and lines, or, as Degas did (Fig. 59), coat the whole plate with a thin coat of oily, heavy printing ink and work in reverse, drawing out the lights with a rag. Degas made the white lines by inscribing them on the plate with a blunt, hard point. The monotype image is easily changed. Whole areas or lines can be erased with rag and turpentine. But when the artist is satisfied, the image is printed on an etching press with presoaked, dampened paper, the same way one prints an etching—except that only one impression can be printed. After the impression is taken, a ghost image sometimes remains on the plate. Degas and monotype artists following him used these leftover images to rework and make variations on the theme. Such a process can lead to countless variations, since each successive impression yields another ghost. Degas even reworked the printed image by adding pastel, watercolor, or oil paints to the finished monotype. Another desirable characteristic of the medium is improvisation, apparent in Mary Frank's monotype *Amaryllis* (Fig. 60). Because the work is extended over two zinc etching plates, it creates, by its startling placement, a fresh image. Clearly, monotype is a highly flexible medium and one that is finally having a revival.

Watercolor Monotype

A young artist, Heddi Siebel, has been experimenting with an interesting combination of media: watercolor monotype (Fig. 61). She has written a detailed set of instructions to explain her process:

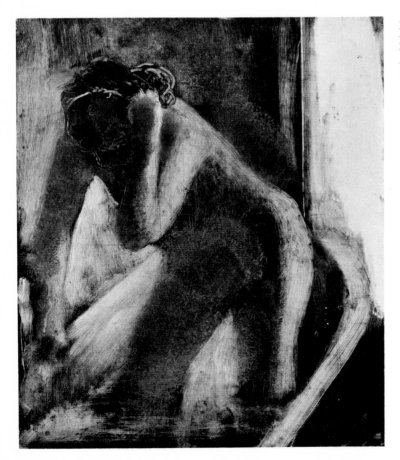

59. Edgar Degas. *Le Bain.* c. 1880–85. Monotype (first of two impressions), 20¼ × 13⅞″ (51 × 35 cm). Art Institute of Chicago (Clarence Buckingham Collection).

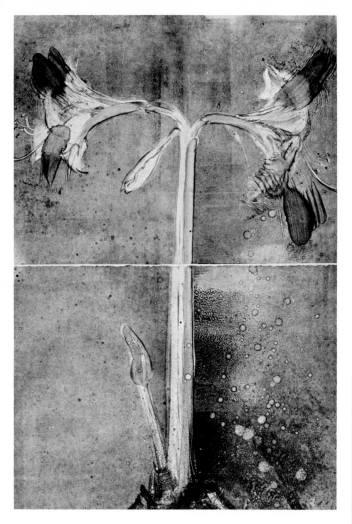

left: **60. Mary Frank.** *Amaryllis.* 1976.
Monotype on two sheets, each 22¼ × 30″ (56 × 76 cm).
Courtesy Zabriskie Gallery, New York.

below: **61. Heddi Siebel.** *Still Life with Fish.*
1976. Watercolor monotype, 14 × 17″ (35 × 43 cm).
Courtesy the artist.

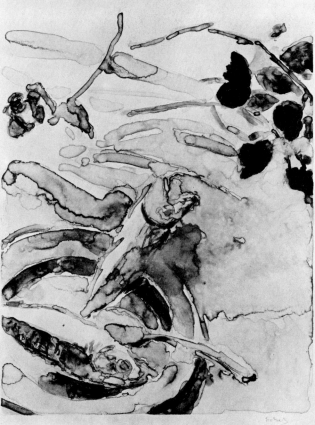

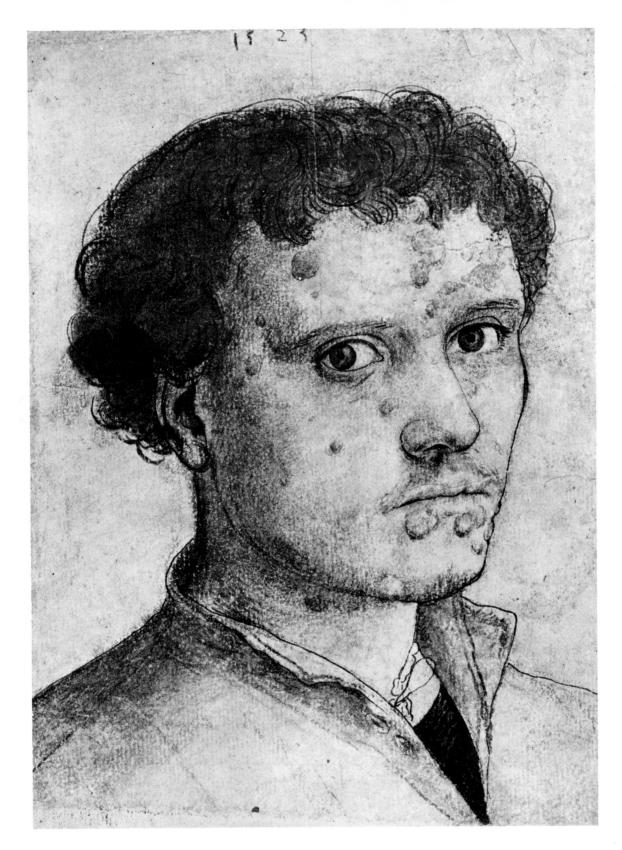

I use ¼-inch Plexiglas ground with 220 grit carborundum as my printing surface—it has a frosted appearance but acts to hold the pigment nicely. Back the glass temporarily with white paper so that it is possible to get an approximate idea of the color.

Paint on glass with watercolor and water (I use the tube variety so that I may have more control over the quantity of pigment).

Let it dry on the glass (but don't let it sit for long), and print it with damp paper (rag paper that has been soaking in water and then blotted). The amount of dampness will also determine the amount of pigment lifted off the glass.

I print my monotypes with the press. I line up the glass and adjust the pressure so that the roller is 1/32 inch away from the glass surface. Then I add one thin blanket and print it (if using thin papers such as rice papers be sure to cover the paper with another sheet of newsprint so that paint does not penetrate through to the blankets). [Make sure the bed of the press has evenly distributed pressure, otherwise the glass will crack.]

Of course it is possible to try a variety of printing experiments, i.e., printing while the watercolor is wet. The process used should depend upon the desired effects.

Mixed Media

Figure 62 presents a drawing that combines most of the media discussed in this chapter. Holbein's superb performance in red and black chalk, quill pen, and washes of ochre and gray should not discourage you from trying your own combinations. Remember, to make sure your materials work in harmony to form one image.

Papers for Drawing

There are as many available papers for drawing as there are tools with which to draw. As always, your own sensibilities and vision must govern your selection. Keep in mind that rag paper is easiest to draw on. The marks stay clearly on the surface without sinking in, and the surface takes erasures without the obvious damage apparent in the cheap woodpulp papers, such as newsprint. The woodpulp papers also yellow and get brittle with time, whereas rag papers, if properly stored or displayed, retain their original character. Every rag paper has a different surface quality, so you should experiment with as many as you can buy.

Do not try large drawings at first. Cutting up each sheet into two or even four parts makes experimentation less costly. In general, the more paper you buy from a company, the cheaper each sheet.

Beyond these basics it is difficult to give exact advice about which paper to choose for a particular project. Most published material on paper deals with the adaptability of various types to printmaking processes. Draftsmen, however, select a paper for its surface, its "feel," and then adapt their vision to these qualities.

The following table (Fig. 63) details and illustrates a test made with a dozen papers, readily available from the four companies listed. Each paper was tested with conté crayon, various pencils, wash, and pen and ink. Charcoal and pastel were omitted, because only relative roughness and smoothness were to be considered, and conté reveals this just as well. Relative acidity (pH) is not listed, because test batches of the same paper showed widely varied readings.

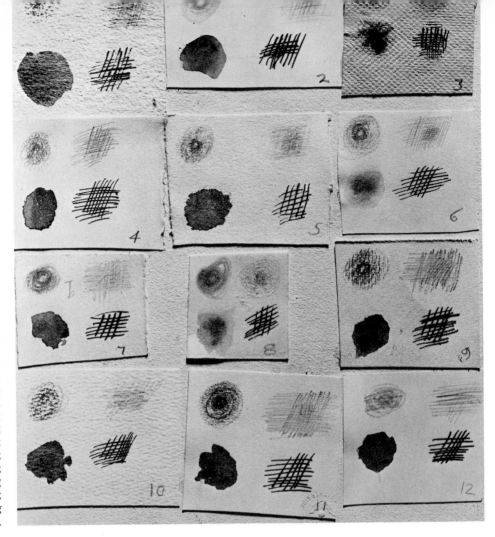

63. Paper samples, with test marks of various media: (1) Classico Fabriano (rough finish); (2) Classico Fabriano (smooth finish); (3) Zaan; (4) Lana; (5) Rives BFK (absorbent surface); (6) Rives BFK (smooth surface); (7) Arches Cover; (8) Toyoshi; (9) Murillo (Fabriano); (10) Strathmore Watercolor; (11) Strathmore Drawing Board (soft surface); (12) Strathmore Drawing Board (smooth surface).

Classico Fabriano Italy	
weight: 140	Takes watercolor and wash well. Too soft for pencil. Conté reveals the very rough surface. Will work with heavy pens—bamboo, reed, and lettering.
surface: rough	
process: hot press	
color: ivory	
size: 22 × 30 inches	
rag content: 25%	
widely available	

Classico Fabriano Italy	
weight: 140	Although sold under the same name as the above, this paper has a different color and surface. It is very smooth and excellent for pen and pencil. A wash stays in place, but does not spread well.
surface: smooth	
process: hot press	

color: white

size: 22 × 30 inches

rag content: 25%

widely available

Zaan Holland

weight: approximately 200

surface: rough

process: not indicated

color: natural (tan)

size: 24⅜ × 28½ inches

rag content: 100%

source: Process Materials Corp.

A rough, mechanical surface that takes pastel well. Conté may not cover the surface texture sufficiently. Wash holds, but the wetness dents the paper, although it eventually dries flat. Too soft for pencil; takes ink but blurs slightly.

Lana France

weight: 140

surface: medium

process: not indicated

color: ivory

size: 22 × 30 inches

rag content: 100%

source: Process Materials Corp.

Takes all media well and is relatively inexpensive.

Rives BFK France

weight: 140

surface: medium (absorbent)

process: not indicated

color: white

size: 22½ × 30 inches

rag content: 100%

widely available

Takes wash well, but pen is slightly blurred. Has a granular effect with conté. May be too absorbent for pencil.

Rives BFK France

weight: 90

surface: medium smooth

process: not indicated

color: ivory

size: 26 × 40 inches

rag content: 100%

widely available

A smoother paper than the above. Takes pen and pencil better. Less absorbent than the above, which keeps the wash more on the surface.

Arches Cover France

weight: 122

surface: medium soft

process: not indicated

color: ivory

size: 22 × 30 inches

rag content: 100%

widely available

Takes all media well, although pencil effects are soft. Arches Company makes many varieties of paper, including excellent watercolor paper in different degrees of roughness, and smoother and harder drawing paper called Arches Silkscreen.

Toyoshi Japan

weight: approximately 120

surface: medium soft

process: not indicated

color: warm white

size: 43 × 75 inches

rag content: 100%

source: Aiko's Art Materials Import

Excellent for all media except pencil, for which it is too soft. Japanese papers are generally highly absorbent and, therefore, superb for water-thinned techniques. Note the large size.

Murillo (Fabriano) Italy

weight: 360

surface: medium to rough

process: not indicated

color: cream

size: 27½ × 39½ inches

rag content: 25%

widely available

May be too rough for pencil and blurs with pen. Conté reveals a good but even and heavy surface. Excellent for wash and watercolor.

Strathmore Watercolor U.S.A.

weight: approximately 140

surface: medium to rough

process: not indicated

color: white

size: 22 × 30 inches

rag content: 100%

source: Strathmore Paper Co.

Too rough for conté and pencil, but excellent for wash, watercolor, and pen.

Strathmore Drawing Board U.S.A.

weight: approximately 140

surface: medium soft

Very good for conté—permits a wide range of tones. Excellent for pen, takes wash well. May be too soft for pencil.

process: not indicated

color: white

size: 23 × 29 inches, 30 × 40 inches

rag content: 100%

source: Strathmore Paper Co. (No. 235-62)

Strathmore Drawing Board U.S.A.

weight: approximately 140

surface: smooth

process: not indicated

color: white

size: 23 × 29 inches, 30 × 40 inches

rag content: 100%

source: Strathmore Paper Co. (No. 235-72)

This variety, smoother than the above, is best for pencil and pen. It does take wash, but achieving a variation of tone is difficult. Too hard for conté.

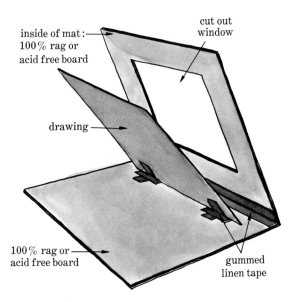

64. A standard hinge mat is easy to assemble.

Matting

All good drawings deserve good mats. An illustration of the standard hinge mat appears in Figure 64. Do not use woodpulp board. The acid in it burns and stains the drawing paper. For both the mat and its backing, use either 100 percent rag board (called "museum board") or a new nonrag board developed by Process Materials Corporation, which is also 100 percent acid-free. To hinge the drawing to the mat, use only gummed linen tape, because it is acid-free. This tape is available from Dennison Manufacturing Company, Gane Brothers and Lane, Inc., and Gaylord Brothers, Inc.

Supports and Grounds for Painting

Chapter Two

Many people confuse the terms *support* and *ground*. In fact, the two often are used interchangeably. However, in a book dealing with techniques, it is important to make a distinction. Three definitions will provide the key to understanding the discussion and formulas given in this chapter.

Support A *support* is the surface, the backing, on which the medium is applied. For paint the support is usually canvas or a panel made from masonite or wood. (Paper would be the equivalent support for a drawing.)

Sizing (or Size) A *size* is a preliminary coating often applied to the support. It is a glue solution, several versions of which are given in this chapter. Size is most commonly used under oil paints to prevent the colors from coming into direct contact with the canvas or board. Such contact causes crumbling and rotting. Acrylic colors and media, which are thinned with either water or turpentine, do not rot canvas, so no sizing is necessary.

Ground A *ground* is also a preliminary coating, but in this case the purpose is primarily to create a luminous undersurface for the paint. Over a period of time colors, and especially oil colors, tend to thin, and a ground provides them with a supporting layer. With oil paints the ground often is applied over a sizing; for acrylics it may be painted directly on the raw canvas or panel. Ground may consist of: a white

oil- or water-base paint; the traditional gesso mixture, comprised of glue, water, whiting, and titanium white powder; a ready-mixed synthetic (acrylic) gesso that eliminates the need for sizing.

Supports

Compared to a canvas prepared in the studio, a well-prepared commercial canvas is very expensive. The added advantage of a studio-prepared canvas is that you have a wide choice of surface qualities. If you purchase an inexpensive commercial canvas, you may encounter the following problems.

Manufacturers label the ground on commercially prepared canvas as either oil or acrylic. But the label does not say, for example, whether an acrylic ground canvas is first sized with acrylic resin under a coat of acrylic gesso. If the size is lacking, the surface may wrinkle during the painting process, and for years afterward. There is one way to determine whether an oil ground is lead (flake) white or titanium white if the label does not specify. Take an edge of the ground coat, and fold and refold. Lead white is brittle and produces a crackle on its skin; titanium is more flexible.

Canvas with Acrylic Ground With a commercial acrylic ground, be sure the ground is not too thin, or oil will soak through. Hold the canvas to the light, looking for those pinholes of light that reveal an excessively thin ground. Also check to see if the ground is applied in a consistent coat. To prevent further absorption, add another coat of acrylic gesso, preferably with a spatula or a putty knife—instruments that will facilitate a more even coat.

Linen Canvas with Acrylic Ground Linen by its nature takes in moisture from the atmosphere and therefore may expand in damp weather. If the acrylic ground is not presized with acrylic medium, this fault tends to be aggravated.

Canvas with Oil Ground On an oil-grounded, studio-prepared canvas, make sure the fabric is heavy enough to sustain the rabbitskin glue and oil priming. Thin fabric tends to retain wrinkles. Some pinholes of light are permissible, since they will be filled in by the glue size and the ground. If the ground comes through to the back, your canvas is too porous.

Caution: Do not use acrylic paints on an oil-prepared ground. Acrylic will not adhere to oil, even though it initially seems to hold.

Linen Texture choices in linen range from very smooth, to medium, medium rough, and finally to rough (Fig. 65). Experiment with each surface in order to find the one most suited to your style. Because the best linen is closely woven, the number of threads per square inch determines the price. In the cheapest varieties you can actually see through the fabric. Linen not only has the widest available range of textural surfaces, but is also the most permanent and long-lasting textile. This permanence depends on several factors—grounds, good technique, and protection from extremes of temperature. If the canvas is stored in a humid place without occasional airing, mold will develop. Remember, too, that linen tends to wrinkle or sag in damp weather.

Cotton The textural range in cotton is narrow and usually does not go beyond a medium surface. The ideal weight is Number 10. (The number is determined by the

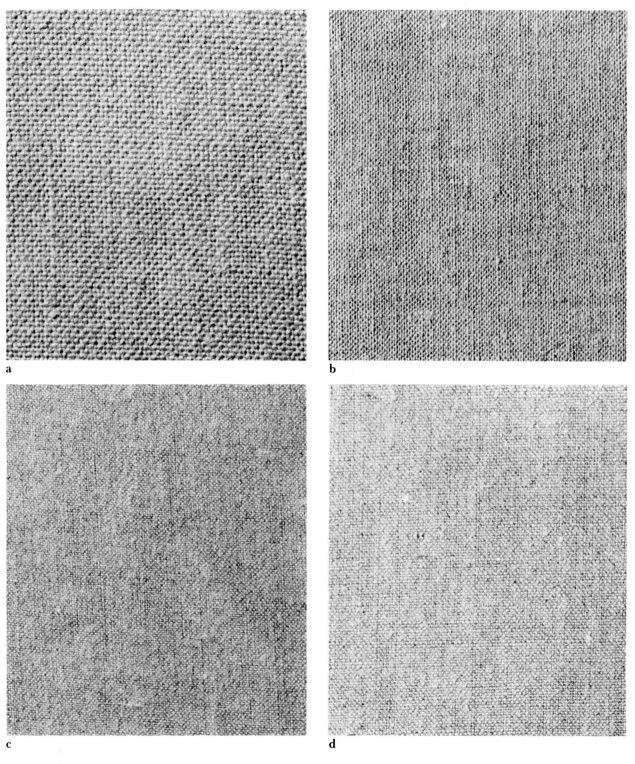

a

b

c

d

65. Linen has the widest texture range
of all the support fabrics. Shown are four examples:
(a) rough, (b) medium rough, (c) medium, and (d) smooth.

weight of ounces per yard.) Numbers 8 and 12, the adjacent weights, are either too heavy or too thin to stretch easily over the wooden frame. Cotton has two advantages over linen. It does not absorb as much moisture and thus stays unwrinkled, even in very damp conditions. It is also cheaper than linen. But there is a lack of textural choice, and the manufacturing process can be undependable. Make sure the surface is even, with no unsightly stitches, brown flecks, or threaded lumps.

Jute Jute is a beautiful, but impermanent, surface that tends to become very brittle as it ages. Gauguin used it and his canvases have had to be relined—that is, glued to linen. Jute is permanent only if used to make canvas or board panels. Prepared and stretched jute canvases can be found throughout European art stores.

Panels **Masonite** Masonite is the most permanent of the rigid supports. Untempered masonite provides a better surface and is less expensive than tempered, or oil-impregnated, masonite. Either the rough or the smooth side of the masonite panel can be used. Whichever one you select, apply at least one coat of your primer to the reverse side in order to prevent warping.

Hard Wood Panels made of hard wood, although permanent, can warp if they are not cradled on the back—that is, braced with an equal stress of horizontal and vertical wood strips affixed with any white vinyl glue.

Plywood Plywood eventually shows its grain, even if sealed, and is thus best avoided as a direct painting surface. Use it only as a support for gluing on canvas.

Plasterboard and Celotex Plasterboard and Celotex tend to rot from within and also should be avoided.

Aluminum Imitation canvas texture has been stamped into aluminum and impregnated with priming, but this method is at present too expensive for general use.

Paper Provided it is all rag content and properly primed, paper is permanent. Tape the paper to a support with brown paper tape to keep it from wrinkling as the priming dries. For priming, use a weak glue solution—14 or 15 parts water to 1 part glue. Dry pigment can be added to the glue mixture to produce a toned ground. Another possibility is two coats of acrylic gesso.

Making the Support

Canvas Panels To make a canvas panel, soak the material in acrylic medium or rabbitskin glue (12 parts water to 1 part glue). This serves as the sizing coat. While the canvas is still wet, wrap it around the masonite, folding it neatly in the back. Squeeze out the air bubbles on the front with a flat piece of wood. Apply any of the ground formulas listed in the first part of this chapter.

Stretching a Canvas As a general rule, do not stretch umprimed fabric too tightly on the stretcher, since the glue in the size may tighten the fabric so much that it will twist the stretcher.
 If commercial stretchers are employed, use a square to determine if they are at right angles. Do not trust your eye. Next—whether for commercial or studio-made stretchers—put three staples at each joined intersection, as illustrated (Fig. 66). This

stapled side will be the back of the stretcher. Cover the stretcher frame with the canvas, leaving at least an inch and a half of extra canvas around the edges, so that you can grasp the fabric with canvas pliers. Locate the first four staples at the center of each side, rotating to the opposite side. Remove these four staples one at a time and pull a little tighter, then replace them at the same locations. These are the key points. With the canvas pliers, proceed by pulling from opposite side to opposite side to keep the tension balanced, inserting new staples as you alternate sides, rather than going completely up or down one side.

66. To stretch a canvas: first use a square to determine if frame is at right angles; then, on the back, put three staples at each corner (a). Cover the frame with canvas, leaving at least 1½″ of extra canvas around the edges, so that fabric can be grasped with canvas pliers. Staple canvas at center points (b). Then remove the center staple from each side, rotating to the opposite side (c). Pull canvas tighter where staple was removed. Using canvas pliers pull canvas, alternating sides, and insert new staples (d).

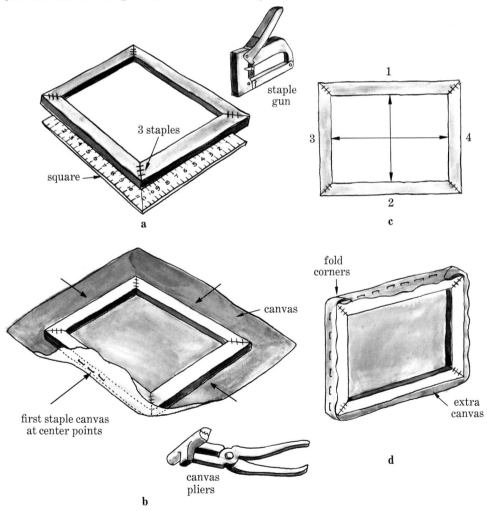

staple gun

3 staples

square

square

3

1

4

2

canvas

fold corners

first staple canvas at center points

canvas pliers

extra canvas

a

b

c

d

67. To assemble Stretcher No. 1:

(a) Use 1-by-3″ wood.
You will need two 48″ and two 31″ pieces.

(b) Glue the end of the 31″ strip to the side
of the 48″ strip.

(c) Secure pieces with a 3″ iron angle.

(d) For cross bracing cut a 43″ strip from 1-by-3″ wood.
Wedge strip between the two shorter sides
of the stretcher, mid-way between the longer sides.

(e) Insert two 14¼″ strips (with glue)
between 43″ cross-bar and 48″ stretcher bars.

(f) For corner bracing use either iron angles on both
front and back or masonite triangles on the back only.

(g) Use T-shape iron angles to brace cross-bars.

(h) Cut two 36″ and two 48″ strips
of quarter-round pine at 45° angles. With ½″ brads
nail the quarter-rounds along the perimeter
of the stretcher to elevate canvas.

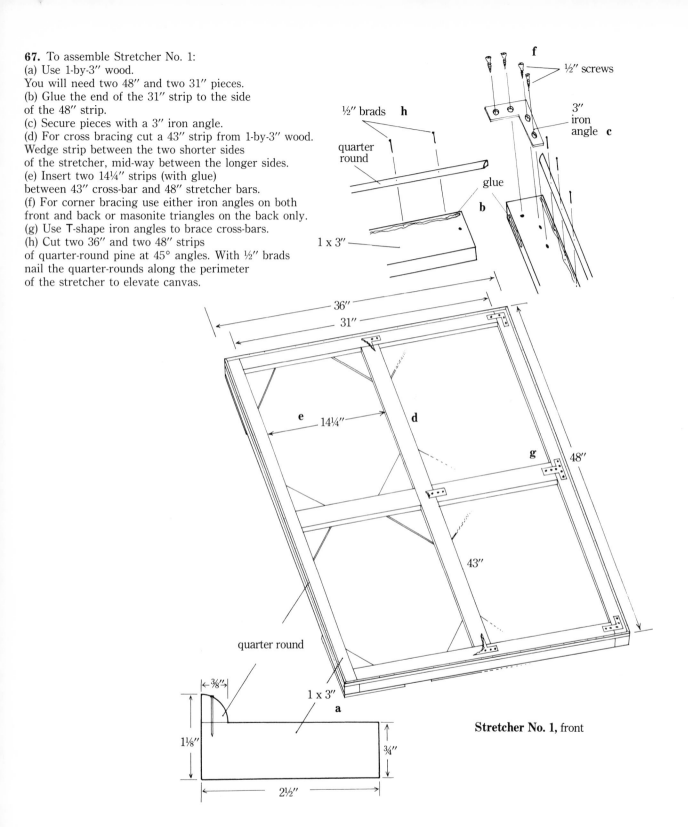

Stretcher No. 1, front

Several kinds of wooden (pine) stretchers, or strips, are available commercially from art supply manufacturers. A stretcher should be produced from kiln-dried wood to prevent warping. Because such stretchers are difficult to find, you must check each strip carefully to make sure it is not warped. Although the narrower variety of strips is adequate for small paintings (up to 24 inches), use the heavier strips whenever possible.

The least expensive brand of these large-size stretchers is manufactured by Utrecht Linens. You will find these strips adequate if you can inspect each piece of wood, for many are warped. If you have to order by mail, specify that each strip be inspected at the factory.

More expensive wooden stretchers are generally free of warped wood and fit together perfectly at the joints. These include the strips produced by David Davis, which are made from hardwood rather than pine. Also recommended are the laminated pine stretchers made by Craft-Cut. Lamination keeps the wood in equal tension and thus prevents warping.

Among the best crafted—and the most expensive—wooden stretchers are those manufactured by James J. Lebron. These stretchers have metal expansion bolts set into the corners, so that you can expand the corner openings by inserting an ordinary nail-set and turning.

To make your own stretcher use only well-dried, straight pieces of wood. Inexpensive "green" wood will warp and is obviously no bargain. There are many different designs for producing wooden stretchers, of which two basic ones are illustrated in detail (Figs. 67, 68). Stretcher No. 1 is very easy to make and needs no special tools, such as a mitre box or a table saw. Stretcher No. 2, (Figs. 68, 69), however, is more complicated, since it requires a table saw, is designed for very large paintings, and can be completely dismantled and rebuilt.

Step 1: Stretcher Strip or Bar Assembly Use 1-by-3-inch wood. When purchased in a lumberyard, such strips actually measure $\frac{3}{4}$ by $2\frac{1}{2}$ inches. Cut the wood into two 48-inch and two 31-inch pieces (Fig. 67a). Make sure the ends are absolutely straight, since they will form the corners of the stretcher. Butt join one 48-inch piece with one 31-inch piece—that is, glue the end of the 31-inch strip to the side of the 48-inch one (Fig. 67b). Secure with a 3-inch iron angle (Fig. 67c). Then take a T-square or other reliable right angle and verify that this corner is at a 90-degree angle. Join the remaining two strips in the same way. Next, attach the two L shapes to each other with glue and iron angles so that they form a 48-by-36-inch rectangle.

Step 2: Bracing Begin with the cross-bar bracing. From 1-by-3-inch wood, cut a 43-inch strip. Apply some white glue (Elmer's, Sobo, or similar) at each end. Wedge the strip between the two shorter sides of the stretcher at an equal distance from each of the longer sides (Fig. 67d). Then cut two $14\frac{1}{4}$-inch strips from the 1-by-3-inch wood. Apply glue to the ends, and wedge them between the 43-inch cross-bar and the 48-inch stretcher bars (Fig. 67e). Make sure they are at an equal distance from the two 31-inch stretcher strips.

For corner bracing you can brace the stretcher either with iron angles on both front and back, or with masonite corners on the back only. For iron-angle bracing, simply lay the stretcher down flat on the floor, and secure the iron angles in each corner with four $\frac{1}{2}$-inch screws (Fig. 67f). Use T-shape iron angles to brace cross-bars as shown in Figure 67g.

Commercial (Wooden) Stretchers

Studio-Made Stretchers

Stretcher No. 1 (36 by 48 inches)

For masonite bracing, cut eight pieces of masonite into right angles, 8 to 10 inches on the short sides. The easiest way to do this is to cut four squares in half diagonally. Keep an additional square in reserve in order to brace the cross-bars in the back center of the stretcher.

Then glue a masonite corner brace to one of the stretcher corners. Immediately start nailing ½-inch brads at 1 to 2 inch intervals on the areas of the braces that are in contact with the stretcher bars (Fig. 67). Repeat this procedure at each corner and at the points where the cross-bar meets the stretcher bars. Finally, glue and nail the masonite square in the center of the stretcher, where the cross-bars meet.

Step 3: Making a Quarter-Round Lip In order to prevent the stretcher bars and cross-bars from making an impression in the stretched canvas, keep the canvas from touching the stretcher by elevating it along the outer edge of the stretcher (Fig. 67h). To accomplish this, cut two 36-inch and two 48-inch strips of quarter-round pine at 45-degree angles, making sure that the angles are cut in opposing, rather than parallel, directions. Apply some glue along the edge of the stretcher bars. With ½-inch brads, nail the quarter-rounds along the perimeter of the stretcher.

This particular stretcher design has many variations. You can make it with mitred corners by laying the quarter-rounds on the stretcher before you cut and then joining them. Cut the stretcher bars (1-by-3-inch and quarter-round) as one unit in the mitre box, and glue all the pieces.

Stretcher No. 2 (7 by 10 feet) Stretcher No. 2 (Figs. 68, 69) is a more complex design. It is able to handle large canvases, and can be folded or dismantled.

Step 1: Stretcher Bar Assembly To make the stretcher bar sections, cut one 7-foot and one 10-foot 1-by-4-inch strip lengthwise at 10-degree angles. The result will be two 7-foot and two 10-foot pieces of wood approximately 1 by 2 inches, with a 10-degree beveled edge. Then cut about ⅟₁₆ to ¼ inch off the bevel to make a ⅛-inch lip.

Step 2 On a table saw, cut two more 7-foot strips of 1-by-2-inch wood. In the middle of each cut a notch 2½ inches wide and ⅜ inch deep (Fig. 68a). Repeat this procedure with two 10-foot strips of 1 by 2 inches, but cut the notches at the one-third points.

Step 3: Assembling the Stretcher Bar Sections Lay a 1-by-2-inch notched strip of either length, with notches facing down, on top of a ½-inch thick strip of wood or any ½-inch thick object. This will stabilize the notched strip while you are joining it with the beveled strip of the same length, beveled edge facing up. Apply some glue to the side of the notched 1-by-2 (Fig. 68a) or the part of the beveled 1-by-2 facing it (Fig. 68b). Nail the strips together immediately, but be careful not to put nails in the notches or within 8 inches of the ends of the stretcher bar elements. If the ends do not appear as securely glued as the rest of the stretcher bar section, fix them with clamps while the glue is drying. Repeat this entire procedure for each set of notched and beveled 1-by-2 sections of the same length. The result will be four T-shape stretcher bar elements that are notched for the insertion of the cross-bar ends.

Step 4: Cutting the End of the Stretcher It is essential that you cut the T-shape stretcher bars at each end at opposing angles of exactly 45 degrees. In this way, the

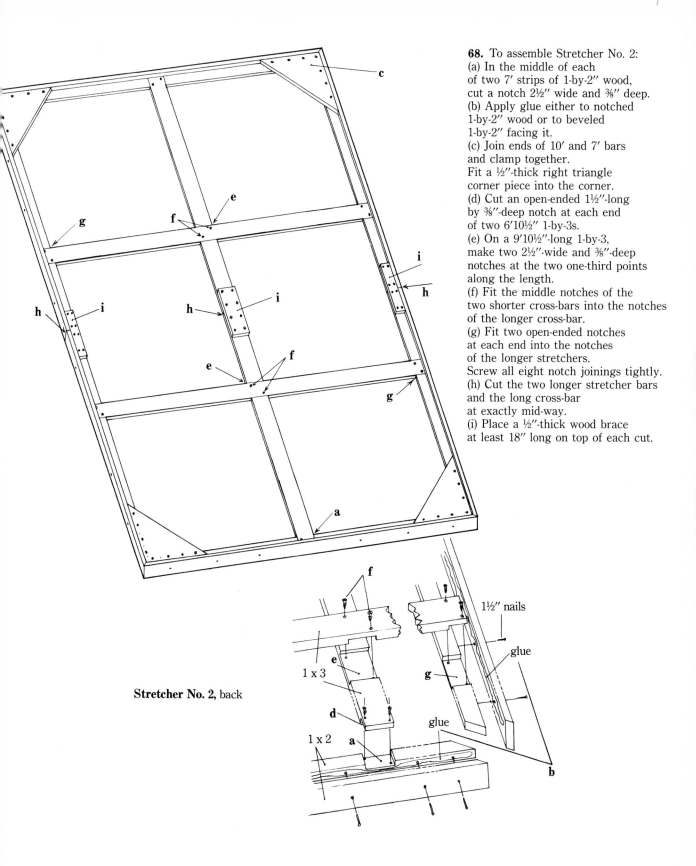

68. To assemble Stretcher No. 2:
(a) In the middle of each
of two 7′ strips of 1-by-2″ wood,
cut a notch 2½″ wide and ⅜″ deep.
(b) Apply glue either to notched
1-by-2″ wood or to beveled
1-by-2″ facing it.
(c) Join ends of 10′ and 7′ bars
and clamp together.
Fit a ½″-thick right triangle
corner piece into the corner.
(d) Cut an open-ended 1½″-long
by ⅜″-deep notch at each end
of two 6′10½″ 1-by-3s.
(e) On a 9′10½″-long 1-by-3,
make two 2½″-wide and ⅜″-deep
notches at the two one-third points
along the length.
(f) Fit the middle notches of the
two shorter cross-bars into the notches
of the longer cross-bar.
(g) Fit two open-ended notches
at each end into the notches
of the longer stretchers.
Screw all eight notch joinings tightly.
(h) Cut the two longer stretcher bars
and the long cross-bar
at exactly mid-way.
(i) Place a ½″-thick wood brace
at least 18″ long on top of each cut.

Stretcher No. 2, back

1½″ nails

glue

1 x 3

1 x 2

glue

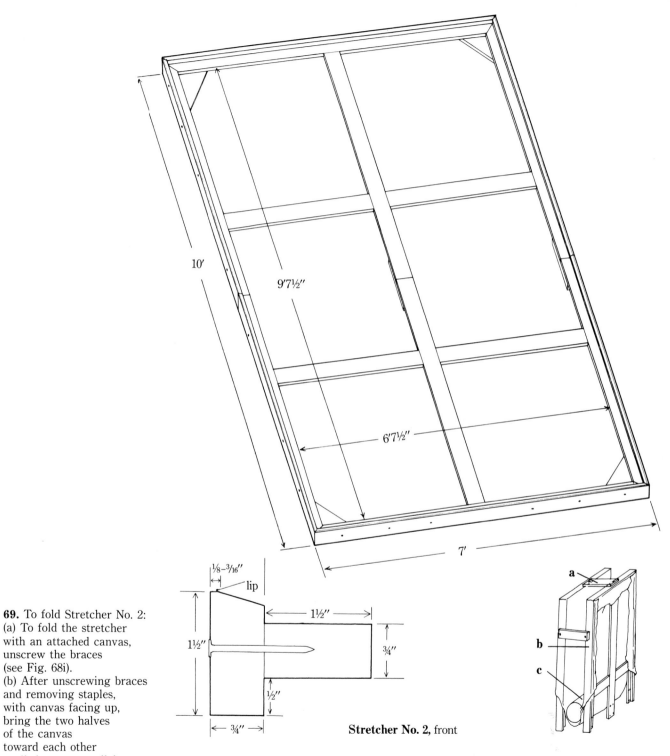

69. To fold Stretcher No. 2:
(a) To fold the stretcher
with an attached canvas,
unscrew the braces
(see Fig. 68i).
(b) After unscrewing braces
and removing staples,
with canvas facing up,
bring the two halves
of the canvas
toward each other
until they are parallel.
(c) Place a cardboard cylinder
in the bottom V of the canvas
to avoid wrinkling.

Stretcher No. 2, front

beveled part of the stretcher (the cross of the T) will be longer (10 feet or 7 feet) than the notched part of the stretcher (9 feet 7½ inches or 6 feet 7½ inches). When the ends of all four T-shape stretcher bars are facing each other, the crosses of the Ts (beveled 1-by-2s) will constitute the outer perimeter of the stretcher and the stems of the Ts (notched 1-by-2s) the inner perimeter. While you are putting the stretcher bar through the table saw, make sure that the stem of the T is parallel to the plane of the table by stabilizing it with a ½-inch-thick piece of wood.

Step 5: Joining the Four Stretcher Bars Place all four stretcher bars on the floor, beveled edge facing down. Support the stem of the T by placing a ½-inch-thick piece of wood underneath it; place it so that it runs parallel to the plane of the floor and the cross part of the T is perpendicular to it. Next, bring the end of a 10-foot stretcher bar face to face with the end of a 7-foot one, and clamp them together. (Do not glue if you want the stretcher to be collapsible.) Fit a ½-inch-thick right triangle corner piece snugly into the corner (Fig. 68c). Drill holes ⅞ inch deep through the corner brace and the notched part of the stretcher. Then, screw in 1-inch screws, making certain that they are equal in diameter to the drill point diameter. Repeat the entire procedure for each corner.

Step 6: Cross-Bracing the Stretcher Take two 6-foot, 10½-inch 1-by-3s, and make a notch in the center of each one. The notch should be 2½ inches wide and ⅜ inch deep. Make sure these notches correspond to the notches on the shorter stretcher bars. Next, cut an open-ended 1½-inch-long by ⅜-inch-deep notch at each end (Fig. 68d). On a 9-foot, 10½-inch-long 1-by-3, make two 2½-inch-wide and ⅜-inch-deep notches at the two one-third points along the length (Fig. 68e). The notches must correspond to the notches on the inner part of the long sides of the stretcher. The last set of notches, which are open-ended notches at the ends of this long cross-bar, must be made on the other side, so that they can fit into the notches in the middle of the two shorter stretcher bars. Once you have fitted the long cross-bar on both sides in this way, you can then fit the middle notches of the two shorter cross-bars into the notches of the longer cross-bar (Fig. 68f). Next, fit two open-ended notches at each end into the notches of the longer stretchers (Fig. 68g). Screw all eight notch joinings tightly with ½-inch screws.

Step 7: Cutting the Stretcher in Half Now that you have completely assembled the stretcher you must cut it in half if you want it to be foldable. Cut the two longer stretcher bars and the long cross-bar at exactly mid-way (Fig. 68h). Then place a ½-inch thick wood brace at least 18 inches long on top of each cut (Fig. 68i). Make sure that the screws are both secure and easy to remove. The best way is to start by drilling holes ⅞ deep for each screw.

To fold the stretcher after the canvas (painted or unpainted) is attached, simply unscrew the braces (Fig. 69a) and remove the staples from the canvas for about 12 to 18 inches on each side of the halfway cut. With the canvas facing up, bring the two halves of the canvas toward each other until they are parallel (Fig. 69b). Use the back braces to stabilize the folded stretchers. Cover the entire painted surface with a plastic sheet for protection. To avoid wrinkling, place a cardboard cylinder (10 to 12 inches in diameter) in the bottom V of the canvas (Fig. 69c). To completely dismantle the canvas, remove all the staples, and roll the painting face out on a 7½-foot-long, 10- to 12-inch diameter cardboard cylinder. If cracking occurs the surface will be restored when the painting is later flattened.

Oil Grounds for Oil Painting

In 1568 Giorgio Vasari transcribed the following recipe for preparing an oil painting for canvas:

> In order to be able to convey pictures from one place to another, men have invented the convenient method of painting on canvas, which is of little weight and when rolled up is easy to transport. Unless these canvases intended for oil painting are to remain stationary, they are not covered with gesso, which would interfere with their flexibility, because the gesso would crack if they were rolled up. A paste, however, is made of flour and of walnut oil with two or three measures of white lead put into it, and after the canvas has been covered from one side to the other with three or four coats of smooth size this paste is spread on by means of a knife and all the holes come to be filled up by the hands of the artist. That done, he gives it one or two more coats of soft size, and the composition of priming.*

70. J.M.W. Turner. *The Slave Ship.* 1840.
Oil on canvas, 2'11¾" × 4' (.91 × 1.22 m).
Museum of Fine Arts, Boston (Henry Lillie Pierce Fund).

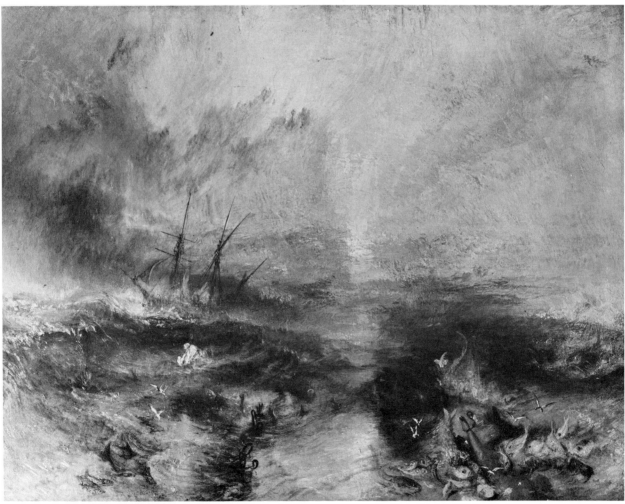

The preparation of oil grounds has not changed radically from Vasari's day. In selecting and experimenting with grounds, keep in mind some general considerations. White is the traditional color for grounds on all supports because, as Giovanni Battista Armenini wrote in his 1587 treatise *The True Precepts of Painting,* dark grounds eventually darken. Moreover, Max Doerner** has warned that the ground exerts an extraordinary influence not only on the durability of the picture, its later preservation, and the action of colors, but as well on the painting's luminosity. The oil film is thinned by time, thereby exposing the ground. For example, artists who have been observing Turner's paintings (Figs. 70, 192) for years insist that the pictures are becoming increasingly brilliant—no doubt because Turner worked on a pure white ground. In de Hooch's painting, *Interior of a Dutch House* (Figs. 71, 72), the tiles showing through the woman's dress illustrate how time thins a paint film.

Lives of the Painters, Sculptors and Architects, translated by Louisa Maclehose in A. P. Laurie, *The Painter's Methods and Materials,* Lippincott & Co., Philadelphia, 1926.
** *The Materials of the Artist,* Harcourt, Brace, and Co., revised edition, 1949.

71. Detail of Figure 72.

72. Pieter de Hooch. *Interior of a Dutch House.*
c. 1658. Oil on canvas, 29 × 25½″ (74 × 64 cm).
National Gallery, London (reproduced by courtesy of the Trustees).

The recipes beginning on page 74 spell out in detail the two major components of an oil ground. The first, sizing, is a highly dilute solution of animalskin glue that is brushed on the canvas in a thin, uniform coat to prevent the oil from coming into direct contact with the cloth. Without sizing, oil will soak into the porous fabric and cause it to become brittle and decay. Apply the glue economically, working out the contents of each brushful, but be sure to cover the whole surface. Do not let the glue soak through the fabric. Be precise in measuring the amounts of water and glue, for glue sizing that is not sufficiently thinned with water makes the canvas buckle and crack. Rabbitskin glue should be thinned with at least 10, but preferably 12 parts water to 1 part glue. If you use gelatin (not the edible variety) for sizing, the proper proportions are 14 to 1. Rabbitskin glue is preferred.

The oil coating is a combination of white pigment (flake white or titanium) in oil. After the size dries, spread the oil coating on evenly with a spatula, and make sure it is thin enough to expose the texture of the canvas. The composition of the ground should also be considered. Although most technical experts find commercially prepared white-lead pastes adequate, remember that the oil used in these products is not as refined as that used in the manufacture of artists' colors. It will yellow in a relatively short period. The inclusion of lead in these house paints has been outlawed in the United States. Hence, the painter must work with the superior professional lead, known as flake white. Titanium white has been widely used as a substitute for flake. Although it dries more slowly, it creates a less brittle surface. But whichever white you choose, never thin it with oil in this priming coat. A ground should be *lean*—that is, relatively oil-free. If thinning is necessary, dilute the white with a little turpentine or a mixture of turpentine and varnish.

Finally, a ground prepared by the artist has advantages over one on a commercially prepared canvas. It is less absorbent. When a thin wash of turpentine is applied, it will stay on the surface and remain transparent, reflecting the white undercoat. And color is generally more brilliant against this ground. Being less porous, the ground keeps the paint from sinking in.

Gesso Grounds

When painters commonly used panels as supports, after sizing with glue they primed the wood surface with *gesso,* a white coating substance composed of chalk or whiting in a glue and water solution (p. 75). Although generally too brittle for canvas—a slight jolt will readily cause cracks—gesso can be combined with other materials for use on fabric supports. For example, if you add about 20 percent boiled linseed oil to the gesso mix while it is being heated and stirred, the result is a half-chalk ground, which the oil renders flexible enough to apply to canvas. Experts are divided about the permanence of this gesso-oil ground. Synthetic emulsion gesso, usually called *acrylic gesso,* is also flexible enough to bend with canvas (or paper) without cracking, and seems satisfactory, having withstood every test except time. But no sign of deterioration has appeared in paintings with an acrylic gesso ground that are 22 years old.

Acrylic gesso can be brushed directly onto the canvas without prior sizing. It will produce an extremely absorbent ground that transforms the normally shiny surface of oil paints into a relatively flat one. If such absorbency is not desired, you should add to the canvas surface a thin coating of turpentine mixed with dammar varnish or another resin over the gesso (p. 126).

Experts warn that the fluids with which conservators clean oil paintings—xylene, toluene, and acetone—will dissolve acrylic gesso grounds. To avoid this, the best

73. Joan Miró. *Painting* (called *The Check*). 1925.
Oil on canvas, 6′4¾″ × 4′3⅛″ (1.95 × 1.3 m). Private collection.

Resin Mixture A resin mixture is composed of 1 part dammar (from a standard 5-pound cut) and 1 part spirits of gum turpentine. Apply the mixture evenly to the surface the same way you apply the final varnish (pp. 142–143).

Resin and Oil Color Mixture A fast drying oil color (p. 198), such as burnt sienna, burnt umber, or cobalt blue, can be mixed in and brushed on with the above proportion of dammar varnish and turpentine. A little Magna color (p. 121) added to the oil color will further speed drying. In fact, you can actually use any color, as long as you are willing to wait for the drying. This imprimatura coat can also be rubbed into the canvas with a clean cloth. The result is a stained effect that should dry quickly. Joan Miró, the contemporary Spanish painter who has said that a painting starts with an interesting ground, employs this method (Figs. 73, 74).

74. Detail of Figure 73.

Media

Painting media are divided into two categories: *water-thinned,* or *waterbase,* media, a group that includes both traditional materials and some plastics; and *turpentine-thinned* media, comprising oil colors as well as some of the synthetic bases.

Natural Waterbase Media

Watercolor painting is the application of a thin solution of colored liquid on a light sheet. This medium permits only minor changes. Inspiration, vision, and skill work together to produce an immediacy different from that of any other painting medium. Unfortunately, the art education tradition presents watercolor as a medium for beginners, so that what passes for instruction in too many classes is technique alone, without regard for concept. But learning to produce tricky effects or to lay down a flawless wash usually leads to a misplaced emphasis on method and paintings devoid of pictorial invention. Paul Cézanne, whose late works in oil were based on his watercolor experience, would not receive a passing grade if technique were the sole criterion, for his watercolors evolve out of personal perceptions and conceptions. Cézanne's watercolor technique is thus a by-product of his imagination.

 The problem, especially in watercolor, is to let the medium function to meet the needs of sensations or ideas—to make the medium do what *your* vision demands. The more visual culture you bring to this medium, the more you can transform it. Watercolor, in short, is not a medium for beginners.

Watercolor

75. Paul Cézanne. *View of a Bridge.* c. 1895–1900. Watercolor, 18¾ × 23½″ (49 × 60 cm). Yale University Art Gallery, New Haven, Conn.

Watercolor painting produces a transparency, a glazed effect. The light source is the paper, for its whiteness illuminates the combination of water and pigment. In one sense, this description could also refer to the wash drawing shown in Figure 43. Keep in mind the differences between watercolor and wash drawing. To begin with, wash refers to a monochrome effect, while watercolor suggests color. The second distinction is the base, the material that holds the pigment. Today's wash drawings are produced with a waterproof ink (India ink) from a shellac base. Watercolor has a gum arabic base that is not waterproof and, hence, enables you to make some changes. You can soak unwanted areas with water and then blot with sponges and/or tissues; some artists even remove mistakes with a weak solution of bleach and water. This last process is a little dangerous, because as the bleach seeps in, it weakens the glue action of the gum. Moreover, the ghost of the original always remains. Obviously, watercolor is a spontaneous performance where only minor changes are possible.

The directness of watercolor nevertheless does not narrow its possibilities, for it is also a medium capable of producing many visual sensations. Each master bends the medium to his or her vision; or, as the following examples demonstrate, each one finds a natural use for it.

Cézanne used watercolor with pencil undermarkings in his painting (Fig. 75) to locate the positions of objects in space. In his complicated structure, perspective views from the left and from the right seem to cross over or become intertwined. In *Green Pears* (Figs. 76, 77), Charles Demuth used the medium to present a symmetrical

above: 76. Charles Demuth.
Green Pears.
1929. Watercolor,
13½ × 15½″ (35 × 40 cm).
Yale University Art Gallery,
New Haven, Conn.
(Philip L. Goodwin Collection).

right: 77. Detail of Figure 76.

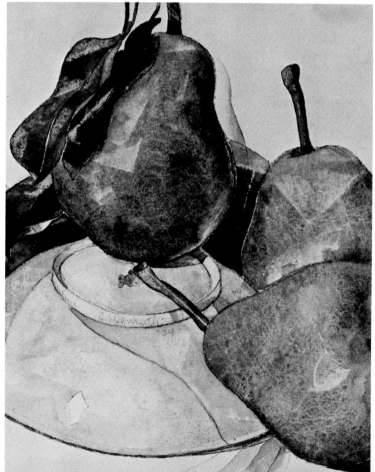

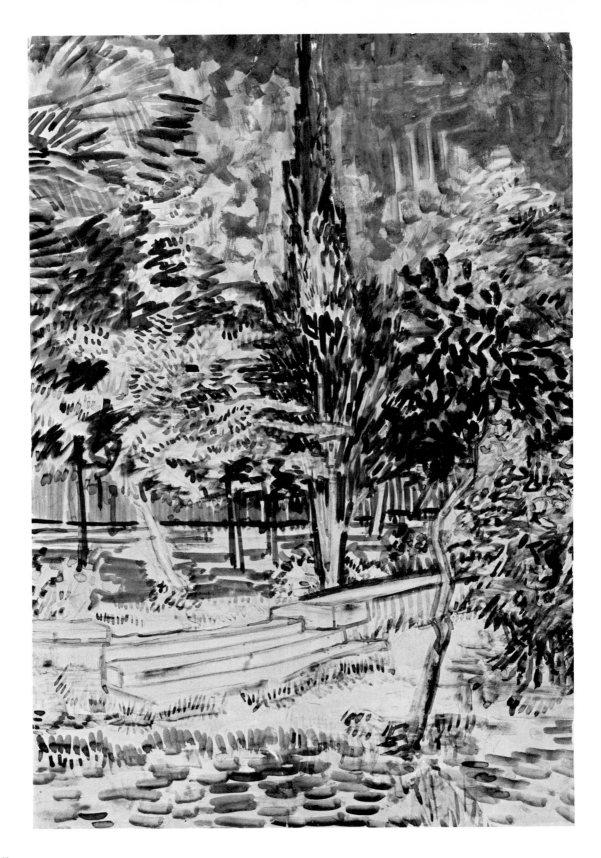

arrangement of forms in a method that combines crisp, clear edges and highlights with fluid modeling. In the detail (Fig. 77), notice that the white contour lines are actually incised gently with a razor blade.

Van Gogh found in watercolor a medium that enabled him to echo the sharp, calligraphic manner of his drawings and paintings (Fig. 78) by working with a limited palette of cool greens and blues.

Whistler, in still another manner, prewet the top section of *Blue and Silver: Chopping Channel* (Fig. 79) to create a flowing, undulating mass. He then contrasted this viscous effect with direct brushwork on a paper with such a strong glue size that it seems to resist the brushstrokes. Maurice Prendergast conceived a different set of contrasts by working the watercolor medium in such a way that some sections seem

opposite: 78. Vincent van Gogh.
The Garden of St. Paul's Hospital
with the Stone Steps. 1889.
Black chalk, pencil, brush with ink
and watercolor; 24½ × 17½'' (63 × 45 cm).
Van Gogh Foundation, Amsterdam.

below: 79. James Abbott McNeill Whistler.
Blue and Silver: Chopping Channel.
Watercolor, 5½ × 9½'' (14 × 24 cm).
Freer Gallery of Art,
Smithsonian Institution, Washington, D.C.

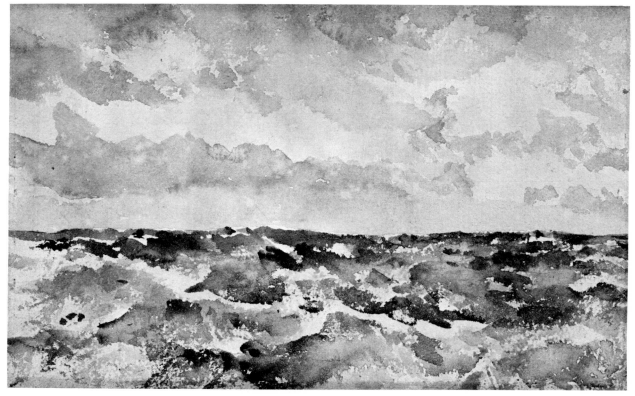

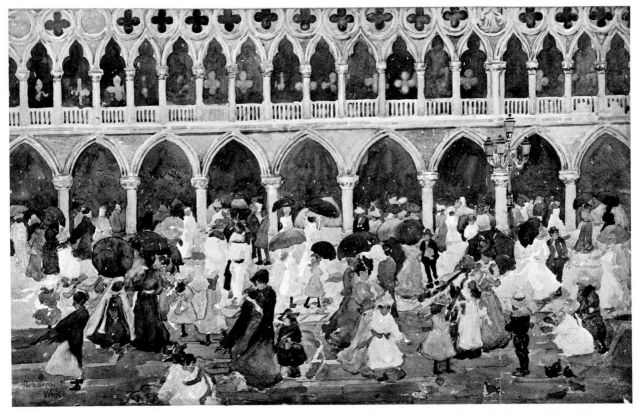

80. **Maurice Prendergast.** *Sunlight on the Piazzetta, Venice.* 1899. Watercolor.
Museum of Fine Arts, Boston (gift of Mr. and Mrs. William T. Aldrich).

dry and some very wet (Fig. 80). As a result, the hard edges in the building dissolve by incalculable degrees to softer edges. It is this interaction of effects that gives the work its energy. Finally, in Emil Nolde's *Friesland Farm Under Red Clouds* (Fig. 81) the stretching cloud forms dominate a low horizon anchoring small houses. To achieve this masterful arrangement, Nolde chose absorbent Japanese paper capable of retaining layer upon layer of iridescent watercolor.

Watercolor Materials

Watercolor Paint Watercolor pigments are ground in gum arabic and then compressed into tubes or cakes. Gum arabic, sold in powdered form, is a substance derived from tropical trees. It has an adhesive power suitable for water-thinned painting, because it dissolves in water. Whether tube or cake, the best watercolors contain a large proportion of pigment ground to a fine consistency. Make sure you cap the tube each time you finish squeezing the color out, since air does dry the gum arabic base.

There is no prescribed set of colors to use on the watercolor palette. Some watercolorists, to have maximum flexibility, will squeeze out a great many colors for each painting, although they may actually use only half of them. Other painters may prepare a few colors and use them all. The real problem in watercolor is to maintain a clarity of tone. Remember that the smallest amount of cloudy color is reflected on the

pure white ground. Therefore, mix as few colors as possible for your final color; the more colors you mix, the dirtier the tone. For the same reason, it is essential to keep changing the water. If the water takes on too much color, it will muddy your tone.

Dyes and Inks There are liquid dyes on the market that are sometimes used in combination with watercolor. These dyes come in rich shades of magenta, pink, and blue that cannot be matched in watercolors. But many of them are not lightfast, so test the dyes on a piece of paper exposed to direct sunlight for two weeks. Colored inks, manufactured from dyes, present the same danger of fading and should also be tested. Indeed, even pure watercolor paintings produced with the most permanent materials should be kept away from strong light, natural or artificial, since they tend to fade gradually if they are exposed to too much light.

81. Emil Nolde. *Friesland Farm Under Red Clouds.*
c. 1930. Watercolor, 12¾ × 18⅜″ (32 × 47 cm).
Victoria & Albert Museum, London (Crown Copyright).

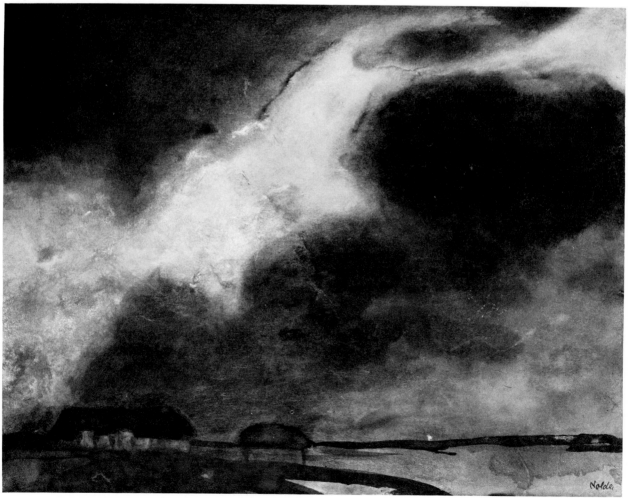

Paper Pure rag paper (p. 53) is the best surface for watercolors, because it does not absorb too much of the color, but rather keeps it on the surface. Watercolor paper is heavier than ordinary drawing paper and comes in smooth, medium, and rough varieties and in weights that range from thin (number 70), to medium (number 140), and heavy (number 300). The letters "C.P." stand for *cold press* paper, which has a smoother, harder, and slightly less absorbent surface than "H.P.," or hot press. The heaviest papers in the roughest range tend to have a stronger glue size that may initially resist the brush. Some artists, therefore, prewet sections (as did Whistler in Figure 79). Be warned, however, that wrinkles may appear when the paper becomes saturated with water. To prevent wrinkles, you can buy the paper in preglued blocks. Cut the painting out of the block only after it is dry. With single sheets, tape the edges all around to a drawing board or sheet of plywood or masonite; use brown paper preglued tape that needs wetting. When the watercolor has dried, cut the paper out along the tape. Whatever surface and weight you choose, remember that the intensely white, handmade rag paper is probably the most tactile painting surface available. It stimulates approaching the act of painting by setting the sense of touch in motion.

Brushes and Palettes Pure red sable brushes (Fig. 82) are the best for water-color, because they keep their resiliency, but less expensive white-haired Japanese brushes also act well. Metal or porcelain palettes for mixing are usually part of the container for cake watercolors. In addition, you can buy large porcelain containers manufactured for this purpose. Throw-away paper palettes are fine, but only the mat-surface variety is useful for watercolor (and this surface seems increasingly

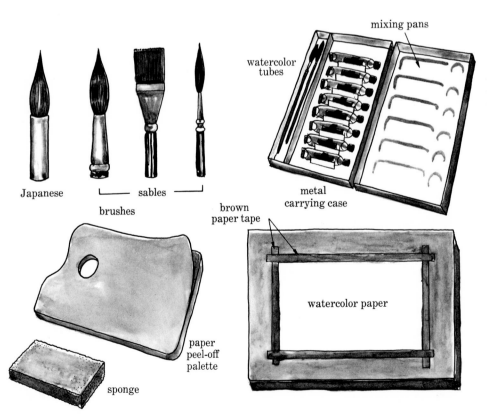

82. Supplies for watercolor work include: brushes, tubes or cakes of paint, mixing pans or paper palettes, sponge, masonite or plywood support, brown paper tape.

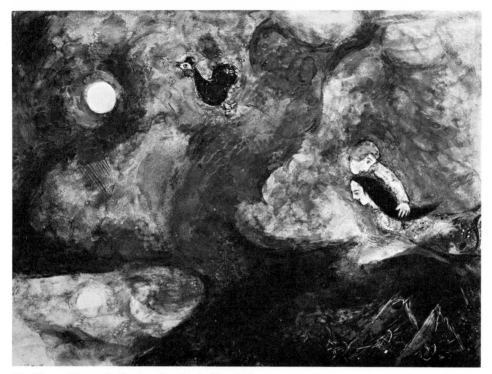

83. Marc Chagall. Design for the ballet *Aleko:*
"Aleko and Zemphira by Moonlight." 1942.
Gouache, wash, brush and pencil; 15⅛ × 22½″ (38 × 57 cm).
Museum of Modern Art, New York (Lillie P. Bliss Bequest).

difficult to find). Because these palettes reflect the same strong white as the paper, they help you to judge how the color will look on the painting surface. The shiny paper palette causes water to bead, and colors left on it at the end of the painting session stay moist for days, instead of drying within hours.

Besides brushes and palettes, you will need a sponge to prewet the paper or to soak up mistakes; tissues are also useful.

Gouache

Gouache usually means the addition of white—that is, Chinese (zinc) white watercolor—to the watercolor, either through mixture with the colors or as a separate coating of white on which the transparent color is floated. In technical terms, adding a layer of white to the paper changes the ground from white paper to white watercolor—and the medium from watercolor to gouache. You can, however, simply refer to this as watercolor over white ground. Manufacturers also produce opaque gouache colors in a gum arabic base. These body colors (as opposed to transparent ones) sometimes bear the label "Designers Colors."

The widely distributed "tempera" paints (also called poster paints) are also ground in gum arabic. But unlike manufactured gouache and Designers Colors, these "tempera" colors are not light resistant and should be avoided.

Transparent watercolor can be combined with body or opaque color in many ways, depending upon the individual painter's conception. For example, Chagall fuses transparent, semitransparent, and opaque sections in *Aleko and Zemphira by Moonlight* (Fig. 83), while Mark Tobey completely covers the surface with opaque layers in

E Pluribus Unum (Fig. 84). And even though gouache, like other waterbase media, is not supposed to blend naturally the way oil might, Picasso manages a subtle modeling of the figures in *Two Acrobats with a Dog* (Fig. 85). He thus "persuades" the medium to do his bidding. Van Gogh, by contrast, lets the subject determine his medium. He uses a combination of watercolor and gouache to produce *The Vestibule of St. Paul's*

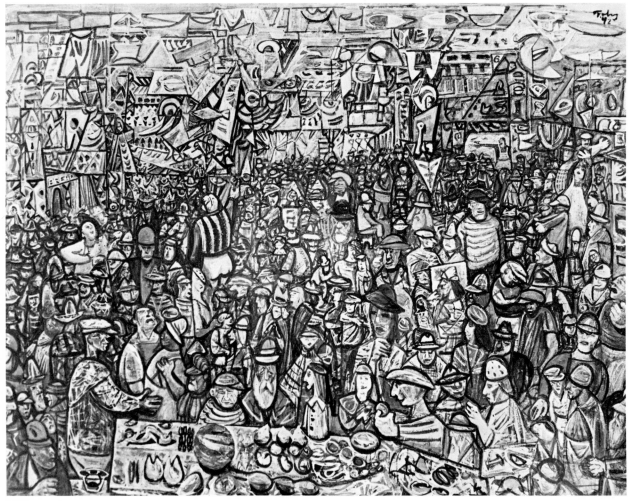

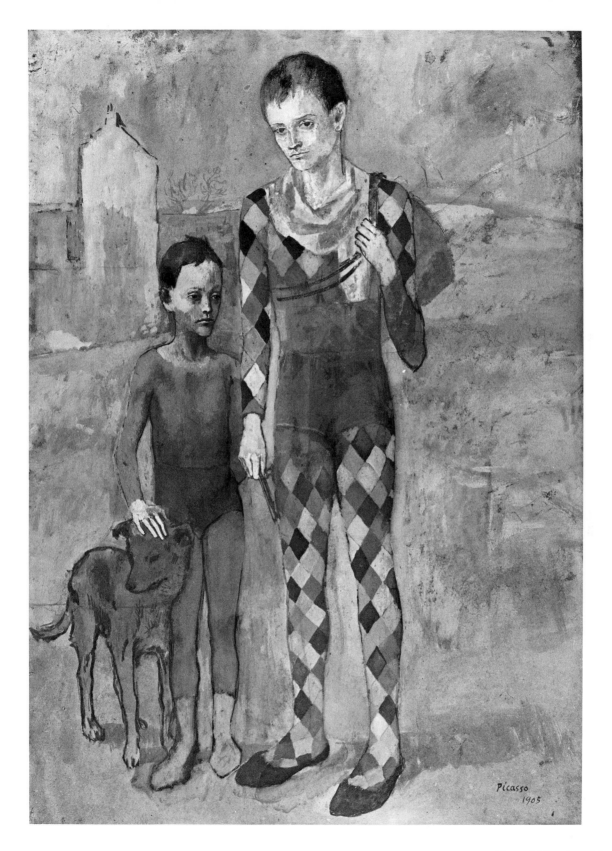

Hospital (Fig. 86). Comparing the solidity of the forms here to his free-flowing transparent watercolor (Fig. 78), you can see why a theme prompts a choice of media.

The transparency of watercolor demands a light-giving white paper, or at least an off-white one. In gouache, however, the opacity of the color enables the artist to work on prepared toned grounds made with watercolor washes or denser gouache. Colored papers, too, can be employed, or even natural-color rag cardboard, as seen in Lautrec's *Dr. Jules-Emile Péan* (Fig. 87). Here the color of the ground appearing between strokes

86. Vincent van Gogh. *The Vestibule of St. Paul's Hospital.* 1889.
Black chalk and gouache on toned paper, 24 × 18⅜″ (62 × 47 cm).
Van Gogh Foundation, Amsterdam.

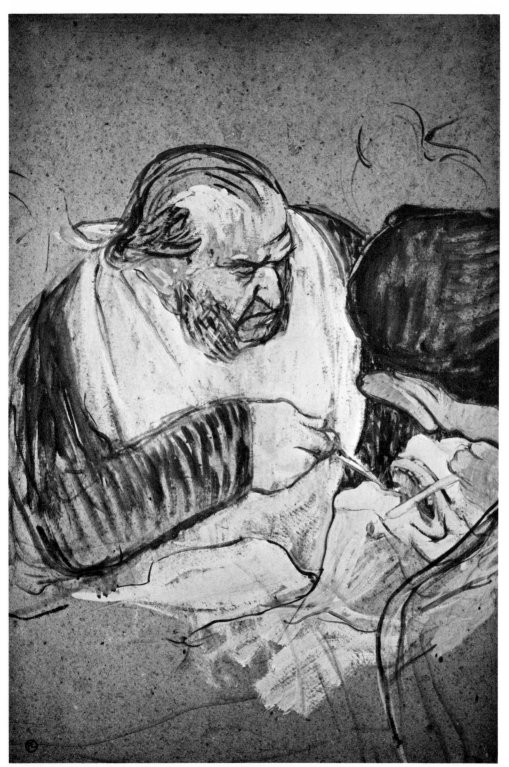

87. Henri de Toulouse-Lautrec. *Dr. Jules-Emile Péan.* 1891.
Gouache on board, 29⅛ × 19⅝″ (74 × 50 cm).
Sterling and Francine Clark Art Institute, Williamstown, Mass.

opposite: 88. Edouard Vuillard. *Under the Trees.* 1894.
Distemper on canvas, 7′½″ × 3′2½″ (2.15 × .98 m).
Cleveland Museum of Art (gift of Hanna Fund).

in the main forms seems to change—that is, different combinations of applied colors blend with the ground's color to produce optical mixtures.

Pat Adams uses gouache in a personal way (Pl. 1, p. 135). On a smooth rag paper she alternates layers of opaque and transparent colors. She may then burnish sections with a lintless cloth or a razorlike knife, wash off sections, blot, scrape and stain with rags, sponges, and brushes. This almost textural juxtaposition of opaque and transparent layers gives her unlimited freedom.

Gouache Materials The tools for gouache are similar to those for watercolor. Bristle brushes, primarily meant for oil (Fig. 205), can also be used in gouache. Painting knives, too, will work with gouache. But be careful not to build heavy surfaces. The binder, gum arabic, cannot bind thick coatings, and cracks will appear. Whether you prepare the ground with a mixture of watercolor and opaque white, or with a pure opaque ground, make sure you tape the paper to a rigid support.

Distemper The term *distemper* refers to painting with size or glue as a medium. In the 17th century, Velázquez' teacher, Pacheco, noted that the Old Masters used distemper exclusively for preliminary exercises. According to Max Doerner, there is evidence that distemper may even have been used for ancient wall painting in Pompeii. Today, we usually come upon distemper in connection with Edouard Vuillard. In the 1890s, Vuillard designed and painted a number of theatrical sets. Since he began to work with distemper about the same time, it is probable that he discovered this fast-drying medium in the theater. And Vuillard continued to employ distemper throughout his career. Unlike most painters, who select water media only for small paintings, Vuillard used distemper for his largest works, at times on board and paper, but mostly on canvas (Fig. 88).

Painters choose a medium to suit their vision. Yet, this vision must then adapt itself to the medium, and each medium has its advantages and disadvantages. Although Vuillard makes it look easy, distemper has peculiar difficulties. If improperly mixed, it becomes sticky; if it spoils, the smell is unbearable. Textural effects are limited, for glue is fairly brittle and cannot be built into a heavy impasto.

Distemper does, however, have definite benefits. The ingredients, rabbitskin glue or gelatin, are relatively inexpensive. They dry rapidly, almost immediately, so that you do not have to think about slow- and fast-drying colors. The color produced is mat, but brilliant. Oil colors tend to be relatively darker because of the oil's shine. With distemper, blues and greens, normally dulled in oil, acquire a special brilliance, and the warm earth colors glow.

Vuillard took full advantage of the visual sensations inherent in the distemper medium. André Gide, reviewing the Salon d'Automne in 1905, wrote of Vuillard: "He explains each color by its neighbor and obtains from both a reciprocal response." Vuillard did not often blend colors, even in oil. Rather, he built brushstrokes into magical color shapes and interspaces. And the warm energy of his ochres and umbers, employed in harmony or dissonance with vibrating greens and blues, springs from his natural use of the distemper medium—a medium well-suited to his color concepts and method of applying pigments.

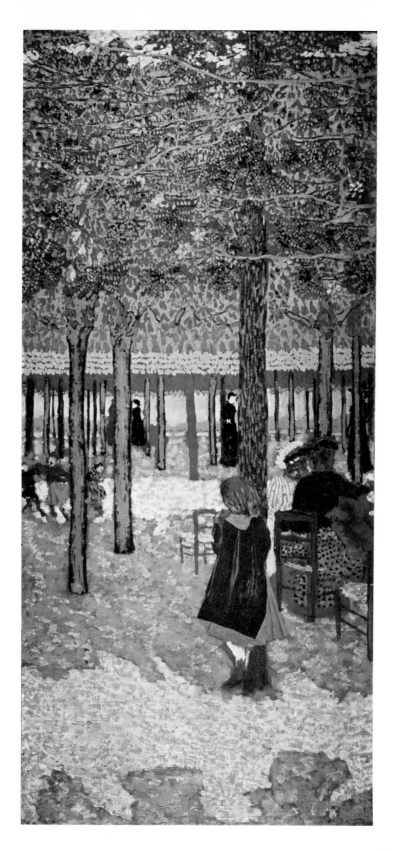

Distemper Materials and Recipes

Recipe There are few published recipes for making distemper, and most of them are vague: "Take some thick glue size and thin with water to desired consistency." Try the following mixture, arrived at after years of experimentation.

Place rabbitskin glue in a pan. The glue should be twelve parts water to one part crushed glue by volume. (If gelatin is used, make the proportion fifteen to one by volume.) Soak this mixture in a pan for an hour; soaking longer does not change any of the results. Then, heat the contents in a double boiler, stirring constantly. When the glue is completely dissolved, the medium is ready. Never allow the glue to boil, for boiling destroys its glue action.

Distemper is easier to apply when warm, since the glue gels as it cools, making it hard to handle. But this does not mean that the glue must be kept constantly on the stove; a pan of hot water will serve to keep it warm, and in hot weather this procedure is unnecessary. Once the medium has been prepared, it must be kept consistent. Do not thin it with additional water. To ensure freshness, the medium should be made anew daily. Finally, there is some difference in handling between the two glues: gelatin sets more rapidly, is more transparent, and is more apt to show the individual brushstrokes.

Colors The colors employed with distemper are dry pigments, but it is not easy to determine how much medium to mix with each pigment. Pacheco, writing about egg tempera, noted that fluffy pigments require more medium than heavier ones, an observation that also applies to distemper. Alizarin and Hansa yellow, for example, require more medium than the earth colors. Preliminary tests should be made by the individual painter. Note that insufficient medium will cause flaking and leave the painting excessively water-soluble. Dry pigments, preground with water and stored in covered jars, can be spooned out in small amounts and mixed on the palette with the glue medium.

Supports Heavy rag paper makes an excellent support. Dampen the paper, and tape it to a board (p. 62). When dry it can be sized with the medium. Sizing is recommended if you want to expose the natural color of the paper; sizing also enables the paint to adhere more evenly. Distemper paintings on paper are flexible enough to be rolled without cracking, if you are careful to keep the sizing thin and do not build up a heavy impasto.

A gesso panel, too, makes a good support and ground. Make sure that the gesso is prepared with the same glue as the medium. A foreign glue in the gesso may prevent the glue in the distemper from really sticking to the panel.

You can use canvas for distemper, but not a commercially prepared oil-ground one, since oil grounds and any tempera medium are not compatible. Unprepared linen is best. First, stretch the linen; then size it with the distemper medium. If you want a ground color, mix the medium with dry pigments, and apply it as a second coat.

Finish A final spray with 4-percent formalin solution protects the painting from bacteria and makes it insoluble in water.

Egg Tempera Egg tempera has been used for more than five hundred years, and time has proven that paintings having egg as the medium yellow less than oil paintings. Nevertheless, today there are few practitioners of the medium. Not many artists want to submit to its limitations—the need to build forms step-by-step with individual brushstrokes. Andrew Wyeth and his followers are, of course, exceptions (Figs. 89, 90). And some

above: **89. Andrew Wyeth.** *Mother Archie's Church.* 1945.
Egg tempera on panel, 2'1" × 4' (.63 × 1.2 m).
Addison Gallery of American Art, Phillips Academy, Andover, Mass.

below: **90.** Detail of Figure 89.

painters—Reginald Marsh, for example (Fig. 91)—have managed to apply egg tempera in a looser, more flexible manner.

Although tradition credits Jan van Eyck with being the first artist to paint in oil, his *Saint Barbara* (Fig. 92), a drawing executed in brush on a smooth gesso panel, shows him to have been a master of the egg tempera method. The underdrawing locked all the forms into place. Then Van Eyck gradually built up the undercolors. The painting guilds of the Middle Ages, aware of the rigidity of egg tempera, worked out formulas and procedures for making the medium appear as flexible as possible. Thus, the painter using egg tempera created tones by starting with a thin coat of terre verte (green earth) pigment applied in fine brush lines. The second coat consisted of pinkish, opaque modeling strokes that appear to start from the center and work outward around the form. This combination of pink over green gives the illusion of translucent flesh. When a vivid red was needed, Van Eyck underpainted in yellow, the yellow under the red adding an extra glow.

91. Reginald Marsh. *Twenty Cent Movie.* 1936.
Egg tempera on composition board, 30 × 40″ (76 × 102 cm).
Whitney Museum of American Art, New York (purchase).

92. Jan van Eyck.
Saint Barbara. 1437.
Brush drawing on panel,
12¾ × 7¼″ (32 × 18 cm).
Musée Royal des Beaux-Arts,
Antwerp.

Neither the invention of oil painting in the 15th century, nor the development of new synthetics in our own time, diminish the greatness of paintings produced in the seemingly inflexible egg tempera medium. For example, in Mantegna's *Dead Christ* (Fig. 93), the linear quality inherent in the medium—the creation of tones through the buildup of individual brushstrokes—is enhanced by the clarity of edges in the figures and especially in the expressive drapery. That egg tempera does permit a variation of surface, however, is clear from a comparison of the *Dead Christ* with Botticelli's *Giuliano de'Medici* (Fig. 94). In Mantegna's picture, the paint is thinner and the line stronger than in Botticelli's work, where a thicker accretion of paint creates a

93. Andrea Mantegna.
Dead Christ. After 1466.
Tempera on canvas, 26¾ × 31⅞″ (68 × 81 cm).
Brera Gallery, Milan.

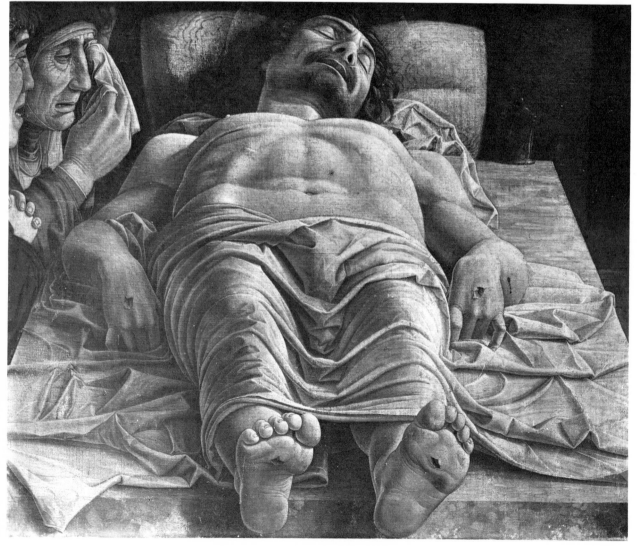

94. Sandro Botticelli. *Giuliano de'Medici.* c. 1476.
Wood panel, 29¾ × 20⅝″ (76 × 53 cm).
National Gallery of Art, Washington, D.C.
(Samuel H. Kress Collection).

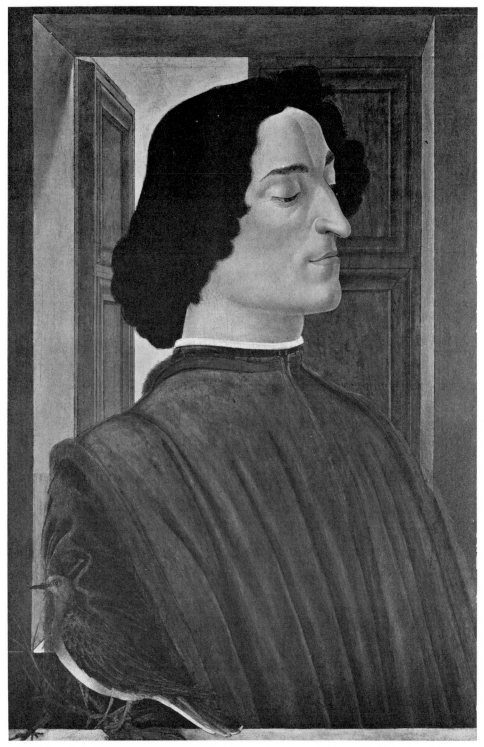

warmer, softer, more glowing surface. Similarly, the *Avignon Pietà* (Fig. 95) seems to defy the egg tempera's rigidity. So flowing are the forms that the magnificently poised Christ is as supple a figure as any painted in the more flexible oil medium.

Egg Tempera Materials

Egg Yolk Tempera To begin, open the egg carefully. Do not break the egg yolk, your medium. Shift the yolk from palm to palm to clean off the residual white. Next, puncture the yolk, spilling its contents in a clean jar that you can close with a cover (Fig. 96). If you want a thinner medium, dilute with about 10 percent water. Keep the closed jar in a refrigerator when not in use. It should be good for a week.

Pigments Dry pigments (see the list of permanent pigments, Chap. 5) from a reliable manufacturer should be ground in water with a muller on a ground glass (Fig. 185; Pl. 5, p. 169) and kept in small covered jars.

Brushes As with the other water-thinned media, sables are best for egg tempera. The method also enables you to make dry brushstrokes from partly worn brushes. Try to experiment on a panel with all the effects possible. Playing idly with materials helps you to understand them.

95. Southern French Master. *Avignon Pietà.* c. 1470. Tempera on wood panel, 5′3½″ × 7′1¾″ (1.61 × 2.18 m). Louvre, Paris.

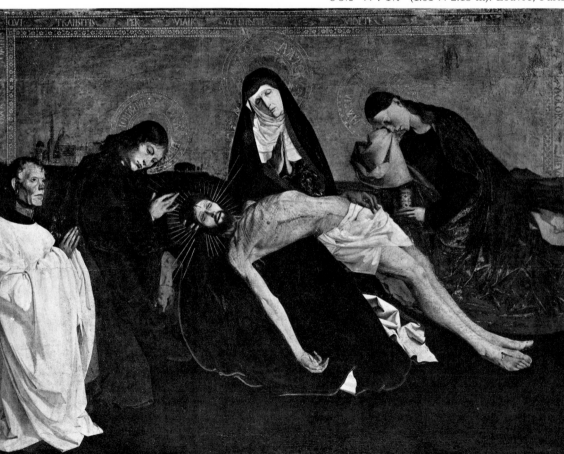

egg yolk

egg yolk

puncture
the yolk

96. After the yolk is separated from the white by changing it from hand to hand, gently pick up the yolk with the thumb and forefinger. Puncture the thin membrane from below, releasing the contents into a jar or cup. The membrane is not part of the medium and should be discarded.

Support and Ground Traditional gesso on a firm support such as masonite (p. 74) works best for egg tempera, but acrylic gesso is possible. Apply four coats, and alternate the directions of the brushstrokes from horizontal to vertical. In addition, put one coat on the back of the panel to keep it from warping.

Palette A glass palette with a white paper underneath is excellent, because the white approximates the color of the ground, allowing you to relate the color. Porcelain and peel-off paper palettes also work. Make a test on the palette with each color and the medium to see how much medium an individual pigment demands to keep it from rubbing off. Remember that fluffy pigments take more medium.

Casein

Casein is a milk product used as a binder for colors and grounds. For example, some of the liquid gesso preparations that are not made from acrylic resins have casein as their base. Casein paints, available in tubes, achieved great popularity in the 1940s and early 1950s. But casein paints were eclipsed by the introduction of waterbase acrylics. In the final analysis, casein is an extremely brittle substance, best reserved for panel painting or heavier weights of paper. Painters who use casein today like its surface as well as its particular light. Comparing it to gouache for use on paper, they emphasize that each coat of gouache tends to pick up the previous coat. By contrast, casein (like acrylic) is waterproof. On canvas it tends to crack from slight jolts to the back of the support.

Synthetic Waterbase Media

The waterbase plastics, developed for industrial use in the 1950s, began to appear in artists' studios even before art suppliers started to manufacture them in tubed paints, jars, cans of acrylic gesso, and acrylic primed canvas.

Synthetic (Plastic) Media

Water-Thinned Media	
acrylic emulsion	
Rhoplex AC-234 (formerly AC-34 or AC-33)	This resin is ground with either pigments or gesso and sold in these mixed forms by many reliable companies—each of which has a slightly different formula and palette.
	The resin itself can be purchased from Röhm & Haas in 5-gallon cans and mixed with dry pigments. No grinding is necessary; just mix pigment and medium with a palette knife.
	Although actually manufactured only by Röhm & Haas, Rhoplex is sold by many companies, each one varying the degree of thickness and glossiness.
	Acrylic emulsion can be applied to raw canvas and acrylic-primed canvas, but not to oil-primed canvas.
wetting agent: Triton CF-10	This agent, manufactured by Röhm & Haas, aids the spreading of paint, especially in large wash areas. Use sparingly.
acrylic gel	A transparent, glossy material used to extend paint, so that it shows brushstrokes. Excellent as a glue for collage. Made by many companies.
thickening agent: Acrysol GS and Acrysol G110	These thickening agents (Röhm & Haas), if used in small amounts, give body to paints.
vinyl emulsion	
polyvinyl acetate (p.v.a.)	Normally used as a white glue, but it can be mixed with dry pigments or other water-soluble paints—watercolor, gouache, acrylic. Use p.v.a. medium only with a solid support.

Acrylic Emulsion In the 1950s, before the avalanche of synthetic materials reached the studio, an experiment was conducted with a group of students using Rhoplex acrylic emulsion. Under fairly primitive conditions, these students produced an acrylic gesso with a hand-powered eggbeater, titanium dry pigment, whiting, and the medium, then called Rhoplex AC-33. They also prepared colors by purchasing dry pigments, grinding them with water (as in the egg tempera recipe, p. 100), and placing these wet colors in jars. The students mixed the medium separately with 5 percent of Tamol 731 (a pigment dispersant) to ensure a homogeneous solution of medium and pigment. Just before use, the medium and the wet pigment were mixed on a glass palette.

By these means the group made their own color blends, including particularly vivid green-blues and red-oranges. In addition, they were able to work with pigments such as cobalt violet, which does not grind well enough with the medium to be put into

commercially prepared tubes. Yet, when thoroughly blended with the spatula, a cobalt violet of brilliant intensity resulted. Today's colors ground in the medium may produce a smoother film, but the colors prepared by hand were purer than what became available in packaged form.

Studio-laboratory experts originally warned painters that the new plastics developed for industrial use were not time-tested and therefore unsafe for artists' use. But painters continued to experiment with these materials, the better to measure their ultimate worth. And because these products possessed unique qualities, they actually served to stimulate creation.

Twenty years later, we can look back and see that the Rhoplex acrylic emulsion medium was instrumental in the development of what became known as Hard Edge Painting, Color Field Painting, and Stain Painting, among other styles. When poured, it could produce instant, heavy textures. Most important, Rhoplex acrylic emulsion enabled painters to make changes constantly, instead of waiting for the slow drying of oil paint. In short, this medium generated wide experimentation. You should not, however, exaggerate its importance, as some have done, by comparing its invention to the invention of oil painting.

A material is only as good as painters with personal vision can make it. Even so, a new medium does not necessarily demand a new aesthetic, for there is a historic continuum of form invention. The tempera painters who first used oil colors still kept to the same form conceptions as had characterized their earlier tempera paintings.

The work of Jackson Pollock, who used some of the new plastics toward the end of his life, provides a good example of this continuity. Pollock also experimented with industrial enamels, which have an elastic liquidity. He tried nitro-cellulose lacquer (the paint sprayed on automobiles), the first synthetic resin, employed by the Mexican muralists of the 1930s. Pouring the paint or spreading it with a stick (Fig. 97), Pollock created an allover energy.

97. Jackson Pollock in his studio in Easthampton, N. Y. 1950.

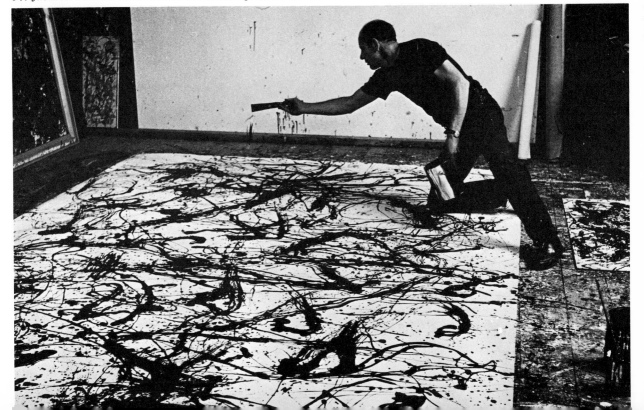

98. Sam Francis. *Untitled No. 9.* 1973.
Acrylic on canvas, 7 × 6′ (2.13 × 1.83 m).
Collection Mr. and Mrs. Thomas A. Spears.

Pollock's form idea influenced the next generation of painters, who used the new plastic emulsion tempera—that is, the Rhoplex medium that came to be known simply as acrylic emulsion (Fig. 98; Pl. 2, p. 135). Working on the floor, as Pollock had done, they employed the medium (on canvas) to produce what appeared to be very large watercolors. A pigment wetting agent (Triton CF-10) helped to disperse the watered-down colorant evenly, especially on an unyielding unprimed canvas, and kept the hue brilliant and evenly distributed. By mixing 5 percent Triton CF-10 into the water-thinned paint, artists made this translucent "stain painting" appear fresh and direct.

Acrylic emulsion paint, with its inherent mat surface, also can be applied directly, without additives. This process produces opaque, seemingly textureless, even, and bright color. Masking tape keeps the edges of the forms neat and uniform (Fig. 99).

99. Kenneth Noland. *Pairs.* 1974.
Acrylic on canvas,
5′9½″ (1.77 m) square.
Collection Ethan B. Stroud, Dallas.

Some painters are attracted to acrylic emulsion by its immediacy, its fast drying. Al Held uses acrylic because he can make constant changes (Fig. 100). Held does not work from a previously calculated design, but searches out the form-shapes on the canvas. When the forms are finally set, he smooths out any bumps and lines of texture with a disk sander.

With acrylic emulsion, you can also pour wet color into wet color to create a rough, open, craglike, earthen texture, as does Larry Poons (Fig. 101). Cracks or fissures in the paint are controlled either by minimizing the amount of water added to dilute it, or by mixing in various amounts of Acrysol G-110, an additive thickening agent that will considerably increase the paint's viscosity.

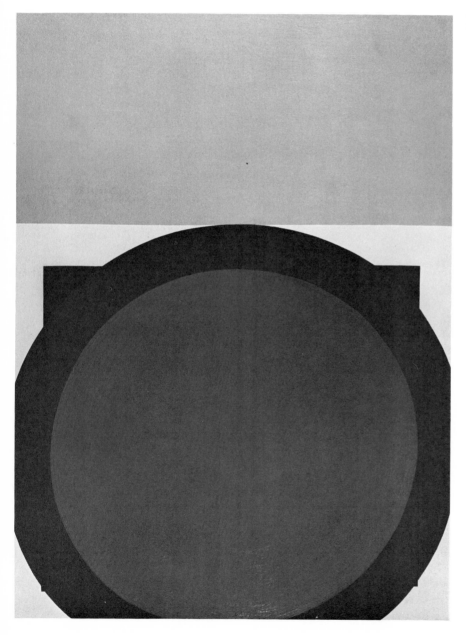

100. Al Held.
The Dowager Empress. 1965.
Acrylic on canvas,
8 × 5′ (2.44 × 1.52 m).
Whitney Museum
of American Art,
New York.

101. Larry Poons. *Ly.* 1971.
Acrylic on canvas, 7'11" × 5'6½" (2.41 × 1.69 m).
Collection Lewis P. Cabot, Boston.

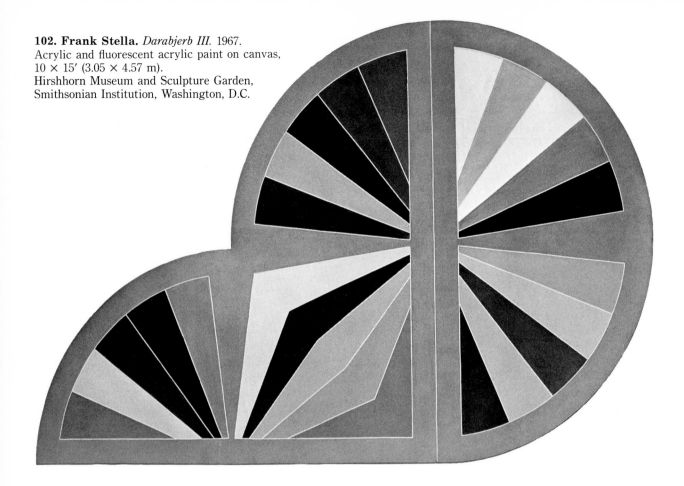

102. Frank Stella. *Darabjerb III.* 1967.
Acrylic and fluorescent acrylic paint on canvas,
10 × 15′ (3.05 × 4.57 m).
Hirshhorn Museum and Sculpture Garden,
Smithsonian Institution, Washington, D.C.

Supports For stained effects in acrylic emulsion, use an unprepared canvas. When using a prepared canvas, never work on oil grounds, but on acrylic gesso grounds only. Acrylic emulsion paints also work well on solid supports and rag paper. Indeed, one of the medium's great advantages is that it "holds on" to the support.

Brushes Avoid oil brushes. Nylon brushes, or other brushes made of synthetic bristles, are excellent.

Fluorescent Paint Commonly known as Day-Glo, fluorescent paint has a Rhoplex base. These glowing colors—used by Frank Stella, for example (Fig. 102)—are manufactured from dyes. All available tests have shown that the dyes fade in a year or two, perhaps less, if exposed to excessive light, so keep fluorescent paintings out of direct light. Micronized mica is an inert fine white powder that adds a sparkling quality to fluorescent paint. Do not confuse fluorescent with iridescent paints, produced by Bocour from pigments, Rhoplex, and micronized mica.

Pastel and Acrylic The endlessly versatile acrylic emulsion medium can be combined with pastel. Thin the Rhoplex medium with 50 percent water to make a mat, waterproof fixative applied with a spray gun. A painting comprised of alternating layers of pastel and acrylic colors can then be worked up by building layer upon layer of pastel, Rhoplex fixative, and acrylic paint.

Varnishing Acrylic Paintings With or without pastel, the varnishing usually is done with a thin coat of either the glossy or the mat medium, whichever is appropriate. Permanent Pigments Company manufactures Soluvar, a new varnish that can be brushed over the first protective coat without difficulty because it is slow-drying. It is advisable to use both coats, since acrylic paintings take fingerprints easily. Never varnish acrylic paints with dammar. The dammar surface is too shiny and spoils the relatively mat acrylic effect. Moreover, the traditional solvent for removing dammar will badly damage an acrylic painting.

Airbrush Acrylic emulsion paint also has been employed with an airbrush—a small, delicately focused paint spraying tool (Fig. 103). It works by focusing compressed air through a nozzle and mixing that air flow with small amounts of liquid (Fig. 104). Acrylic and ink are the most common media. Among the many types of airbrushes, some are extremely simple devices, pulling the liquid into the airstream by the vacuum created behind it. More complicated instruments have small motors driven by air pressure.

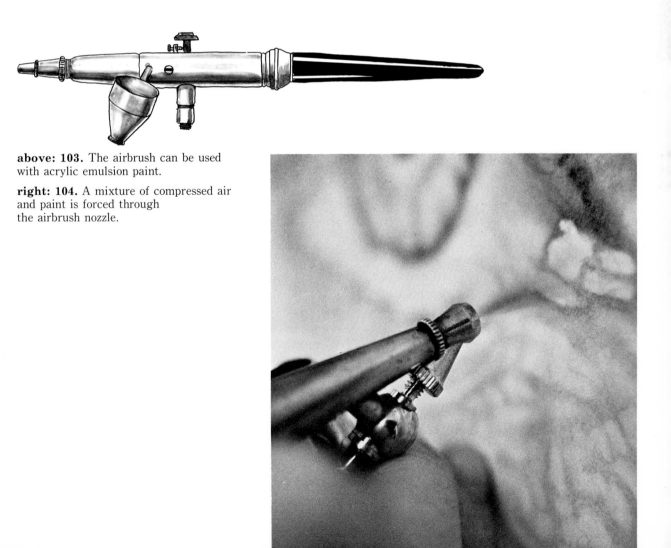

above: 103. The airbrush can be used with acrylic emulsion paint.

right: 104. A mixture of compressed air and paint is forced through the airbrush nozzle.

The airbrush principle may even have been used for the prehistoric cave paintings at Lascaux and Altamira. In these primitive works, it is possible that the artists blew dry pigments into incised lines with a tube—a process not unlike the modern mouth-blown fixative spray.

Until fairly recently, the airbrush was primarily a tool for retouching photographs and other commercial purposes. Now, however, artists such as Jules Olitski (Fig. 105) have found creative inspiration in the ability of the airbrush to spray pure color in mist form. When using the airbrush mainly for color effects, a little color—heavily diluted with water—goes a long way, since the density is produced by an optical

105. Jules Olitski. *4th Stride.* 1971. Acrylic on canvas, 9′3″ × 6′8″ (2.82 × 2.03 m). Courtesy Hans Strelow Gallery, Düsseldorf, West Germany.

106. Audrey Flack.
Wheel of Fortune. 1977–78.
Acrylic with airbrush
and oil on canvas,
8′ (2.44 m) square.
Courtesy Louis K. Meisel
Gallery, New York.

mixture. In this sense, Olitski's work is an extension of the pointillist technique (Chap. 6), except that the dot is practically invisible. Olitski seems to clog the airbrush nozzle deliberately (probably by not cleaning it out with warm water)—a decision that results in a random, textured spray of color.

The Airbrush and Photography The growing popularity of the airbrush with contemporary artists is also due to the influence of photography on painting. Among the artists whose use of the airbrush is derived from photographic sources, some also employ an additive color process—for example, red sprayed over yellow to produce orange. Audrey Flack projects a slide on the canvas to be painted and then works with her finely pointed airbrush in a darkened room by the beam of one intense lamp (Fig. 106). She first fixes the image on the canvas with the help of stencils, and then begins the painting process by spraying red, yellow, and blue, one color at a time. Working in the dark with the slide projected and one strong light for illumination, she can "read" the light beams to see where each color belongs. She finishes the painting in oil, in the daylight. It should be noted that Flack takes her own slides.

107. Chuck Close. *Bob No. II/616.* 1973.
Ink and pencil on paper, 30 × 22½″ (76 × 57 cm). Courtesy Pace Gallery, New York.

Chuck Close takes his own photographs with a large 8-by-10 view camera and uses them as a basis for his large paintings. He sets up a grid on the canvas (Fig. 107) and gradually builds up the image (Fig. 108). Thanks to his great skill in manipulating the airbrush, the finely modulated surface seems easy to achieve. Close employs diluted ink in his sketches on paper, and acrylic on the very large paintings. When working in color, he sprays one color at a time to produce the desired color balance. By spraying red, yellow, and blue in separate steps, Close can push the color climate toward any of these primaries; that is, he can let one of these colors predominate.

108. Chuck Close. *Linda.* 1975–76. Acrylic on linen, 9 × 7′ (2.74 × 2.13 m). Courtesy Pace Gallery, New York.

Michael Mazur's black-and-white painting *Easel-Chair #1* (Fig. 109) shows how focus can be controlled with soft and hard edges. Mazur demonstrates that bringing the airbrush close to the canvas creates a fine line. By contrast, moving the airbrush some distance from the painting surface results in a diffuse edge. In addition, Mazur uses masking tape to obtain a straight edge.

Airbrush Drying Time and Ventilation Drying in acrylic with airbrush is almost immediate, because the evaporation of the medium begins with the initial air flow. There appears to be no build-up of surface and little trace of the underpainting-overpainting procedure, the spraying of layer upon layer. You see only a flat surface.

109. Michael Mazur. *Easel-Chair #1.* 1968–69. Acrylic with airbrush on canvas, 4′ × 5′6″ (1.22 × 1.69 m). Courtesy the artist.

110. Andy Warhol. *Jackie.* 1964.
Silkscreen; 35 panels,
each 20 × 16″ (51 × 41 cm).
Hessisches Landesmuseum,
Darmstadt, West Germany.

As for ventilation, although an acrylic mist sprayed into the air is not as toxic as other materials, inhaling it is still dangerous. A ventilating mask, or respirator, is a basic need, as is a ventilating system. An exhaust fan that pulls the spray out through a window is probably insufficient. Use a spray booth that sucks out the air. Respirators or face masks for airbrush, as well as for other toxic procedures such as varnishing (p. 142), come in cartridge and air tank varieties. Different types of cartridges are available that purify the air against dust, fumes, or vapors. There are also self-contained air tanks that attach by a hose to masks, like scuba-diving equipment. Dust masks, sold in hardware stores, are not as efficient as the cartridge masks or air tanks.

Photo-Mechanical Processes The three airbrush artists discussed above are influenced by the photographic image in their own way: Flack with the separate breakdown of colors emanating from the projected light of the slide; Close with the bending surface focus of a photograph's close-up distortion; Mazur with the in-and-out focus of the photographic vision. But for Andy Warhol the subject of the chosen photograph acquires importance—it is, in fact, the message. In *Jackie* (Fig. 110) the technique is not the hand-held airbrush, but the mechanical photo silkscreen process. The photographic image is first transferred to the silkscreen and then flashed across

111. James Rosenquist.
Terrarium. 1977.
Oil on canvas,
6′9¼″ × 12′3″
(2.06 × 3.73 m).
Courtesy Leo Castelli
Gallery, New York.

the surface in a series of multiples to produce a parade of images that intensifies the visual impact. Warhol sometimes uses acrylic paint in combination with the silk-screen. Unity is achieved because both have a mat surface.

Photographic Advertising as a Source James Rosenquist is also influenced by photography. His forms, produced with oil paints, derive from the stark simplicity of the projected billboard photograph. Rosenquist's paintings break down forms in the same manner, so that they re-form when read at a distance (Fig. 111). His special gift is an ability to conceive an interesting relation of scale between objects and to relate disparate objects in startling juxtapositions.

Limitations of Acrylic Emulsion Despite its apparent versatility for everything from stain painting to airbrush, acrylic emulsion does have limitations. First of all, it cannot blend as the oil medium inherently does. (Oil paints, incidentally, can be used over acrylic, but do not apply acrylic over oil.) However, the use of a retarder, which each company produces, or a fine-mist water spray, can facilitate a longer period of workability. Most important, acrylic emulsion has a unique optical surface that painters either love or hate. The personal vision of the artist is the final arbiter.

*Vinyl Emulsion
(Polyvinyl acetate
or p.v.a.)*

Vinyl emulsion is most familiar to us as a white glue sold in plastic containers under such brand names as Elmer's. Available from the late 1940s, vinyl plastic often was employed as a painting medium before the introduction of acrylics. For painting, a good variety is Polyco 953 from the Borden Chemical Company—a highly polymerized and therefore relatively acid-free p.v.a. Karl Zerbe used this medium with many fillers—marble dust and powdered clay, for instance—to produce heavily textured paintings with a bas-relief qualify (Fig. 112). As for permanence, a student study of

112. Karl Zerbe. *Jook Joint.*
1957. Vinyl emulsion
(polyvinyl acetate),
5′6″ × 3′ (1.68 × .91 m).
Courtesy Webb Books.

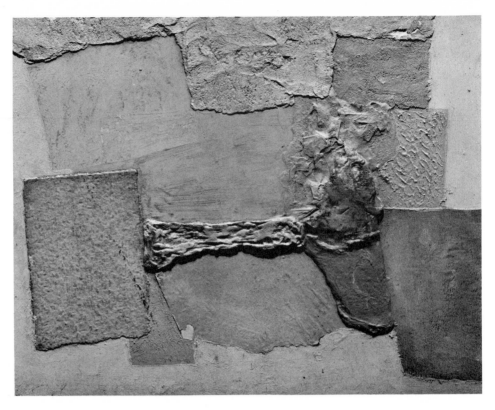

113. Study of textures. 1953. Vinyl emulsion (polyvinyl acetate).

possible textures made in 1953 with p.v.a. and marble dust and clay fillers still shows no signs of fading or cracking (Fig. 113).

Supports In the early 1960s many painters in Spain and Italy were employing the local version of vinyl emulsion (called Vinavil in Italy) with dry pigments on a rigid support. Since p.v.a. is a very brittle material, only a firm support such as masonite will hold it. For paper supports, the medium must be thinned down with at least 50 percent water. Heavy impasto, which will cause wrinkling, should be avoided. Do not use p.v.a. on canvas. The medium's glue action is too strong and, when combined with its inherent brittleness, results in incurable wrinkling and buckling. Canvas panels, however, can be prepared for p.v.a. (p. 62). The chief advantage of p.v.a. over acrylic is that, if applied to a strong support, it permits a heavy buildup of impasto. In this way, you can create a wide variety of textures with such materials as powdered clay, whiting, marble dust, and fine white sand.

Grounds A traditional gesso or an acrylic gesso ground will suffice, but a gesso prepared with the medium will guarantee adherence. Mix the p.v.a. medium with titanium powder—$\frac{1}{3}$ medium, $\frac{2}{3}$ titanium powder. The titanium can also be cut in half with whiting.

Colors The best procedure in preparing colors for p.v.a., as in egg tempera (p. 100), is to grind the pigments with enough water to keep them in paste form and then store them in closed jars. When you are ready to paint, mix $\frac{2}{3}$ of the paste pigment with $\frac{1}{3}$ of the p.v.a. medium on a glass palette. You cannot store the colors once they are

mixed with the p.v.a., because the medium is so brittle and fast-drying that they would harden in a few hours.

Brushes　　The p.v.a. medium is particularly destructive to brushes. Use nylon brushes only. Wet them with water before dipping into the paint, keep them immersed in water during the painting process, and clean with soap and water immediately afterward. Remold misshapen brushes with soap and water.

Synthetic Turpentine-Thinned Media

Some synthetic resins, including acrylic, rather than being emulsified to mix with water, are suspended in media that can be thinned with spirits of gum turpentine and can thus be used with oil paints. In this sense, the three acrylic resins and one alkyd resin listed on the chart below act as substitutes for dammar, the natural resin (p. 126). They take its place in an oil medium normally composed of $\frac{1}{3}$ oil, $\frac{1}{3}$ resin, and $\frac{1}{3}$ turpentine. This proportion can be changed to suit the painter.

Synthetic (Plastic) Media

Turpentine-Thinned Media	
acrylic resins	
polybutyl methacrylate	
Elvacite 2044 (formerly Lucite 44)	A resin in crystal form, produced by Dupont, that dissolves in turpentine. Mix in the same proportions that you would dammar (p. 126). Elvacite 2044, however, does not mix with dammar. It can be used with oil paints.
Acryloid F-10	A resin that comes in solution, manufactured by Röhm & Haas. Thin with turpentine. Acryloid F-10 can also be used with oil paints. It, too, does not mix with dammar.
Magna paints (Bocour) and Magna medium (an acryloid derivative)	Can be thinned with turpentine. Magna medium can be used alone or mixed freely with oil paints—$\frac{1}{4}$ Magna to $\frac{3}{4}$ oil. Do not mix with dammar.
alkyd resin	Alkyd resin colors (produced by Winsor & Newton, Liquin, Win Gel, and Oleopasto) are alkyd media—all thin with turpentine. Used with oil colors, the proportions are $\frac{1}{4}$ alkyd color to $\frac{3}{4}$ oil color. The alkyd media also can be used with oil colors to speed drying.
	Caution: Elvacite 2044, Acryloid F-10, Magna medium, and Magna colors are allergic to dammar varnish. When mixed together, the result is a sticky, nondrying liquid.

Ethyl Alcohol-Thinned Varnish	
Magna varnish (Bocour)	
polyvinyl acetate	An excellent final varnish (eggshell mat) for Magna, oil, and tempera colors. Also, when thinned (four parts ethyl alcohol to one part Magna Varnish), it makes an excellent fixative for pastel and other dry media.

Acrylic Resins The four resins and colors (ground with the media) listed on page 119 are important additions to the painter's studio. They have a sensuous paint quality and a different color-light than waterbase or oil paints. Indeed, when combined with oil, these turpentine-thinned acrylic and alkyd resins seem to extract more light from dark colors. Compare them with traditional media using one color.

Elvacite 2044 Elvacite 2044 (formerly Lucite 44) was employed first by conservators and restorers in the late 1940s as a final varnish for oil paintings. Being clear and easy to remove, it meets the requirements of an ideal final varnish (p. 141). However, precisely because it can be removed instantly, Elvacite must be handled with caution when used as an oil painting medium. To thin oil paint, never mix Elvacite with turpentine alone, for this film may wipe away with turpentine even after it is dry. Add at least 20 percent, and preferably 30 percent, of linseed oil to the mix. The glue action of the oil will prevent the easy destruction of the film.

Elvacite 2044 comes in crystal form and should be dissolved only in spirits of gum turpentine. (Avoid toluene, which also dissolves Elvacite, since its fumes are toxic.) A safe proportion is 1 ounce of Elvacite by weight to 2 ounces of spirits of gum turpentine. Bear in mind that Elvacite must be thinned with enough turpentine so as not to appear elastic. It rapidly turns into a sticky, molasses substance if the solution is too thick. Moreover, it might dissolve and pick up coats of underpainting. Keep thinning until it has only a slight "pull" between the fingers.

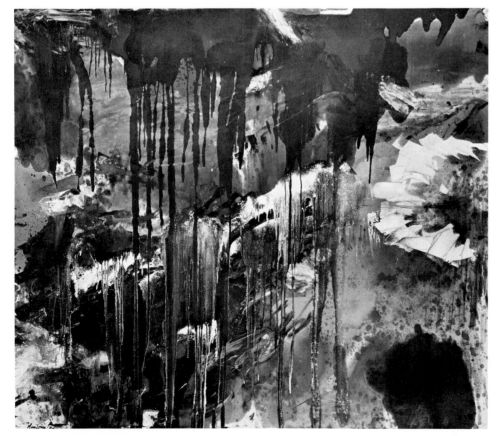

114. Morris Louis.
Number IV. 1957.
Magna on canvas,
6'4½" × 7'9⅞" (1.94 × 2.38 m).
University Art Gallery,
University of Arizona,
Tucson
(Edward J. Gallagher III
Memorial Collection).

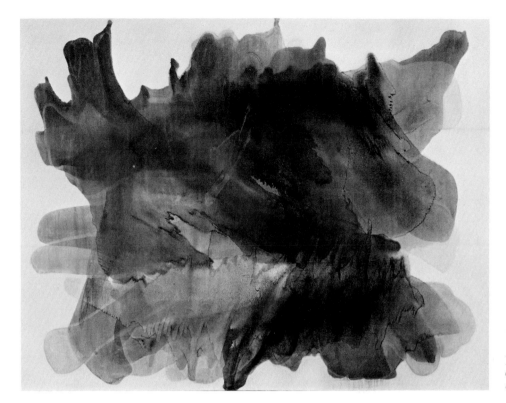

115. Morris Louis.
Terrain of Joy. 1954.
Magna on canvas,
6′7″ × 8′8″ (2.01 × 2.64 m).
Collection Graham Gund.

Despite these cautions, Elvacite has distinct advantages. Unlike dammar, it never becomes too glossy or glassy. And Elvacite seems to give off more light from dark colors. Test this by painting alizarin and ultramarine with both media. Elvacite is also faster drying than dammar, and produces a more flexible surface, making it easier to roll up a canvas without causing cracks.

Acryloid F-10 Acryloid F-10 is the same material as Elvacite, but it comes already dissolved in a thick solution. Nevertheless, you must thin it further with spirits of gum turpentine before using with oil colors.

Magna Medium and Magna Colors Magna medium, an Acryloid F-10 derivative, comes thinned to a consistency ready for use either as a medium or as a final varnish (p. 141), although it was intended to be manufactured primarily as a medium for Magna colors.

Magna colors, from Boucour, are pigments ground in this acrylic resin without the addition of oil. The grinding process cannot be duplicated in the studio, for it requires sophisticated machinery. Magna colors dry quickly, but not so quickly as waterbase acrylic emulsion. They have a somewhat elastic feeling and, consequently, cannot be blended like oil. Magna colors produce both slightly shiny opaque surfaces and, when thinned with turpentine, translucent and transparent effects. And whereas the contact of oil with unprimed canvas rots the canvas, Magna colors can be used directly on unprimed cotton or linen.

Morris Louis worked with Magna colors, first with heavy impasto (Fig. 114) and finally in a very thin film (Fig. 115). Mark Rothko, perhaps more than any other artist,

116. Mark Rothko.
No. 19, 1948. 1948.
Magna and oil on canvas,
5'8" × 3'4" (1.72 × 1.02 m).
Art Institute of Chicago
(anonymous gift).

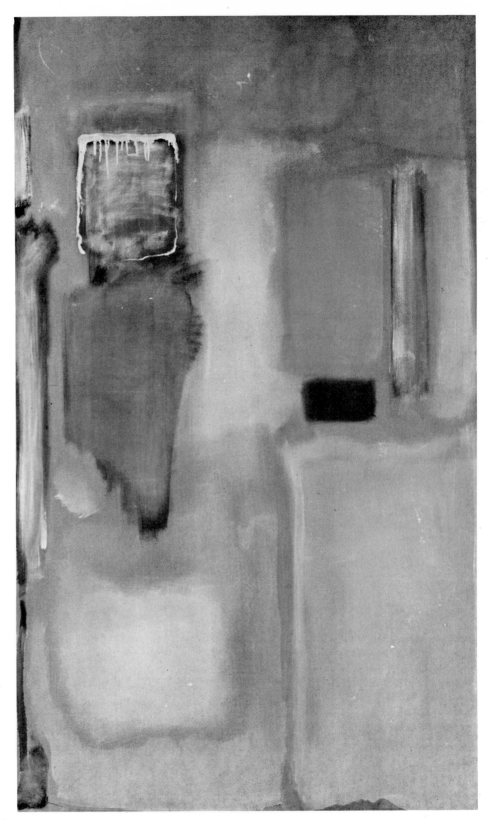

explored the luminous possibilities of Magna colors. Using both thinned and opaque Magna colors, he created glowing, iridescent surfaces (Fig. 116; Pl. 18, p. 220). With a different aesthetic in mind, Roy Lichtenstein employed Magna colors to produce flat, uniformly opaque surfaces (Fig. 117)—a striking contrast that illustrates the versatility of Magna colors.

Magna paints also can be combined with oil paints. The addition of up to 25 percent Magna will accelerate the drying time of oil colors. For example, if you add Magna cadmium red to an oil cadmium red of the same hue, the drying time will be cut in half. Magna is best employed in undercoats, where fast drying is desired.

Caution: Paintings with Magna color should be varnished with Magna varnish. Without such varnishing, they may stick together if stored face to face. Magna varnish, an unemulsified vinyl that thins with ethyl alcohol, also is recommended for use between heavy coats of Magna colors. Furthermore, it is an excellent final varnish (p. 142) for works painted with acrylic resin or for thoroughly dry oil paintings containing other media. Magna varnish has a very slight gloss—an eggshell finish. Compared to other varnishes it is hardly visible. (See the discussion of pastel, p. 141, for its use as a fixative.)

117. Roy Lichtenstein. *Modern Painting with Bolt.* 1966. Magna and oil partly silkscreened on canvas, 5'8¼" × 5'8⅜" (1.73 × 1.74 m). Museum of Modern Art, New York (Sidney and Harriet Janis Collection).

Alkyd Resin Alkyd resin, a substance produced by a reaction between two materials, polyhydric alcohol and polybasic acid, has been around for more than fifty years, and by now there are about two hundred varieties. Because of its tough film, alkyd resin has been used primarily for automobile paints and housepainting enamels. Some brands have been known to turn dark rapidly, but the variety that Winsor & Newton has tested for years and has now placed on the market withstands the three-month fading test performed on eleven out of thirty colors. Winsor & Newton tested these colors outdoors by painting their familiar wooden signs (seen outside art suppliers' shops) with alkyd and calling the signs in regularly for comparison.

Winsor's alkyd colors thin with turpentine and/or with their three forms of alkyd medium: Liquin, a thin fluid liquid; Win Gel, a gel; and Oleopasto, a thickener. Even when thinned, the colors keep their tone and never seem to lose their depth and richness. Also, you do not have to worry about fast- and slow-drying colors, as in oil paints, for alkyd colors dry in 24 hours. Like Magna they have a slight tackiness that you may even find pleasant. Alkyds also can be used with oil paints—25 percent alkyd to 75 percent oil color. Naturally, alkyd colors hasten the drying time of oil. They can, in addition, be mixed with other oil media (dammar, for instance), although this produces an excessive shine. A shine reduces the light coming from pigments: the deeper the shine, the darker the colors appear. Since alkyd paints have a characteristic shine to begin with, they are best used on absorbent grounds that suck out some of the shine. Alkyds are a versatile new medium that permits both precise and loose handling of the paint. The only drawback at present is the steep price.

118. Yves Tanguy.
Untitled. 1935.
Oil on canvas,
14⅝ × 18″ (37 × 46 cm).
Private collection.

There are other plastics being employed in novel ways—for example, Ron Davis' use of polyester and fiberglass. There are also pigments ground in epoxy. But heed this warning: In the mid-1960s, when many artists were experimenting with these materials, several became severely ill. Articles appeared in both medical and art journals to alert physicians and caution artists about the toxic fumes such plastics produced. Some artists have become ill even though they worked in well-ventilated areas with industrial respirators. Do not use these materials without competent medical advice. The solvents for polyester, fiberglass, and epoxy are equally toxic. At all costs, avoid methyl ethyl ketone, methyl butyl ketone, methyl isobutyl ketone, ethyl acetate, butyl acetate, amyl acetate, and banana oil.

Oil Paints

Most artists do not use oil colors straight out of the tube. For the purposes of handling, surface textures and effects, color variation, as well as drying time, oil paints are mixed with different media.

Components of the Oil Media

Drying Oils Below is a general guide to drying oils. You should experiment with at least three of the oils listed. Sun-thickened linseed oil, for example, has a honey consistency that seems to pull a little in an elastic fashion and retains brushmarks more sharply than stand oil. Stand oil is looser and naturally produces a smooth, blended surface (Fig. 118).

Oil	Drying Time	Preparation and Characteristics
sun-thickened linseed oil	fast	Mix equal amounts of water and linseed in a pan. Cover with glass, but let a little air in. Expose to sunlight. When thick, pour off water.
linseed oil	medium	Use only cold-pressed linseed oil (also the best for grinding pigments), or, if not available, refined (steam-pressed) linseed oil. Avoid boiled linseed oil, which darkens, and raw linseed oil, which is insufficiently refined.
stand oil (polymerized oil)	slow	Stand oil is linseed oil heated at 300°, but the heating process cannot be duplicated in the studio. Stand oil yellows less than linseed and blends more easily as well.
walnut oil	slow	Also yellows less than linseed, but it must be obtained fairly fresh. Walnut oil does not store well and quickly turns rancid.
poppyseed oil	slower	Yellows less and blends more easily than linseed. Used by manufacturers to grind difficult colors, such as whites and ultramarine blue.
safflower oil	slower	As with poppyseed oil, safflower oil yellows less than linseed and is used to grind difficult colors. Also mixes well with wax.

Natural Resins Dammar, obtained from tree sap in Malaysia, is the best and most frequently used natural resin. Figure 119 illustrates the making of dammar varnish from straw-colored crystals. The standard proportion of crystals to gum turpentine is called a 5-pound cut. This is the mixture recommended for use as a painting medium. There is no need to buy a separate dammar solution labeled "Picture Varnish," for it is the same mixture with 50 percent more turpentine and sells at the same price.

opening for string
in cover

alternate method:
string lodged in cover

spirits of gum
turpentine

dammar crystals
in cheese cloth

use 6¼ oz. crystals
to 10 fluid oz.
turpentine

119. Dammar is made by allowing dammar crystals to dissolve in turpentine.

a b

Venice Turpentine Venice turpentine is a balsam that constitutes a permanent resin; it is now rarely seen in art supply stores. It produces a very glossy surface and should be used in moderation. Some formulas call for it to be used in the painting medium in addition to dammar (p. 128). Balsams tend to get very thick in the bottle. Placing the container in hot water helps keep the resin fluid.

Mastic Resin Although much used in the 19th century, mastic resin tends to form whitish "bloom" areas and should be avoided.

Copal Resin Copal resin is used to make a varnish that is, at best, doubtful as a permanent material. Tests vary, but most reveal darkening in a relatively short time.

Turpentine Only pure spirits of gum turpentine are acceptable. Rectified turpentine is fine, since it is merely pure spirits of gum turpentine strained through cheesecloth. Avoid wood turpentine, which is not as refined as gum spirits. Paint thinners are petroleum products that can replace turpentine (except in the making of dammar varnish). Note that some people are allergic to either turpentine or paint thinners.

Wax Beeswax can be used in a painting medium. Heat pure white beeswax in a small metal container. It will soften with a minimum amount of heat. Remove it from the heat, mix in some turpentine, and then store the mixture in a closed jar. Caution: The turpentine-wax combination is highly combustible. Do not mix near the stove.

The Oil Painting Medium

Although it is recommended that the painting medium contain ⅓ oil, ⅓ resin, and ⅓ spirits of gum turpentine, some artists, such as Edward Hopper (Fig. 120), defy the experts by painting with linseed oil and turpentine alone—even though resin has the technical advantage of protecting against dampness. Thus, the three-part formula provides only a general guide. Painters must find the appropriate proportion of ingredients to make the medium that best serves their own vision.

120. Edward Hopper. *Second-Story Sunlight.* 1960.
Oil on canvas, 3′4″ × 4′2″ (1.02 × 1.27 m).
Whitney Museum of American Art, New York
(gift of the Friends of the Whitney Museum and purchase).

There are also many formulas for what constitutes the "perfect" medium, including one that calls for 4 parts dammar, 2 parts sun-thickened linseed oil, 1 part Venice turpentine, and 4 parts turpentine. Again, your medium must be learned, first by knowing what ingredients are permanent, and, second, by experience acquired through experimentation. Some painters do not use additional oil in their medium, for they feel enough oil has already been ground into the pigment (p. 206). Some use a mixture of turpentine and resin, and others simply thin the oil paints with turpentine.

121. William Bailey. *Still Life—Table with Ochre Wall.* 1972. Oil, wax, and dammar on canvas; 3'11¾" × 4'5¾" (1.19 × 1.34 m). Yale University Art Gallery, New Haven, Conn.

122. Brice Marden. *For Hera.* 1977.
Oil and wax on canvas, 7 × 10′ (2.13 × 3.05 m).
Courtesy Pace Gallery, New York.

The only danger in the latter formula is that too much thinning with turpentine takes the glue action out of the oil paint and causes flaking.

Wax as Part of the Medium Wax paste (p. 127) can be added to linseed oil and dammar varnish to give the surface a soft glow. This quality appeals to artists of as widely different aesthetic styles as Bailey and Marden (Figs. 121, 122). Make sure that you do not use too much wax. The proportion should be ⅓ dammar, ⅓ oil, and ⅓ wax. Test this by putting the medium and color on a glass. When it is dry, scratch with a fingernail; it should be scratchproof. If it scratches, reduce the amount of wax in your formula. A paste made from safflower oil and beeswax, produced by David Davis, also mixes smoothly with dammar varnish and oil paints.

Driers Cobalt Linoleate Drier is the most permanent. If you feel you must add a drier to the medium to speed the process, use it sparingly. A drier never should comprise more than 2 percent of the medium. Too much drier produces cracks.

Mixed Media Oil was used first as part of mixed media. Although opinions vary, one reading of Bosch's surface (Fig. 123), and that of many other painters ranging from Grünewald to Bruegel, is that the undercoat was executed in egg tempera and the oil paint was applied over it, both opaquely and in glaze. Today, you could use tempera and oil in the same way, as long as you work on a rigid support. But the new acrylic emulsion paints make an equally good underpainting for oil paint. Remember that while oil can be applied over a waterbase medium like egg tempera, no waterbase paint can be applied over oil—with one exception. Northern European Renaissance painters found that they could make sharp details by brushing fine strokes of egg tempera into a wet oil varnish. The tempera strokes did not blend into the oil, but they did merge into the form, thus highlighting such minutiae as single strands of hair, as illustrated in Figures 124 and 125.

123. Hieronymus Bosch.
Christ Mocked
(The Crowning with Thorns). c. 1515.
Panel, 29 × 23¼″ (74 × 59 cm).
National Gallery, London
(reproduced by courtesy
of the Trustees).

left: **124. Lucas Cranach the Elder.**
Madonna and Child. 1529 (?).
Oil and tempera on panel,
32¾ × 22⅝″ (84 × 58 cm).
Kunstmuseum, Basel.

below: **125.** Detail of Figure 124.

Egg-Oil Emulsion There are many formulas for egg-oil emulsion, involving a whole egg, linseed oil, and dammar varnish in various proportions. You would do best to stay away from this medium. Most 20th-century artists who have used it have ended up with cracking surfaces.

Other Media

Encaustic Wax painting, which was practiced centuries ago by the Egyptians, the Greeks, and the Romans (Fig. 126), is sometimes called *encaustic,* which means "burned in" and therefore implies the use of heat. As practiced today, the process involves the heating

126. Funerary portrait. Egypto-Roman, c. A.D. 100. Encaustic. Louvre, Paris.

127. Jasper Johns. *Device Circle.* 1959. Encaustic and collage on canvas with movable arm, 40″ (102 cm) square. Collection Mr. and Mrs. Burton Tremaine, Meriden, Conn.

and mixing together of dry pigment and wax, with a portable heating instrument employed to burn in the mixture. The comparatively complicated encaustic technique has been revived in the modern period and adapted to contemporary modes of expression because of the special optical qualities—translucence and brilliance—with which the wax is endowed. Nevertheless, few artists are willing to give up the directness of expression possible with acrylic emulsion or oil paint for the more indirect system that requires special equipment. An exception is Jasper Johns, who uses encaustic, sometimes with collage, on canvas to build up a rich surface (Fig. 127).

3. Claude Monet.
The Houses of Parliament, London.
1905. Oil on canvas,
32 × 36″ (81 × 92 cm).
Musée Marmottan, Paris.

4. Balthus
(Balthasar Klossowsky).
Katia Reading. 1970–76.
Oil on canvas,
5′11″ × 6′10¾″ (1.8 × 2.1 m).
Private collection.

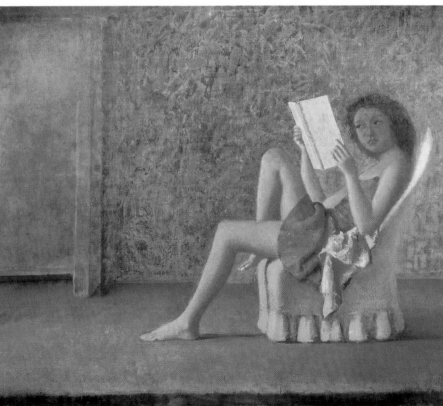

A rigid support such as masonite (with a traditional or acrylic gesso ground) is safest. However, Jasper Johns, as we have seen, can handle large-size paintings on canvas. The proportion of ingredients in the paint can be adjusted to fit the desired support. For canvas, use more oil with the melted wax and dry pigment mix, because oil makes the medium more flexible. By contrast, a rigid panel is necessary when there is more dammar in the formula.

Oil-wax crayons are essentially the pigment-medium combination in stick form. *Oil-Wax Crayons*
Because they are made with real pigments, oil-wax crayons, such as those made by Markal, will not fade. Some artists use these crayons on unsized paper, but there is a chance that the oil content will stain and eventually rot the paper. To prevent this, size with a rabbitskin glue and water solution (15 parts water to 1 part glue). Make sure you tape the paper to a hard surface in order to prevent bulges. Before using the crayons, peel or pierce the tip, so the flow will not be stopped by the wax covering.

Because of the wax content in these crayons, it is unwise to paint over them in oil; wax will repel the oil. They can, however, be used on top of a well-dried oil surface. Nevertheless, the best advice is to use oil-wax crayons alone.

Degas and Redon are usually credited with transforming pastel into a major medium *Pastel*
of expression. More recently, Picasso, Klee, and Miró have occasionally worked in pastel, Max Beckman often used it for underpainting, and de Kooning employed it with a direct graphic intensity (Fig. 129). Today, pastel is becoming an increasingly

129. Willem de Kooning. *Two Women's Torsos.* 1952.
Pastel, 18⅞ × 24″ (48 × 61 cm). Art Institute of Chicago (John H. Wrenn Fund).

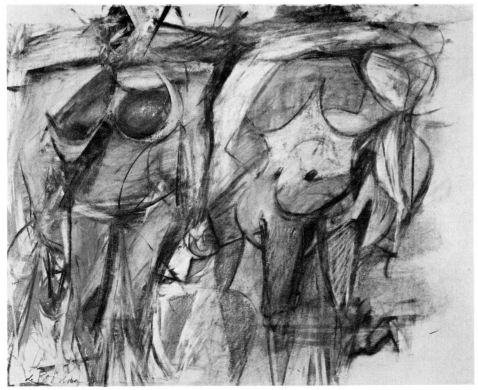

common material in artists' studios, no doubt because of the new interest in color, the compatibility of pastel with waterbase paints, and its facility for rapid execution.

Pure color is perhaps best represented by the brilliance of dry pigment. This near-spectrum intensity is an exciting visual experience—but an experience that is dulled by the change in the color produced when the pigment has been ground with a medium. Pastel, however, offers the painter the same brilliance as the original pigment itself.

opposite: 130. Edgar Degas. *Duranty.*
1879. Distemper, watercolor, and pastel
on linen; 39¾ × 39½″ (101 × 100 cm).
Burrell Collection, Glasgow Art Gallery
and Museum.

right: 131. Odilon Redon.
Wildflowers in a Long-Necked Vase.
After 1912. Pastel, 22¼ × 13⅝″
(57 × 35 cm). Louvre, Paris.

The relatively dry surfaces of gouache, distemper, and acrylic emulsion make it possible to incorporate them with pastel without the visual separation that a contrast of surface shine would cause. By placing one medium over another, you can almost immediately achieve a finished effect. Degas, for example, employed pastel in this manner with distemper and watercolor (Fig. 130), as well as gouache and oil paint. He built glazelike surfaces by spraying fixative between the layers of pastel and paint. Degas also sprayed pastel paintings with hot water and worked on them in this wet state with a brush. And, on occasion, he soaked his pastel sticks in steam, so that they would produce an impasto quality. Degas' experiments thus transformed pastel into a medium that had the depth and translucence of oil paint. Redon, on the other hand, preferred a more direct application so as to dramatize the intensity of individual pigments (Fig. 131).

Preparing Pastels Commercial pastels are adequate, but painters who desire a special range of color and a guarantee of permanence blend and manufacture their own pastel sticks. To prepare pastels, follow the formula* below. Other than dry pigments, you will need a mortar and pestle for grinding, gum tragacanth as a binder, beta naphthol as a preservative, and precipitated chalk as filler.

> Pour a pint of water on about ⅓ ounce of gum tragacanth, cover the vessel and allow it to stand overnight in a warm place. To the resulting gelatinous mass add a little beta naphthol to prevent it from spoiling. Label this solution **A**. Dilute a portion of it with one part water, labeling this solution **B**, and another portion with three parts water, labeling this solution **C**. The various pigments will require solutions of different strengths to produce crayons of the proper degree of softness; very few will need the full strength **A** solution. Because of the variations in raw materials, no accurate instructions can be given for the amounts of binder necessary to make pastels of the proper texture.

The average pastel sticks consist of approximately 2 ounces of pigment. Mix each pigment in the mortar with a sufficient amount of the binder solution, roll it into a stick, and allow it to dry. For a basic palette, make the following color sticks in the given solutions:

Color	Solution	Color	Solution
viridian	A	**ultramarine**	B and C
cadmium red light	A and B	**chrome green oxide**	B
cadmium red medium	A and B	**cadmium yellow medium**	A and C
cadmium red dark	A and B	**cadmium yellow deep**	A and C
manganese violet	A and B	**cadmium orange**	B and C
terre rose	B	**white:** 80% precipitated chalk 20% titanium white	C

Premix and form into sticks the following color combinations:

1 part manganese violet, 3 parts white	C	1 part cadmium red light, 3 parts white	B and C
equal parts cadmium red light, manganese violet, and white	B and C	equal parts cadmium yellow deep and chrome green oxide	A and B

Caution: avoid emerald green and all lead colors. These dry pigments are poisonous.

Supports Experiment with masonite, canvas, and paper as supports for pastel. Paper with a certain degree of roughness, or "tooth," is necessary for adherence. Commercially prepared toned papers are readily available, and parchment paper, sanded lightly with emery paper, works well. You can also try unsized linen glued to masonite or gesso over muslin, again glued to masonite. Keep in mind that each of these supports and grounds produces a different surface texture.

*Ralph Mayer, *The Artist's Handbook of Materials and Techniques,* revised edition, Viking Press, New York, 1970, pp. 314–315.

Fixatives Experiment with several fixatives, particularly acrylic emulsion Rhoplex AC 234 (p. 102), or any company's mat medium acrylic, thinned with 5 parts water. A highly recommended fixative is Magna varnish (p. 119), thinned with 4 parts ethyl alcohol. This formula also works well for all other dry media, including conté and charcoal. Spray on the fixatives with an atomizer. The Jet-Pak sprayer made by Ambroid Company works well, producing a fine mist. It is powered by a replaceable cylinder of nontoxic, nonflammable gas.

Fixatives do, of course, change the color and must be used sparingly. You can frame a pastel without fixing it by placing narrow strips of wood between the glass and the painting.

The Final Varnish

Should all paintings be varnished? If, as was the case with Rubens, there is enough oil and resin in your medium, varnishing may not be necessary. If your dry painting is even, with no dull spots, and has a good mix of oil and resin, you would be best advised not to risk a varnish. A varnish, after all, has its own characteristic optical effects. It makes the image glossier and darker, effects that might not cooperate with your aesthetic vision. How much oil and resin is sufficient, however, cannot be answered easily. We still cannot determine with accuracy the precise proportion of oil and resin used by the Old Masters. For your own work, keep in mind the components of your medium, then study the finished painting and decide whether it requires a varnish. Remember that a varnish should not be applied as a means of visually holding the picture together or achieving a completed look, for its effects may not be lasting.

A final varnish does have some advantages. First, a varnish offers a limited protection from moisture and temperature change. Second, dirt will remain on the surface of the varnish rather than on the painting. Third, a varnish can (within limits) restore the original optical character of old surfaces. Ideally, a varnish should be easy to remove without damage to the painting. Above all, the rules of good craftsmanship must be followed, for the poor application of material obviously can do harm to a painted surface. Therefore, experiment with each resin, natural or synthetic, for the formulas are endless.

The key to varnishing is the painter's optical intention and the quality of the medium. You would not, for example, put a glossy varnish on an egg tempera painting, since the glossy surface of the finish would violate the medium's optical intent—its mat quality—and thereby destroy its inherent beauty. In oil, varnishing is more difficult because a variety of optical effects are possible, ranging from semimat to very shiny. As with every technical aspect of painting, you must acquire a good knowledge of the available materials and use it to create your desired effects.

The chart on page 142 lists a variety of varnishes and the painting media to which they can be applied. Each one has varying degrees of matness and glossiness, as well as permanence. In general, the natural resins, which are yellow to begin with, tend to increase in yellowness with age. This observation is the result of exhaustive tests carried out by Robert L. Feller of the Mellon Institute of Industrial Research. He further concluded that the synthetic resins—polyvinyl acetate (Magna varnish) and polybutyl methacrylate (Elvacite 2044)—are clear and highly resistant to yellowing. However, these plastics may lose their solubility under intense heat and light.

Because of the diverse characteristics of each varnish, a variety of surface effects are possible, and this is where personal experimentation comes in. In addition, solvents can be added to the varnish to change its mat or gloss effect. Xylene,

Varnish	Painting Medium
natural resin varnish 1 part dammar, 1 part spirits of gum turpentine. Mix well. For mat varnish, add beeswax (p. 127); but do not use on dark paintings—a milky white film will appear.	oil
synthetic resin varnishes Magna medium (Bocour) acrylic resin. Miscible in turpentine (p. 119), but can be used without further thinning.	oil, Magna, Elvacite, Acryloid
Magna varnish (Bocour), vinyl resin. Miscible in ethyl alcohol (p. 119).	oil, Magna, Elvacite, Acryloid
Artist's Picture Varnish, ketone base. Miscible in turpentine (Winsor & Newton).	oil
Synvar, Univar (F. Weber), acrylic resins in spray cans.	oil, Elvacite, Acryloid
varnish for waterbase painting Although these media are waterproof, some artists prefer a surface coating. For best results use p.v.a. (Magna varnish).	egg tempera, casein, distemper
Thin coat of either glossy or mat medium followed by Soluvar, a new varnish that can be brushed over first coat without difficulty.	acrylic
Do not varnish. This medium is best kept under glass as varnish destroys color and surface effect.	gouache

petroleum thinners, and acetone are solvents for the polybutyl methacrylate resins (Elvacite); Magna medium, ethyl alcohol, and toluene for polyvinyl acetates (Magna varnish). The solvent usually comprises at least 60 to 70 percent of the varnish. These synthetics can be employed in combination—that is, one can be sprayed on top of another (after the lower coat is thoroughly dry), and both can be either brushed or sprayed. For spraying, use a spray gun that gives a steady, even pressure and has a fine nozzle. But the solvents may be toxic, and should be used with a maximum of ventilation. Needless to say, avoid smoking. The following solvents for varnish are known to be harmful: benzol (benzine, present in most spraycan varnishes), xylene, toluene, naphthalene, carbon tetrachloride, ethylene dichloride, and ethanol. Read the label of the spraycan or varnish, and make sure you do not come into contact with these materials without using a cartridge respirator, or better still, a self-contained air tank respirator (p. 115).

Application Place the painting in a horizontal position. Apply the varnish evenly with a fine-haired flat brush; be stingy with the liquid. Stretch each brushstroke as far as possible, for otherwise you will get a very glossy finish. Be sure the painting is dry—at least a month and longer is better. Never use oil in the varnish, for oil yellows.

If you prefer to use a spraycan, test it on a piece of paper to make sure it gives a very fine mist and does not dry in spots. Always spray on a vertical surface, never a horizontal one.

Remember that a varnish should never be too glossy. It should be thin, colorless, and easy to remove. Make sure it will dissolve with a weak solvent that will not destroy the film below. Practice varnishing on a small, expendable painting.

If you have any questions about a varnish, write to the manufacturer for complete information and instructions. For general problems, some conservators will be happy to assist. In sum, the new plastics demand experimentation, and the painter who employs a varnish should be aware of its particular optical effect. The problems involved are complex, and no one varnish or procedure can meet every need.

Painting Surfaces

Once you understand the technical behavior of painting media, you can achieve an almost endless variety of surface effects and textural qualities. These rich possibilities are best illustrated by oil, the most flexible painting medium. As always, the handling of paint is a matter of aesthetic choice. What is sensuous to Rembrandt or Monet may seem self-indulgent to Raphael or Mondrian. Mondrian's surface accords with his vision of the art of painting and is as sensuous to him as the manipulation of paint layers is to Monet. In short, a painter's personal aesthetic determines the beauty of a particular surface.

Young artists must experience the handling qualities of all the various oils and resins discussed in Chapter 3 in order to decide intelligently upon their own preferences. The same experience promotes an understanding of how some of the great masters produced their surface effects. Bear in mind, however, that there is no way to duplicate the exact medium used by your favorite master. Max Doerner's *The Materials of the Artist*[*] contains notes on the techniques of the Old Masters, but the recipes are mildly interesting at best, and misleading if you expect precise results. Jacques Maroger[**] also gives specific recipes. In the end, the only way to achieve the results you desire is to play with the materials. There are no shortcuts and no expert can

[*]Revised edition, Harcourt, Brace and Company, New York, 1949.
[**]*The Secret Formulas and Techniques of the Masters,* Studio Publications, Inc., New York and London, 1948.

show you *the* way. Hence, the examples here, which match materials to masterly surface effects, are given only as suggestions, not rules. No formulas exist, secret or public, that will satisfy the needs of the individual developing painter. The main purpose of the following discussion is to trigger a personal response to the various media presented.

Painterly Painting

Painterly painting—the physical manipulation of paint—usually refers to a generous or loose spreading of colors by direct application and with fairly unenclosed or open-edge contours. Edges can have, of course, different degrees of clarity. Among the Venetians—the greatest painterly painters—Tintoretto keeps the edges of the forms clear and clean in this painting (Fig. 132), while Titian's edges in Figure 133 are smoky and soft. The Venetians achieved a richly colored surface with direct brushwork. Color for them cooperated with the light-to-dark value structure of a composition.

below: **132. Tintoretto.** *The Last Supper.* 1592–94.
Oil on canvas, 12′ × 18′8″ (3.66 × 5.69 m).
S. Giorgio Maggiore, Venice.

opposite: **133. Titian.** *Christ Crowned with Thorns.* c. 1565.
Oil on canvas, 9′2″ × 6′ (2.79 × 1.83 m).
Alte Pinakothek, Munich.

An artist's handling of paint initially imitates that of an admired predecessor. Some masters adopt a mode of textural and surface effects early in their careers and maintain it throughout their lives. For example, Ingres and Delacroix, two famous antagonists, remained faithful to their primary influences—Ingres to Raphael and Delacroix to Rubens. In *The Death of Sardanapalus* (Fig. 134), Delacroix builds on the arabesque rhythms of Rubens (Fig. 135), with their turbulent energy, open contours, and swift brushstrokes that result in opaque ribbons of color. To produce such effects, both artists must have used a thicker medium, such as stand oil or sun-thickened linseed oil. The perfection of Ingres' controlled clarity of focus was produced with thin, luminous layers of paint that lean heavily on the tradition of Raphael (Figs. 136,

134. Eugène Delacroix.
The Death of Sardanapalus. 1844.
Oil on canvas, 29⅛ × 36⅝″ (74 × 93 cm).
Collection Henry P. McIlhenny, Philadelphia.

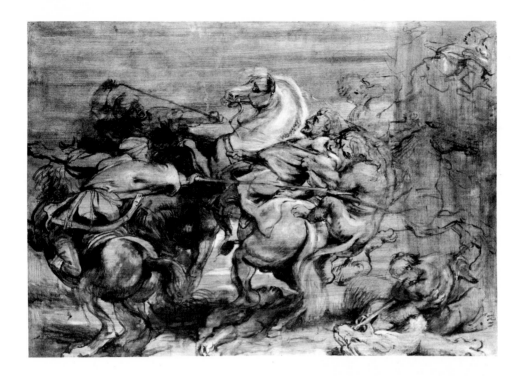

above: 135. Peter Paul Rubens.
Study of a Lion Hunt. c. 1615.
Oil on panel, 29 × 41″ (73 × 105 cm).
National Gallery, London
(reproduced by courtesy of the Trustees).

right: 136. Jean Auguste Dominique Ingres.
Madame Moitessier Seated. 1856.
Oil on canvas, 47¼ × 36¼″ (120 ×92 cm).
National Gallery, London
(reproduced by courtesy of the Trustees).

137. School of Raphael.
La Fornarina. c. 1516.
Oil on panel, 33⅛ × 23⅜″ (85 × 60 cm).
Galleria Borghese, Rome.

137). Raphael's models, in turn, were ancient Greek and Roman sources. Ingres and Raphael extracted from these sources the notion that forms must be reduced to their basic underlying structures. The painters thus visualized heads as simple, egg-shape volumes with clear edges.

Unlike Ingres and Delacroix, other masters changed their paint handling as they matured. The early works of Titian, Rembrandt, Goya, and Degas reveal clear contours and fairly thin, luminous paint surfaces rather evenly distributed. It is as if the young painters wanted to physically possess their images by enclosing and containing their contours. Compare the loosely painted Titian (Fig. 133), with its soft edges and merging areas of thick and thin paint, to the earlier *Reclining Venus* (Fig. 138), a picture with a much smoother surface, a glowing even paint quality, and relatively sharp contours.

The same tendency appears in two Rembrandt self-portraits, the one early, the other a late work. In the first, Rembrandt achieves a gentle, yet clear illumination, all

138. Titian. *Reclining Venus.*
(Venus of Urbino). c. 1538.
Oil on canvas, 3'10⅝" × 5'5" (1.19 × 1.65 m).
Uffizi, Florence.

the while that he strives for textural differentiation, manipulating brushstrokes and painting knife in an attempt to duplicate nature (Fig. 139). But in the late work, he seems to be literally constructing the textures with veritable mounds of paint troweled and brushed into distinct planes (Fig. 140). A thicker stand oil or sun-thickened linseed in combination with a varnish might be employed to imitate this technique.

For Goya, too, the smooth and sparkling surface delicacy of *The Duke of Osuna and His Family* (Fig. 141) gradually gave way to a ferocious, direct, and almost brutal attack of brushstrokes (Figs. 142, 143), which may have involved a thicker oil. Degas' style also moves from tight clarity to looseness, although in a different way. Under the influence of Ingres' clearly delineated forms, Degas painted *The Bellelli Family* (Fig. 144), one of his early masterpieces. The late *Combing the Hair* evolved after years of handling pastel, a medium that for Degas became a dialogue between

141. Francisco Goya.
The Duke of Osuna and His Family. 1789-90.
Oil on canvas. Prado, Madrid.

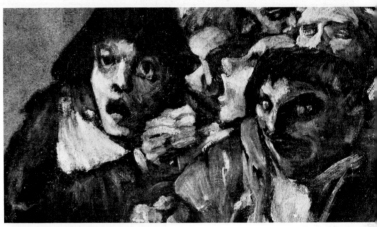

above: 142. Francisco Goya.
The Vision of the Pilgrims of San Isidro.
Early 19th century. Oil on canvas. Prado, Madrid.

right: 143. Detail of Figure 142.

below: 144. Edgar Degas.
The Bellelli Family. 1859. Oil on canvas,
6'6¾" × 8'3½" (2 × 2.53 m). Louvre, Paris.

drawing and color (Fig. 145). Transferred to oil painting, the dialogue produced a breathtaking freedom and inventiveness: abrupt, quickly sketched lines form volumes, and the turpentine-thinned paint creates both solid planes and surrounding atmosphere in this "unfinished" work.

A stylistic development from clear to loose paint handling is not the only possible path for an artist to take. Indeed, the development is reversed in Cézanne. His early portraits and still lifes are sculpturally conceived. The paint in *Ham and Bread*

above: 145. Edgar Degas.
Combing the Hair (unfinished).
c. 1885–95. Oil on canvas,
3′9″ × 4′9½″ (1.14 × 1.46 m).
National Gallery, London
(reproduced by courtesy
of the Trustees).

right: 146. Paul Cézanne.
Ham and Bread. c. 1865.
Oil on canvas,
10½ × 13⅞″ (27 × 36 cm).
Kunsthaus, Zürich.

actually is molded like colored clay (Fig. 146). But as Cézanne matured, he too was influenced by the experience of another medium, in his case watercolor. Combining this experience with a desire to model in color, Cézanne produced oil paintings such as the *Portrait of Joachim Gasquet* (Figs. 147, 148). Because he washes the thin, translucent paint onto the canvas with much turpentine thinner, patches of the white canvas ground are revealed. This exposed surface acts as the lightest tone, just as in watercolor painting.

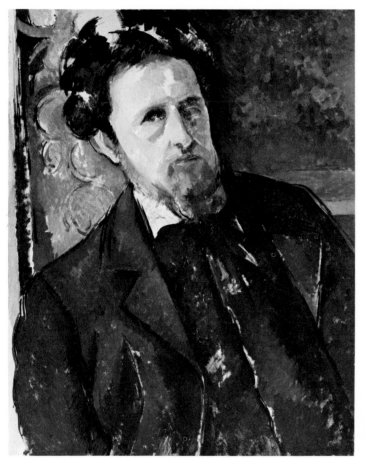

left: 147. Paul Cézanne.
Portrait of Joachim Gasquet.
c. 1896–97. Oil on canvas,
25⅝ × 21½″ (65 × 54 cm).
National Gallery, Prague.

below: 148. Detail of Figure 147.

Following still another path, Renoir abandoned his direct virtuoso color brushing in mid-career to pursue a classical solidity, using Ingres' technique of linear clarity and thin, glowing paint. The landscape that surrounds *The Bathers* still retains the vestiges of Renoir's Impressionism (Fig. 149). But the late portrait of *Tilla Durieux* (Fig. 150) seems to evoke Ingres as well as Impressionism, thereby creating a synthesis of two different periods.

No matter what stylistic path an artist takes, when the aesthetic imagery or mode of thinking changes, so does the technique of handling paint. Technique, in other words, is the servant of artistic vision, not the other way around.

The obvious tactile qualities of paint manipulation by Rembrandt and Courbet, however inventive or physically attractive, never dominate the image. Young painters can easily be seduced by beautiful surface quality at the expense of form invention. In Rembrandt and Courbet surface and image are one.

149. Auguste Renoir. *The Bathers.* 1887.
Oil on canvas, 3′10⅜″ × 5′7¼″ (1.18 × 1.71 m).
Philadelphia Museum of Art
(Mr. and Mrs. Carroll S. Tyson Collection).

150. Auguste Renoir.
Tilla Durieux. 1914.
Oil on canvas, 36½ × 29″ (92 × 74 cm).
Metropolitan Museum of Art, New York
(bequest of Stephen C. Clark, 1960).

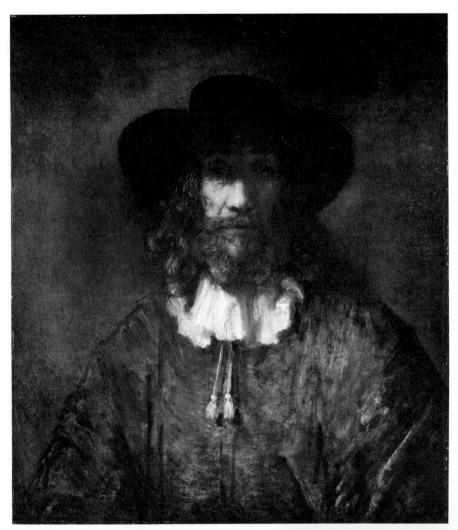

above: **151. Follower of Rembrandt.**
Man with a Beard. 1665.
Oil on canvas, 28⅞ × 25¼″ (73 × 64 cm).
Metropolitan Museum of Art, New York
(gift of Henry G. Marquand, 1889).

right: **152.** Detail of Figure 151.

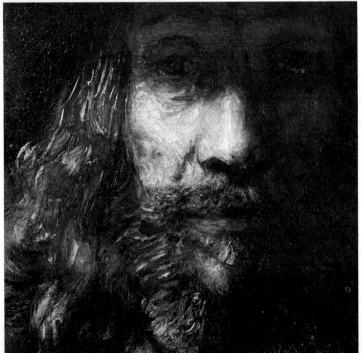

A close-up enlargement of *Man with a Beard* (Figs. 151, 152) reveals the thick and thin layering of paint in what is probably a wet-on-wet technique (p. 175). Notice that each object portrayed is presented with different kinds of brushstrokes, some with only subtle differences and others with sharp contrasts of texture. What is important is that all these textures are orchestrated to flow in unison.

Courbet also produces forms with a raised surface. Employing a painting knife, he literally constructs the grotto (Fig. 153). But this texture-making technique operates in the service of a unique pictorial experience. The constructed planes lead us into the darkness of the grotto in a forceful, physical way.

153. Gustave Courbet.
La Grotte de la Loue. c. 1865.
Oil on canvas, 3′2¾″ × 4′3⅜″ (.98 × 1.3 m).
National Gallery of Art, Washington, D.C.
(gift of Charles L. Lindemann, 1957).

Painterly painting also refers to the kind of inventive brushwork found in El Greco's *Christ Driving the Traders from the Temple* (Fig. 154). Here, the electric brushing creates an air of immediacy, as if we were witnessing the event. Fluid slashes such as these, in a painting built up of several layers, organically intertwine form and space. A free-flowing linseed oil would be the modern equivalent of El Greco's medium.

In still another kind of tactile effect, Watteau applied abrupt, yet minuscule, punctuations of impasto in loose patterns (Fig. 155). These touches pick up details of clothing and vegetation, energizing the whole surface and causing an allover shimmer, so that the brushstrokes seem to be created with nerve endings.

154. El Greco. *Christ Driving the Traders from the Temple,* detail. c. 1600. Oil on canvas, entire work 3′5⅞″ × 4′3⅛″ (1.06 × 1.3 m). National Gallery, London (reproduced by courtesy of the Trustees).

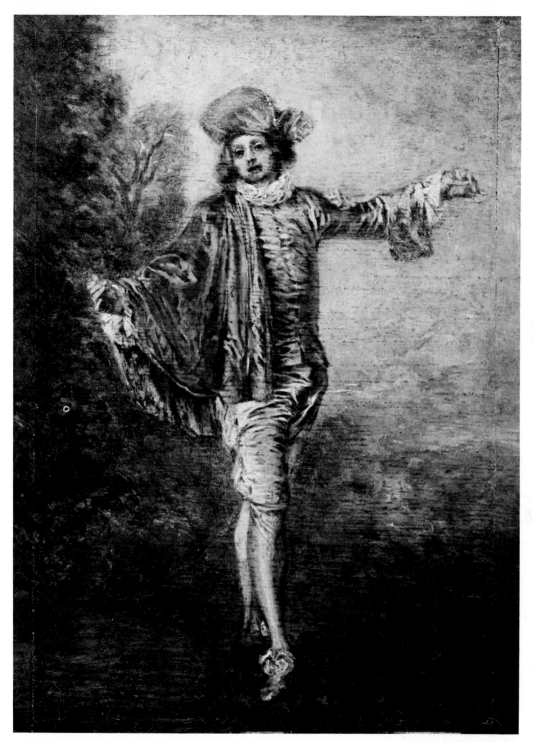

155. Jean-Antoine Watteau.
L'Indifférent. c. 1716.
Oil on canvas,
10⅜ × 8″ (26 × 20 cm).
Louvre, Paris.

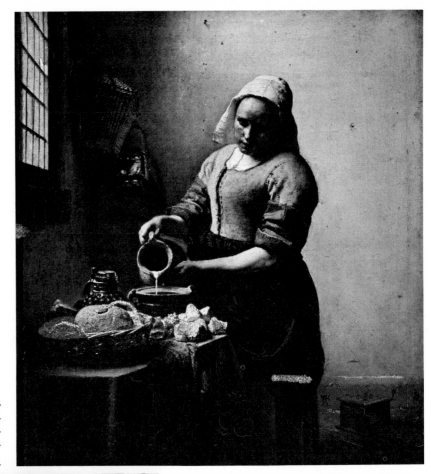

right: **156. Jan Vermeer.**
The Kitchen Maid. c. 1658.
Oil on canvas, 17¾ × 16″ (46 × 41 cm).
Rijksmuseum, Amsterdam.

below: 157. Detail of Figure 156.

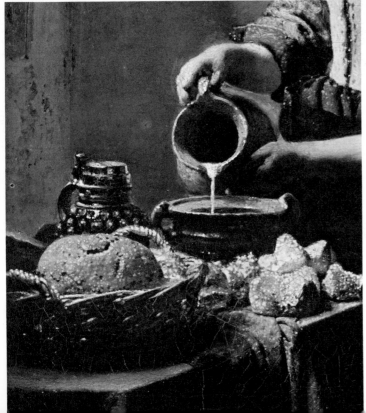

Vermeer's sense of touch is very painterly (Fig. 156). Semitranslucent, thin coats of warm and cool tones play against more opaque surfaces and finally coalesce in an optical vibration around each form. They ultimately engulf the whole space in a magical light. Vermeer's spatial organization and sense of scale match his paint handling. A detail of *The Kitchen Maid* shows his method of highlighting objects that catch the light (Fig. 157). These highlights are produced with tiny dots of opaque pigment, made with the point of a fine brush and possibly inserted when the paint underneath was still wet.

Returning to a more obviously physical manipulation of paint, Chaim Soutine's *Les Porcs* (Fig. 158) displays a variety of surface effects that distinguish one texture from another: opaque, smoothed-out areas of paint with rough edges, stippled marks, and paint-filled brushstrokes skimming the surface. And yet, all the marks merge, each mass and stroke knows what the other is doing within the allover rhythmic surge.

158. Chaim Soutine. *Les Porcs.* 1942. Oil on canvas, 18¾ × 23″ (48 × 51 cm). Musée d'Art Moderne de la Ville de Paris.

159. Willem de Kooning. *Easter Monday.* 1955–56.
Oil and newspaper transfer on canvas, 8′ × 6′2″ (2.44 × 1.88 m).
Metropolitan Museum of Art, New York (Rogers Fund, 1956).

Finally, Willem de Kooning creates an explosive avalanche of richly painted layers (Fig. 159). De Kooning mixes a little water into his resin oil mixture (probably stand oil or safflower oil with dammar varnish) to produce a skidding effect—what house-painters call "short" paint, because the water keeps the paint from spreading. De Kooning sometimes presses newspaper into the fresh paint to speed drying. An impression of newspaper print may even appear on the dried surface. In addition, de Kooning has made unique impressions from wet paintings by pressing sheets of vellum against the wet surface to produce large monoprints.

One-Coat Painting

Some painters try to capture their motif directly in one sitting. Such rapidity enabled Vincent van Gogh (Fig. 1) to paint two or more paintings a day. In the first half of the 20th century one of the best of these *alla prima,* or *premier coup,* painters was Albert Marquet (Fig. 160). In one consistent thin coat—probably thinned with a little turpentine and without the addition of another medium—Marquet's masterly control of tone,

160. Albert Marquet. *Naples, le Voilier.* 1909.
Oil on canvas, 25⅜ × 31⅝″ (65 × 81 cm). Musée des Beaux-Arts, Bordeaux.

color, and scale suggests the weather, as well as simplified volumetric projections of objects in space.

In Bonnard's loose painting (Fig. 161), executed mostly in turpentine washes, the artist instantly captures the figure and objects in the environment. A technical danger here is that too much turpentine may weaken the glue action of the oil bond. Compare this one-shot, effervescent work to another Bonnard painting shown in Figure 162. In

161. Pierre Bonnard.
Nude in Yellow (Le Grand Nu Jaune).
1931. Oil on canvas,
5'6⅞" × 3'6½" (1.67 × 1.06 m).
Private collection, New York.

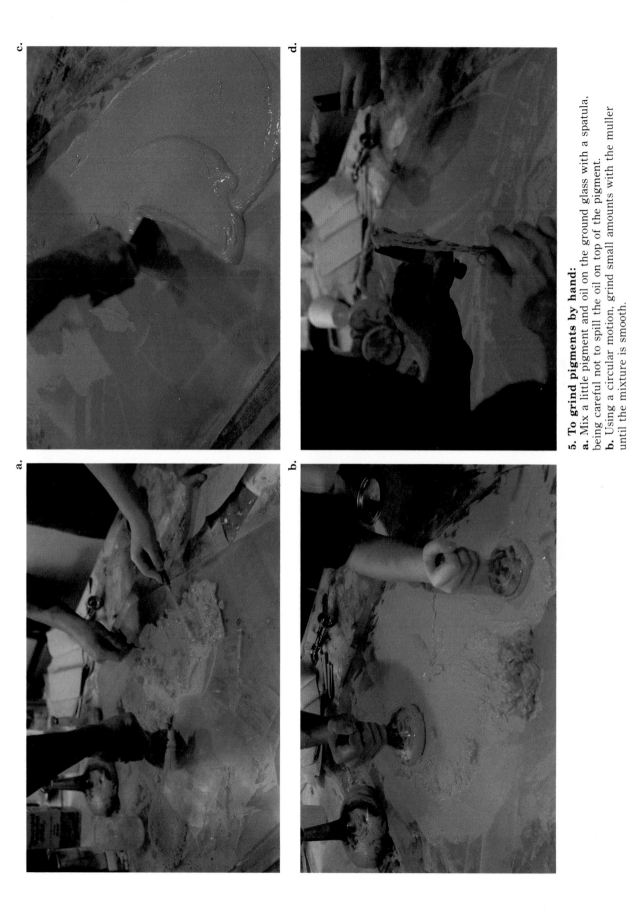

5. To grind pigments by hand:
a. Mix a little pigment and oil on the ground glass with a spatula, being careful not to spill the oil on top of the pigment.
b. Using a circular motion, grind small amounts with the muller until the mixture is smooth.
c. After the beeswax paste is added and the mixture reground, it is ready to be put in the tube.
d. Fill the tube, using a spatula; tap the tube to settle the paint.

169

6. Josef Albers. *Homage to the Square.*
above left: *Dense-Soft.* 1969. Oil on canvas, 40″ (100 cm) square.
above right: 1964. Oil on canvas, 30″ (75 cm) square.
below left: *What You Want.* 1969. Oil on canvas, 24″ (60 cm) square.
below right: *Floating.* 1957. Oil on canvas, 24″ (60 cm) square.
All collection Yale University Art Gallery, New Haven, Conn.

the latter painting, Bonnard builds a slower, more carefully balanced mosaic-like composition of interacting colors and shapes. Even the paint is applied differently, with heavier layers patiently built up to produce a sharper delineation of edges and object-shapes.

In more recent developments, Rothko's use of Magna paint, which thins with turpentine, produces a thin, flat, and uniform surface. Noland, Frankenthaler, Stella, and Louis achieve a similar effect with acrylic water-thinned paint, although they employ different methods. Louis and Frankenthaler stain the surfaces, transferring the watercolor glaze method onto a large cotton canvas whose unprimed surface literally soaks up color (Fig. 115; Pl. 2, p. 135). Louis, who worked with Magna as well as water-thinned acrylic, called one series of his paintings *Veils*—a title that aptly describes both the painting technique and the surface appearance. Both Franken-thaler and Louis paint on a horizontal surface (the floor). They pour and manipulate

162. Pierre Bonnard. *The Palm.* 1926. Oil on canvas, 44 × 47½″ (110 × 119 cm). Phillips Collection, Washington, D.C.

the fluid paint with large sponges, sticks, pieces of cardboard, and squeegees (a strip of rubber mounted on a long handle made for squeezing water off smooth surfaces such as window glass). An even staining is best accomplished by prewetting the unprimed canvas (preferably No. 10 cotton) with water and a sponge.

By contrast, Noland and Stella apply evenly distributed, uniform coats of paint (Figs. 99, 102). Ellsworth Kelly prefers the optical effect of oil paints, which he thins with turpentine in large mixing bowls, on a traditional ground of rabbitskin glue and flake white.

Artists often find the one-coat method efficient for studies and sketches. Onto the Venetian red ground of *Barges on the Stour* (Fig. 163), Constable brushed semiopaque strokes that reveal a textural sweep as they present, reading from the bottom up, a narrow strip of land with a tree trunk, water, a barge, three figures, another horizontal plane of land, a bridge, and a sky. All these details are transferred and ultimately transformed by the swiftly moving brushstrokes that capture the rapid movement of clouds in an instant light. The whole composition measures only 10¼ by 12¼ inches and is painted on paper.

Manet created an astonishing shorthand study for his famous *Déjeuner sur l'Herbe* (Fig. 164). The brushing technique is stunning in its scope. Although direct and swift, it encompasses and places into space a great many forms at once. Compare the textural energy—the movement of brushstrokes—in the nude and in the trousers of the man on the right, with that in the finished painting (Fig. 165). In the final work, Manet smoothed out the brushstrokes, blending their diverse directions into an even surface.

163. John Constable.
Barges on the Stour.
c. 1810. Oil on paper
laid on canvas,
10¼ × 12¼″ (26 × 31 cm).
Victoria & Albert Museum,
London (Crown Copyright).

164. Edouard Manet.
Study for
Le Déjeuner sur l'Herbe.
1862–63. Oil on canvas,
35¼ × 45¾″ (89 × 114 cm).
Courtauld Institute Galleries,
London.

165. Edouard Manet.
Le Déjeuner sur l'Herbe.
1862–63. Oil on canvas,
7′¾″ × 8′10⅜″ (2.15 × 2.7 m).
Louvre, Paris.

above: **166. Rembrandt.**
*Saskia van Ulenborch
in Arcadian Costume,* detail. 1635.
Oil on canvas, entire work
4'5⅝" × 3'2⅜" (1.24 × .98 m).
National Gallery, London
(reproduced by courtesy of the Trustees).

right: **167. Peter Paul Rubens.**
The Judgment of Paris, detail. c. 1632–35.
Oil on canvas, entire work
4'9⅛" × 6'4⅜" (1.45 × 1.94 m).
National Gallery, London
(reproduced by courtesy of the Trustees).

Wet into Wet

The idea of painting strokes of wet paint onto a still-wet surface in order to produce a multilayered, spontaneous effect is a tradition that began with the invention of the oil medium, whose slow drying made it possible. The chart on page 125 provides a list of oils that can be used to slow down the drying time even more, thereby lengthening the wet-on-wet process.

Rembrandt probably worked into layers of paint when they were almost dry—that is, in the tacky, sticky stage (Fig. 166). In some places, he gently manipulated the thin coats of paint into the surface and added light and dark accents; in others he inserted bold brushwork; and in still others he inscribed marks with his brush handle.

Rubens, some experts say, produced his characteristically iridescent flesh coloring by painting flesh tints into a wet, thin, gray undercoat (Fig. 167). Another possibility is that Rubens first executed a fast-drying underpainting in grays with a turpentine-resin mixture and no oil (Fig. 135). He then floated pinkish flesh colors on top of the dry undercoat to simulate a wet-on-wet effect. Whatever the method, Rubens' handling of the oil medium is one of the greatest accomplishments of paint manipulation in the history of art.

With the paintings of Frans Hals there is no need to guess at the technique, for he truly celebrates the brushstrokes (Fig. 168). Every mark stays clearly on the surface,

168. Frans Hals. *The Merry Drinker.* 1627. Oil on canvas, 31⅞ × 26¼″ (81 × 67 cm). Rijksmuseum, Amsterdam.

never blended or blurred. His is the classic wet into wet performance, where the brilliance of the brushwork immediately energizes the image. Two centuries later, Manet mastered Hals' brush action without imitating his predecessor's frantic pace (Fig. 169). (Of course, Manet also was influenced by Goya and Velázquez.) Manet maintained his own slower rhythm, combining it with an expanded color spectrum: cerulean blue background, warm and cool greens, blue-violet and pink flowers, and, on the vase, strokes of a manganese color and Naples yellow spots.

left: 169. Edouard Manet.
Carnations and Clematis in a Vase.
c. 1882. Oil on canvas,
22 × 11″ (56 × 28 cm).
Louvre, Paris.

opposite: 170.
James Abbott McNeill Whistler.
Nocturne in Blue-Green.
1871. Oil on canvas,
19⅝ × 23⅞″ (50 × 61 cm).
Tate Gallery, London.

Monet, another wet-on-wet master, took up a fresh canvas as the light changed. The next day he sometimes went back to the earlier canvas when the same light condition appeared. By this process, Monet produced many works in the series *Houses of Parliament* (Pl. 3, p. 136). In all his works, Monet managed to sustain more than a fresh set of brushstrokes into a wet surface. He was able to apply countless layers of paint without any color ever turning muddy. In the painting reproduced here (Pl. 3), he appears to have started with a turpentine-thinned red-ochre ground, perhaps rubbed down with a rag. Into this coat, Monet built a dull, blue-violet sky, dragging whites into the tone and crowning with a heavier, pure white at the top. The building on the left appears to be cobalt blue mixed with white. On the right, the main buildings reveal an added viridian and white brushed on in streaks into the cobalt-white. The highlights on the water have a touch of yellow mixed with the white. From a technical point of view, there does not seem to be much medium added to the tubed colors. (Monet also worked in heavily textured layers, allowing each coat to dry. Here we can detect flake white—the only pigment that can produce this rough surface.)

Whistler, too, used a wet-on-wet technique, but with an entirely different color light. He painted his *Nocturne in Blue-Green* on a red ground, so that the subtle dark greens and blues blend into each other (Fig. 170). Marks representing the lights of the buildings and their reflections in the water are dashed into the wet surface in a deft shorthand. In the foreground, graphic strokes represent a barge and a person.

171. Georges Braque. *The Table.*
1928. Oil on canvas,
5′10¾″ × 2′4¾″ (1.8 × .73 m)
Museum of Modern Art, New York
(Lillie P. Bliss Collection).

Textural Additions to the Medium

Georges Braque, an apprentice house painter in his youth, learned the art of imitating in oils such diverse surfaces as woodgrain and marble. This feeling for contrasting textures stayed with him throughout his career, from his early collages of pasted paper and cardboard (Fig. 193) to his later method of mixing fine white sand with oil paint. In *The Table* (Fig. 171), the sand produces a subtle but lasting physical presence. If you experiment with this process, don't use too much sand. Sand tends to hold moisture, thereby weakening the glue action of the oil. The p.v.a. medium, with its stronger glue action (p. 116), can sustain more sand.

There are two main schools of textural preference, one holding that the surface, no matter what textures are suggested, should be consistent and uniform, the other that physical textural changes add to the presence and energy of the picture.

The early works of Balthus belong in the first category, while his late works belong in the second. In *Katia Reading,* a late work, Balthus creates the back wall, the chair, the drapery, the legs, and the face, all with different textures (Pl. 4, p. 136). Despite this variety, Balthus maintains an overall unity of light and persuades the opposing physical energies to work together. The head is modeled in smooth shiny strokes, the legs have a granular surface, and the wall is built of layers of variously shaped brushstrokes. Balthus executed this painting during his long stay in Rome, a city whose beautifully textured walls may have triggered this physical manipulation of contrasting texture. Before the Roman period, Balthus scattered sand at random, with no correspondence to the depicted forms. It was Rome that inspired the contrapuntal textural mode of *Katia Reading.*

Technically, the texture of the legs in Balthus' painting could be produced with a very fine sand or marble dust added to the oil paint. Flake white that has been dried out—that is, where the cap is removed from the tube and the oil is allowed to drain on a blotter—can also produce the same effect. Since flake white does not require much oil in grinding, the drying process is quite short. Be careful not to let the paint get too dry, for the oil is a necessary adhesive. Small amounts of whiting (chalk) can be worked into oil paint to flatten the oil's shine and add a slight tooth to the paint. Mix the paint thoroughly with a spatula.

In another textural addition, Max Beckmann used pastel in the bottom layers of his oil paintings to make corrections over very thin (mostly turpentine) linear under-paintings (Fig. 172). The final layers of oil paint lock in the pastel and give the surface

172. Max Beckmann.
Siesta.
1947. Oil on canvas.
Nationalgalerie, West Berlin.

a particularly bright mat look, highly appropriate for Beckmann's strong, simple, and sensuous figure paintings. Again, if you try this technique, be sure there is enough oil, for it provides the adhesive to lock the layers together.

Painting in Layers

Beckmann's technique can also be defined as one of underpainting and overpainting—one layer on top of an already dried coat. Ingres, however, gives us the clearest example of painting in layers. He wrote about building up his paintings in thin *grisailles*—that is, in tones of gray applied underneath the final color coats. Ingres kept the grisaille *Odalisque* in his studio (Fig. 173), while another version in full color hangs in the Louvre. The artist explained how to control values in the grisaille system. After the grisaille stage dried, he built up and smoothly blended the color. The result was a crisp fluidity, for the monochrome underneath clearly differentiated the values to be maintained. Yet, looking at a glowing, yet elusively delicate work such as *Bather of Valpinçon* (Fig. 174), there is no way to perceive this process.

173. Jean Auguste Dominique Ingres. *Odalisque en Grisaille,* study for *Grande Odalisque.* c. 1813. Oil on canvas, 32¾ × 43″ (83 × 109 cm). Metropolitan Museum of Art, New York (Wolfe Fund, 1938).

174. Jean Auguste Dominique Ingres.
Bather of Valpinçon. 1808.
Oil on canvas, 4′8⅝″ × 3′2¼″ (1.44 × .92 m).
Louvre, Paris.

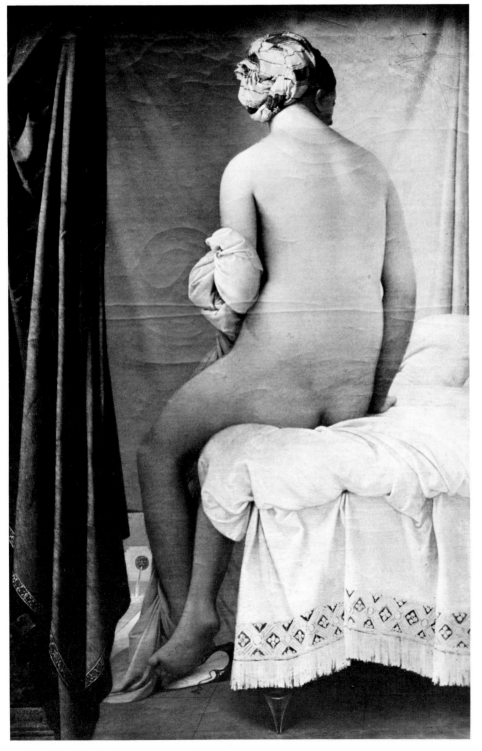

175. Lucas Cranach the Elder.
Adam and Eve. 1526. Oil on panel,
46⅛ × 31¾″ (115 × 79 cm).
Courtauld Institute Galleries,
London (Lee Collection).

Painters of the 16th century—Bosch (Fig. 123), Cranach, and Grünewald, for example—inherited a mixed-media tradition of layering with a tempera underpainting and an oil coat on top. Each produced a distinct form type and, more important, created different textural surfaces.

You have seen in another chapter Cranach's ability to place single strokes of egg tempera into the final oil-resin coat to give crisp, linear highlights to flowing hair (Fig. 125). He uses the same highlighting in Figure 175, but in a more complicated and detailed composition. Softly modeled animals contrast with stark hard-edged, light-colored figures and complicated foliage with individual fruit forms. Cranach's technique of highlighting with tempera brushed into wet oil-resin is not used for its own sake. Rather, it creates the focus that miraculously shifts from form to form, even though all forms occupy the same plane. They are perceived in an order invented by the artist.

176. Matthias Grünewald.
The Resurrection, detail of the *Isenheim Altarpiece.*
c. 1510–15. Oil on panel, detail 8′10″ × 4′8¼″
(2.69 × 1.43 m). Musée Unterlinden, Colmar.
(See also Pl. 19, p. 221.)

Cranach's highlighting with tempera into oil is the last step in the painting. The first is a clear linear drawing on a smooth ground followed by a build-up of light, tempera color in the largest flat areas. These areas provide a solid base for the final coats. (For the contemporary painter, waterbase acrylic paint can be substituted for tempera in this process, but the paint should be fairly thin.) The tempera underpainting yellows much less than oil, with the result that these paintings remain in amazingly good condition except for some characteristic tempera crackle, the product of countless changes in humidity to which the paintings were exposed before modern technological controls.

Grünewald's *The Resurrection* employs few, if any, tempera-into-oil highlights (Fig. 176; Pl. 19, p. 221). It is executed with a tempera undercoat followed by layers of oil color. Compared to Cranach, Grünewald used a thicker, richer coloration, transparent in the main, but with areas of heavier buildup in oil-varnish. Either his medium

was thinned less than Cranach's, or the formula had almost equal amounts of oil and varnish. Whatever the case, Grünewald achieved a remarkably translucent surface. In sum, Cranach and Grünewald painted with a combination of oil and tempera to produce unique visions. Each made a personal use of the media and methods of his own time.

Unless one can miraculously maneuver all the layers at once like Monet (Pl. 3, p. 136), layering of paint is obviously a process of underpainting and overpainting. Picasso gives us a visual comment on the characteristic tempera underpainting by Van Eyck (Fig. 92), with its strict crosshatching of forms as preliminaries and guides to the overcoatings. Picasso's *Harlequin* features the same process of modeling by traditional crosshatching to build volumes (Fig. 177). But Picasso plays this device against an area of quickly brushed color and another of untouched canvas. While it

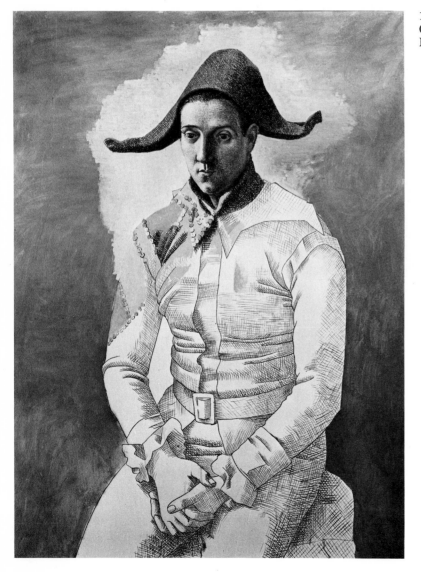

177. Pablo Picasso. *Harlequin.* 1923. Oil on canvas, 4′3″ × 3′2″ (1.3 × .97 m). Musée National d'Art Moderne, Paris.

178. Michelangelo (?).
The Entombment
(unfinished).
Panel, 5′3⅝″ × 4′11″
(1.61 × 1.49 m).
National Gallery, London
(reproduced by courtesy
of the Trustees).

is possible to read *Harlequin* as a parody, it is more likely that Picasso used this method, as he used others, to house his own form inventions.

Michelangelo's unfinished painting (Fig. 178) gives us a rare opportunity to witness the transformation of flat shapes into modeled volumes. The forms in the tempera underpainting retain simple, cut-out shapes that recall ancient Roman painting. Out of the flatness, Michelangelo built up forms that ultimately resemble relief sculpture. In his approach to painting, the closer it resembled sculpture, the higher the attainment. As he modeled, Michelangelo consciously built a *limited* spatial depth, a painted equivalent of the bas-relief.

The term underpainting usually moves beginning students to ask whether they should begin the canvas by drawing with charcoal or pencil, or by drawing directly with thin oil paint. The answer is that the possibilities of underdrawing are as numerous as the methods of applying paint. Do what is easiest and natural. Your methods and choices will change with your aesthetic vision.

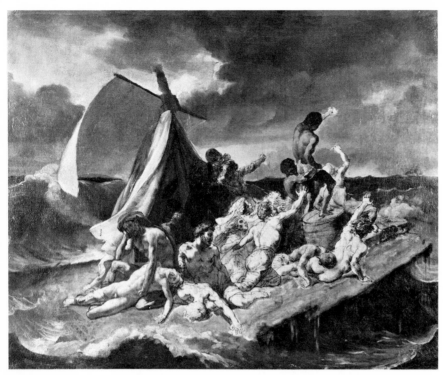

179. Théodore Géricault. Study for *The Raft of the Medusa.* 1818.
Oil on canvas, 24½ × 32¾″ (65 × 83 cm). Louvre, Paris.

Large complicated compositions demand careful planning in the form of a series of studies that chart the growth of the initial concept. Masters always take the time to make these studies, whereas students, too eager to arrive at the finished product, start with the large canvas. The advantageous flexibility of the step-by-step process is revealed by Géricault, whose method of underpainting is exposed in his preliminary oil sketch for *The Raft of the Medusa* (Fig. 179). This first thought is a clear linear drawing produced with a fine sable brush, in which you can follow the gradual transformation of line into planar mass, of line drawing into modeled painting volumes—a process already hidden in the more finished sketch (Fig. 180) and fully developed in the final painting (Fig. 181). A comparison of the two versions (Figs. 179, 180) also attests to Géricault's superb visual stage direction, where figures are moved around and actors added or subtracted.

Summary

This chapter has explored the endless variety of textural surface quality, primarily in the oil medium. It has avoided didactic formulas in order to suggest possibilities. Having experimented with all the known media, you can match this technical experience of surface quality to your own aesthetic sensibility. The chosen medium and its handling are interdependent products of your personal vision. Moreover, no exploration of technical possibilities is feasible without a broad visual culture, for knowledge of past and present form languages must be seamlessly bound to both techniques and methods.

above: 180. Théodore Géricault. Study for *The Raft of the Medusa* (first sketch of definitive tableau). 1818. Oil on canvas, 14¾ × 18″ (38 × 46 cm). Louvre, Paris.

below: 181. Théodore Géricault. *The Raft of the Medusa.* 1818.
Oil on canvas, 16′1¼″ × 23′6″ (4.91 × 7.16 m). Louvre, Paris.

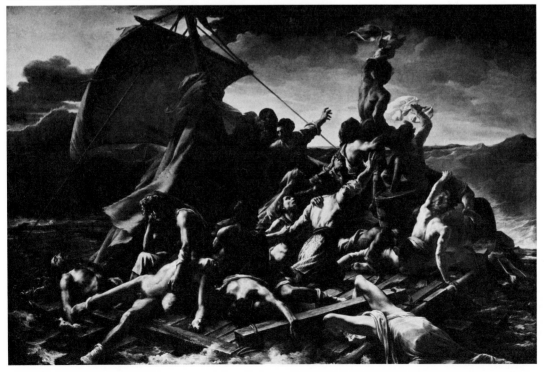

The Permanent Palette

A visit to a paint manufacturing plant to see buckets of cadmiums, cobalts, and earth colors being mixed and tubed is an exciting experience for a painter. The first thing you learn is that the color selections on each company's charts are different, and that this is not the result of poor quality control. Suppliers make available to manufacturers as many as thirty shades of a particular hue of pigment. The individual manufacturer must then choose a balanced chart and, of necessity, limit the number of colors on it. A manufacturer also picks a shade for its ability to mix well with the other colors and for its tinting strength—its ability to hold the color when thinned. The potential variety is such that you could easily select six cadmiums instead of the normal three (light, medium, dark) sold by each company, for the range from light red-orange to red-purple is vast. A painter—for example, Josef Albers (p. 204)—who preferred not to mix colors could have six different cadmium yellow medium shades, all from different manufacturers.

Pigments are ground in the factory on large mills that can hold vast amounts of pigment. The pigment and the various oils are weighed out and dumped into a large vessel, and the vessel is placed under a mixer that stirs the ingredients. This "rough mix" is then put into the back of the mill and ground. When the color comes off the mill, it is checked for shade brilliance and consistency. The pigment is then put back into the mill and ground again, after which it is placed in smaller containers, covered to keep out the air, and stored for aging. This aging process allows the medium to saturate the pigments completely. The amount of oil used in mixing is so carefully controlled that very seldom will any of it "sweat" to the surface.

The three-roller mills employed (Fig. 182) are water-cooled, for a machine that is not so cooled can "burn" the pigments. In addition, the mills have pressure gauges to ensure equal grinding at both ends of the large rollers. Each final run produces up to 60 gallons of pigment. After aging and testing, the pigment is emptied into a group of still smaller containers, taken to the tubing department, and connected to a feeding device that injects an exact amount of paint into tubes rotating below (Figs. 183, 184). As the last step in the operation, each batch of pigment is retested for tone and consistency. All the controls always have to be constant, for a company must produce a color with the knowledge that it can be repeated exactly in the future.

Another piece of valuable information is acquired at a manufacturer's plant: that "student grade" colors, as opposed to "professional" or "artist's grade," are diluted with a great deal of filler, usually aluminum stearate. This may not harm the tone of the color but it definitely limits its tinting strength. Test this by comparing the tinting power of a c.p. (chemically pure) cadmium or a cadmium-barium of the artist's grade with cadmium of the student grade variety. You will find the artist's grade to be at least three times as strong. Aluminum stearate also acts as a stabilizer that prevents the separation of oil from pigment. For this purpose, however, only 2 percent by volume is needed, whereas student grade paints carry between 30 and 50 percent of the filler. In less expensive student grade pigments, such as earth colors, clay is

182. High-speed three-roller mills are used for grinding pigments.

above: 183. During the manufacturing process, the mixed pigments are tested for proper grind, sheen, and color.

below: 184. The empty tubes are filled and crimped by machines.

sometimes used, because it is cheaper than aluminum stearate. Remember that an excess of aluminum stearate may also slow drying time. In more costly artist's grade paint, beeswax paste serves as the stabilizer. The beeswax paste also prevents the paint from hardening in the tube.

To avoid the problems inherent in manufactured paints, you can, of course, grind your own pigments according to the instructions on pages 199–201. Before attempting this, or before purchasing a set of colors, keep in mind some basic information about pigments and palettes.

The names of some colors are chosen arbitrarily. As an example, there is no such pigment as "lemon" yellow. The pigment inside the tube could be cadmium yellow light, zinc yellow, Hansa yellow, azo (a light-fast dye), or chrome yellow. Learn to read the labels. Chrome yellow, for instance, is impermanent, darkens quickly, and should be avoided. If some companies still produce chrome yellow, it is only because its exact shade is in demand by amateurs, or professionals who do not know or care.

There are and have been controlled experiments to measure the permanency of pigments, their fading, drying time, and the percentage of oil needed to grind each one. But the actual handling preferences for individual pigments are the result of personal experience.

A Basic Permanent Palette

However you choose to work with colors, the ones listed below could serve as the basis for your permanent palette:

white flake or Cremnitz (lead), zinc, titanium

yellow cadmium, Naples, zinc, Hansa, ochre, aureolin (cobalt), Indian, Mars

orange cadmium

red cadmium, alizarin, Mars, Indian, Venetian, quinacridone

brown burnt umber, raw umber, burnt sienna, raw sienna, Mars

blue ultramarine, cobalt, cerulean, manganese, phthalocyanine (monastral)

green viridian, chromium oxide, terre verte (green earth), cobalt, phthalocyanine (monastral)

violet cobalt, manganese, Mars

black Mars, ivory

A detailed breakdown of each color group appears below, including pigments that are not on the basic list. In addition to its function and drying time, the color's degree of opacity is cited.

White **Flake or Cremnitz** Flake and Cremnitz are lead pigments, Cremnitz being the name for the finest grades. (Winsor & Newton adds a touch of zinc white and grinds the pigment in safflower oil.) Opaque in density, flake and Cremnitz are the oldest pigments, going back to ancient wall painting in China. They also provide the heaviest, densest white, and are used in grounds and underpaintings because of their fast drying. But flake and Cremnitz are poisonous in powder form. Do not grind them, for inhaling this powder is lethal. The pigment is dangerous even in tube form if it gets into an open cut in the skin. So if you must use it—and it does seem to lend an

indispensable quality of density—be careful to wash your hands thoroughly after use. Do not use it if you paint with your hands. (Lead in house paints has been outlawed in the United States.)

Zinc White An opaque, cold tone compared to flake, zinc white covers less than flake, and is slower drying. In watercolor it is called Chinese white. An excessive build-up of this pigment may cause circular cracks in paintings.

Titanium An opaque pigment, titanium has a buttery smooth feeling; it is not as opaque as flake. Many painters like its maneuverability compared to flake's thickness. Winsor & Newton adds a small amount of zinc white and grinds the mixture in safflower oil.

Permalba White Made by the F. Weber Company, Permalba white is an opaque mixture of titanium and zinc.

Cadmium-Barium In opaque cadmium-barium, the barium acts as a filler. Chemically pure cadmium is rare and very expensive. Cadmium yellows range from pale to yellow-orange, each company producing a group of three. There is no substitute for these colors. Experiment by buying many shades from several companies.

Yellow

Naples Yellow The genuine Naples yellow, a dense, opaque, fast dryer, is a lead antimonate and as poisonous as flake. Also like flake, it is heavy in the tube. If the tube is light, read the label, and you will find it is an imitation made from yellow ochre and zinc or titanium white. Each company makes a different shade, from Blockx' very pale to Bocour's almost ochre. Winsor & Newton's Naples yellow is pale—an imitation made from flake white, cadmium yellow, light red (iron oxide), and yellow ochre. In watercolors, zinc is substituted for flake. Some painters use Naples yellow in place of white on occasion.

Zinc Yellow Zinc yellow is opaque. Although listed as a permanent pigment, it often darkens rapidly and should be avoided.

Hansa Yellow A light-fast, semiopaque azo dye, Hansa yellow should be used carefully, for it may bleed—that is, show through the top coats. Rembrandt Company calls it Talens yellow. Hansa yellow is a cool, lemonlike color that cannot be mixed from other pigments.

Ochre Indispensable ochre is opaque and comes in many shades.

Aureolin or Cobalt Yellow All experts call cobalt yellow transparent, but Winsor & Newton's version is close to opaque. It is a beautiful, mustardlike color, very expensive, and with low tinting power.

Indian Yellow Transparent Indian yellow was made originally from the urine of cows force-fed on mango leaves. Today, Indian yellow is derived from coal tar (Winsor & Newton). It has a dark, almost iodine tone.

Mars Yellow Mars yellow is opaque and has a golden, yellow-ochre-orange tonality, produced in different shades by each company.

Aurora Aurora is another name for cadmium.

Barium and Strontium Semiopaque barium and strontium are very pale yellow-greens that may turn greener.

Green-Gold A transparent azo dye, green-gold is light-fast, but may bleed.

Golden Ochre Transparent golden ochre is a nice, permanent shade—if it is not made with chrome yellow. Be sure to read the label.

Chrome Yellow Opaque chrome yellow, as well as chrome orange and chrome red, turns dark and is poisonous, so it should be avoided. Do not confuse chrome with chromium oxide, a permanent green pigment.

Orange **Cadmium** More than any other color, opaque cadmium orange varies in shade from company to company. Buy tubes from several different manufacturers.

Red **Cadmium-Barium** Pure cadmium is too expensive. Opaque cadmium-barium shades range from light orange-red to dark red-purple. This color is indispensable to the basic palette.

Alizarin Transparent alizarin has replaced madder lakes, which were not permanent pigments.

Mars Red A dense, opaque brick red, Mars red seems to dry clearer than Venetian red, and without spots.

Indian Red Indian red is an opaque Mars color (iron oxide), but darker and more red-violet than others.

Venetian Red Opaque Venetian red tends to dry unevenly.

Quinacridone Red Transparent quinacridone red offers a different light quality from alizarin. Some companies use their own names on this pigment: Winsor red, Bocour red, and so forth. Check the label.

Selenium Selenium is another name for cadmium.

Rose Madder Transparent rose madder is a weaker alizarin, but permanent. The choice is a matter of taste.

Rose Doré Winsor & Newton's rose doré is even weaker than rose madder.

Alizarin Violet Alizarin violet is transparent and permanent.

Golden Alizarin Grumbacher's golden alizarin, transparent and permanent, is made from alizarin mixed with burnt umber.

Pozzuoli Red An opaque earth color, Pozzuoli red is permanent. Check the label for its composition.

Vermilion Opaque vermilion works well in egg tempera, but in oil its use is questionable, some samples having turned dark rapidly. It is also expensive.

Magenta Magenta fades, and should be avoided.

Madder Lake Madder lake is now made from alizarin. Check the label.

Harrison Red Avoid Harrison red, for it is not light-proof.

Mauve A lake pigment that fades, mauve should be avoided.

Burnt Umber Semiopaque burnt umber is fast drying and useful. *Brown*

Raw Umber Raw umber is semiopaque and has a greenish tint. It is fast drying and useful.

Raw Sienna Opaque raw sienna offers a darker ochre tone.

Burnt Sienna Transparent burnt sienna gives a brilliant, dark orange-brown. This basic color is fast drying.

Mars Brown Opaque Mars brown, a chocolate color available in a great variety of shades from company to company, is useful but hard to mix. Bocour's shade is unique.

Vandyke Brown Vandyke brown cracks, and should be avoided.

Sepia Transparent sepia is used in watercolor only.

Ultramarine Some companies make semiopaque ultramarine in light and dark *Blue* shades. The lighter is preferable, since oil tends to darken deep blues. Blockx makes a very strong ultramarine light.

Cobalt Opaque cobalt is the spectrum blue. Beware of imitations—that is, mixtures of ultramarine and white. Read the label; it should say "genuine oxides of cobalt and aluminum" if it is true cobalt.

Cerulean Cerulean is an opaque, bright green-blue. Again, read the label; it most often says cerulean *hue. Hue* in this case means imitation. The original is made from oxides of tin and cobalt. Winsor & Newton and Blockx ceruleans have strong shades.

Manganese Manganese is a transparent green-blue. Bocour produces a rich shade.

Phthalocyanine Also called monastral, phthalocyanine is transparent and has very strong tinting power with white. Companies use their own names to denote this pigment—Winsor Blue, and so on.

Prussian Semitransparent Prussian is a beautiful dark shade. It was called Berlin Blue in Paris and Paris Blue in Berlin, because it is risky to work with. Prussian cracked a great deal when Cézanne used it, but in Soutine's paintings it seems to hold up. In general, it is best avoided. Although Prussian works well in watercolor, it may

be that recent samples are made with phthalocyanine blue, a color intended to substitute for Prussian.

Indigo Transparent indigo may be adequate in watercolor, but, on the whole, its worth is questionable.

Turquoise A transparent blue-green with low tinting power, turquoise is hard to find, except in dry pigment.

Academy Academy is a mixture of ultramarine and viridian.

Green **Viridian** Viridian is semitransparent and slow drying. Read the label to make sure it is hydrous chromic oxide.

Chromium Oxide Opaque chromium oxide is the same pigment used for viridian, but treated to become opaque. It is fast drying and produced in many shades.

Terre Verte or Green Earth Transparent terre verte is produced in many shades and is permanent.

Cobalt Opaque cobalt has a granular surface, very little tinting power, and is hard to grind. It is a beautiful color, but expensive.

Phthalocyanine (Monastral) Transparent phthalocyanine has strong tinting power. Companies use their own names—Bocour Green, and so on.

Emerald Green Opaque emerald green is poisonous, although some companies still produce it, because it is an unusual color. Emerald green also destroys all other colors, except for titanium white. Read the label carefully. It may be, like Winsor & Newton's, a mixture of phthalocyanine and a dye, in which case it is permanent.

Permanent Bright Green Grumbacher's opaque permanent bright green is a mixture containing phthalocyanine designed to approximate the emerald shade.

Cadmium Green and Permanent Green There are no pigments called cadmium green and permanent green. The opaque grass green shades are actually mixtures. Read the label to make sure the color is made with cadmium and viridian, not chrome yellow. If cadmium, it is permanent.

Hooker's Semitransparent A Prussian blue and gamboge mixture, Hooker's should be avoided, because it is impermanent.

Cinnabar Semiopaque A chrome-yellow and Prussian mixture, cinnabar is also an impermanent pigment.

Violet **Cobalt Violet** Opaque cobalt comes in light and dark. Check the label; the color should be made with cobalt phosphate. Most books list this pigment as made with arsenite, which is poisonous, although manufacturers assure that it is now made with cobalt phosphate. Also beware of mixtures made from dyes that fade rapidly. Cobalt is fast drying and expensive.

Manganese Opaque manganese is duller, denser, and darker than cobalt, but still a useful color.

Mars Violet Opaque Mars is a permanent reddish violet related to Indian red. There are differences in shade from company to company.

Thioviolet Made by Grumbacher, thioviolet is a transparent, dark, rich, red-blue in an alizarin base.

Quinacridone Permanent quinacridone offers a softer shade of thioviolet, which is permanent. Usually it is sold under the name of the manufacturer.

Mars Black Mars is opaque, has a warm tonality, is fast drying, and dries evenly compared to ivory.

Black

Ivory Semiopaque ivory has a cooler tone than Mars. It is very slow drying and tends to dry unevenly in shiny and mat spots. Although it is permanent, it probably should be avoided. To obtain a colder black tone, mix phthalocyanine blue with Mars.

Lamp Semiopaque lamp, like ivory, is a carbon pigment. It dries very slowly and is best avoided.

The so-called "gold" and "silver" powders are actually bronze powders that discolor unless coated with wax and should be avoided. Aluminum paint used for industrial purposes, however, does not tarnish. Genuine gold and silver come in thin sheets, produced in books about $3\frac{1}{2}$ inches square, with tissue paper between the leaves. The sheets will adhere to panel or canvas.

Metallic Colors

To Use with Oil Paint Buy a can of oil-gold size—a thick, sticky mixture. Coat the area to be gold-covered with this size. Open the book of sheets, and place the leaf directly on a prewet area. Do not handle the sheet with your fingers; just apply it directly from the open book. Keep the painting horizontal during application. After about 24 hours, when the gold size dries, you can paint over it with oil paint.

To Use with Waterbase Acrylic Proceed according to the method for oil, but affix the sheet into a wet acrylic medium.

The highly burnished gold-leaf paintings in combination with egg tempera produced during the early Renaissance involve a complicated procedure. Briefly, these paintings all were executed on wood panels with glue sizing and gesso grounds. The sections to receive the gold were built up with a mixture of *bole* (a clay in water and paste) and glue size. The proportions varied, but 1 part bole to 3 parts glue size probably was the common formula. (Bole is still available commercially in some art supply stores.) After six thin coats had been built up, the bole was burnished with an agate burnisher. Next, the areas to be gilded were wet with a mixture of 50 percent water and 50 percent denatured alcohol. The artist then used a special thin, wide, flat gold-leaf brush to pick up the leaf and apply it to the wet areas. It was burnished when dry. Modern students following this technique sometimes find that cracks appear on the panels. This may be due to storing the pictures in damp or cold places, which should be avoided at all times.

Drying Time of Pigments in Oil

If you paint in layers, you must consider the drying time for each pigment. The easiest way to produce cracks is to place a fast-drying color on top of a slow-drying one, which may seem dry on the surface but is actually soft underneath. This is why burnt sienna, burnt umber, flake white, and cobalt blue, to name the fastest drying colors, have been used in underpainting. Remember, too, that successive layers of paint should have more oil medium. The rule *fat over lean* means that more turpentine (with or without resin) should be used in the beginning stages and more oil on the top layers. You will almost certainly have cracks and dry spots if you use too much turpentine on top, for the turpentine seeps through and loosens the glue action.

It is difficult to measure the drying time of various oil paints, because of the different oils they contain. Some manufacturers use poppyseed oil, which produces a more uniform mix than linseed, in grinding white pigments. It is also used in ultramarine and other colors that are hard to grind, but it is not always registered on the labels. Poppyseed oil is slow drying compared to linseed. Excessive aluminum stearate also slows drying. As a consequence, the results of drying tests vary. The following table takes this variety into account.

Rapid Driers	Average Driers
flake white	raw sienna
raw and burnt umber	Mars colors
burnt sienna	chromium oxide green
cobalt green, blue, and violet	zinc yellow
manganese blue	strontium yellow
Prussian blue	phthalocyanine blue and green
Naples yellow	viridian
aureolin (cobalt)	quinacridone red and violet
Venetian red	ultramarine violet
	Indian yellow

Slower Driers	Slowest Driers
green earth	ivory
cadmiums	lamp
cerulean	Vandyke brown
vermilion	emerald green
ultramarine	
ochre	
titanium	
Hansa	
permanent or cobalt green	
zinc white	
alizarin	

Colorfastness

As new colors are introduced, especially dyes that purport to be colorfast, it is important to know how to test their permanence. On a small piece of primed canvas, brush on the color. In one section, mix it with titanium white. When this sample is thoroughly dry, cut the canvas in half. Place one half in a book and place the other half in strong light. In six weeks compare the two. The colors should be identical.

Identifying Pigments

If somebody gives you unlabeled white or yellow pigment, you must identify it, because some of these pigments are poisonous. Does it contain lead or zinc? Put some of the dry pigment on a spoon, and gently heat it over a candle. Lead will turn yellow and stay yellow, whereas zinc will turn from white to yellow and back to white. Needless to say, discard the lead. To distinguish between cadmium yellow and chrome yellow, again test over a candle. Cadmium turns red then returns to yellow; chrome turns red, then turns into a dirty yellow.

If you have dry pigments that you suspect may bleed in oil (show through top coats), put a little in a small jar of turpentine. When the turpentine has settled, the powder should not have stained the turpentine.

Grinding Pigments

Why should you grind your pigments when good-quality paints are manufactured by reliable companies? First, with hand-ground colors, your color is much stronger. A hand-ground cadmium orange, for example, is so much more intense that it seems to belong to another color-light range. Second, for those who use a heavy impasto, hand-ground pigments are less expensive. You will save about 50 percent over the cost of the best manufactured paints. A whole set of colors—twelve to sixteen different pigments—can be done by two people in a day, depending on knowledge and skill.

You will need the following equipment for grinding:

- dry pigments (Fezandie & Sperrle, Bocour)
- a large muller, 3 to 5 inches in diameter (Fezandie)
- empty tubes (Fezandie and Bocour)
- a heavy plate glass
- a small amount of medium-weight carborundum (as used in grinding lithographic stones or plates)
- the best refined linseed oil
- beeswax paste (p. 127)
- spatulas
- turpentine
- a generous supply of rags and paper towels
- canvas pliers

To begin, put a thick pad of newspaper or cloth under your plate glass to absorb the pressure of the grinding. (Figure 185 illustrates the entire process.) Then, grind the carborundum with a little water, in a circular motion, between the muller and the plate glass until the whole surface is charged. This will ensure an even tooth to the

185. Hand-grinding your own colors is not difficult, but requires organization of materials.

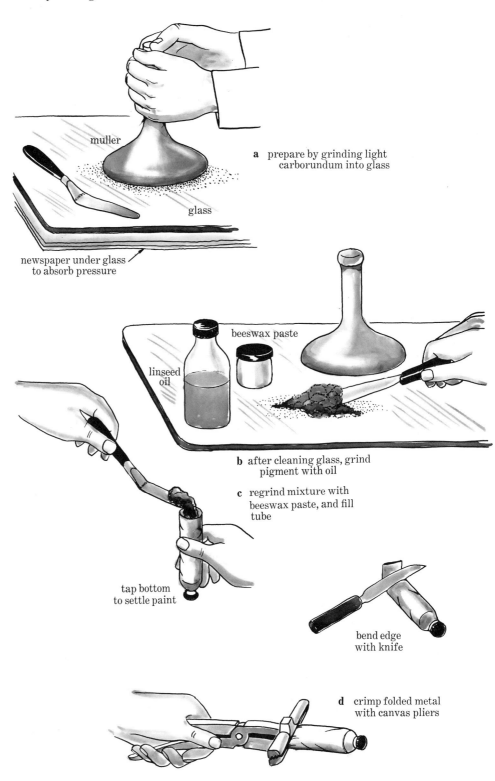

muller

a prepare by grinding light carborundum into glass

glass

newspaper under glass to absorb pressure

linseed oil

beeswax paste

b after cleaning glass, grind pigment with oil

c regrind mixture with beeswax paste, and fill tube

tap bottom to settle paint

bend edge with knife

d crimp folded metal with canvas pliers

grinding surfaces. Next, clean off the carborundum thoroughly with water, and dry. Take a little pigment and oil, and mix them together with a spatula. Do not spill the oil on top of the pigment. Grind small amounts with the muller, again using a circular motion. Continue this process until the mixture is smooth.

When you have enough for a tube, add 2 percent beeswax paste, and regrind. Now you can fill the tube with a spatula. Keep tapping the tube to settle the paint. When you are near the top, lay the tube on its side, crease it, and fold the edge with a palette knife or spatula. Then, crimp the edge with canvas pliers. Before starting another color, clean the muller and the glass well with turpentine or paint thinner. The grinding procedure is not difficult, nor does it take excessive strength. But you must be organized and have the materials in place (Pl. 5, p.169).

How much oil to use in the grinding depends upon the pigment. Each one requires a different proportion of oil. If this proportion is not *approximated,* the result is a soupy, thin liquid containing too much oil—a useless mixture.

Below is a list of a dozen colors that grind well and the necessary proportion of oil. Omitted are the pigments that are difficult to grind: cobalt green (too gritty); ultramarine (too stringy); and viridian (will not mix thoroughly with oil). Also excluded are the poisonous pigments, flake and Naples. When grinding the following pigments, you must wear a respirator: titanium white, all cadmiums, all cobalts, cerulean, manganese, chromium oxide green, viridian, raw and burnt umber, Mars brown.

Pigment	Spoonfuls	
	pigment	oil
titanium white	2	1
cadmium-barium red (light, medium, dark)	3	1
cadmium-barium yellow (light, medium, dark)	3	1
cadmium-barium orange	3	1
Indian red	2½	1
alizarin	2½	1
Mars yellow	1¼	1
yellow ochre	3½	1
burnt sienna	1¼	1
Venetian red	2	1
Mars brown	3	1
raw umber	1¾	1
cerulean blue	3	1
Mars black	4	1

The right proportion of pigment to medium is necessary only for oil paint. As noted (p. 102), acrylic paint can be produced on the palette with a painting knife, dry pigment, and the medium. The pigment does not have to be ground, because acrylic medium acts as a strong binder. If, however, you want a smooth coat, without a fine granular surface, grind with a muller. You do not have to worry about fast- and slow-drying pigments, as you do with oil paints. The acrylic medium dries the mixture in a few hours. Do not grind watercolors. The binder, gum arabic, is difficult to control when these colors are ground.

Color Theory and Painting

Chapter Six

Every pigment has an individual level of opacity, ranging from opaque to transparent. These natural characteristics contribute to the behavior of the pigment, for when ground into different vehicles, pigments give off different light energy, depending upon their natural opacity. Equally important in controlling this energy, are the quality of the brushstrokes and the particular medium's degree of gloss. For example, the shinier the surface, the darker the color appears. Medium and texture, in other words, alter a color's light effect.

The best way for the beginning painter to test how medium and texture change the value of a pigment is to conduct the following experiment. Take a masonite panel about 20 by 24 inches; prime it carefully (at least three smooth coats, followed by sanding) with either the traditional gesso formula (p. 75) or acrylic gesso. Employing only one color manufactured by one company, design a composition of flat shapes. Apply a different oil medium to each shape, choosing from the various recipes given on pages 125 to 132. Make sure you use linseed oil, stand oil, sun-thickened linseed, and resins—dammar, Elvacite, and wax. Also, vary the textures within each medium by working with different kinds of brushstrokes; vary, too, the density of the application and the degree of smoothness. A painting knife can be used in one or two sections.

186. All the textures in this study were made with the same color.

The exercise reveals that just by changing the medium and surface texture you can transform one color into many (Fig. 186). The broad variety of hues thus created should make it clear that any general color theory, or any of the numerous "rules" that painters encounter, must take into account the surface quality and the medium. These conditions provide a frame of reference that is essential if the artist is to turn theory into practice.

The Interaction of Color: Josef Albers

Nothing could better illuminate the exciting wealth of possibilities in color dynamics than the work of Josef Albers. "A knowing colorist," he wrote, "can make equal colors look different and different colors alike." The colorist "not only recognizes that color is deceiving us all the time, but uses color as an acting agent, changing its identity in many ways." Albers called these phenomena the "interaction of color" and even published a comprehensive study of the same name.*

In his famous series of paintings, *Homage to the Square* (Pl. 6, p. 170), Albers went beyond our simple experiment with media and textures, demonstrating that color is affected by other colors and, consequently, by aspects of placement, size, and the

The Interaction of Color, Yale University Press, New Haven, 1963.

character of boundaries. Whether the boundaries are firm or loose, for instance, changes the appearance of a color. Locating a color above, below, to the left, or to the right of another also will transform it. Adjacent colors interact in definite ways: a stronger color pushes the neighboring color toward its opposite, or complementary, hue; a light color makes a neighboring color look darker, and the reverse. If one color area is larger than an adjacent one, it will influence the neighboring color in the same way as does pronunciation of shape.

For Albers, these ideas constituted not simply a theory, but a working thesis that he practiced from day to day in his long painting career. Albers' paintings reveal far more than mere information about color relationships. Indeed, critics have compared them to icons in their light-giving quality. Unlike paintings where light is created by the contrast between light and dark, Albers' *color* is the real "light source." Many critics considered Albers to be a geometric painter, but his interest in geometry always took second place to his fascination with color interaction. Geometric subdivisions in the *Homage to the Square* series remain constant, yet color seems to alter the size and relative distance of the squares. When viewed in sequence, the identical squares appear either to shrink or to expand and, on occasion, even to blend with the adjacent squares. In short, color is that "acting agent" which forces shapes as well as other colors to lose their identify.

The painter can learn much from a step-by-step explanation of Albers' experiments with various supports, grounds, and colors. While it is not necessary to emulate his procedure, the account discloses how a deeply concerned artist labored to capture the most subtle and fugitive properties of color. To achieve this goal, Albers did not start with preconceived ideas. Instead, he utilized his painting experience to develop a working theory.

Albers came to prefer masonite—untempered, $\frac{1}{8}$ inch thick—over canvas because masonite had "wall character." Canvas, on the other hand, had little resistance, and canvas stretchers, being available only in full-inch dimensions, limited proportion. In addition, he chose the rough, mechanically textured side of the masonite. When combined with transparent oil color scraped on with a painting knife, the surface became highly sensuous, although Albers claimed that this tactility was only a by-product, and not a conscious effort on his part.

The desire to render colors as brilliant as possible led Albers to experiment constantly with grounds. A semiabsorbent white casein ground initially attracted him, since it kept the pigment, rather than the oil, on top of the surface. But this ground dulled the deep earth colors so much that Albers had to apply varnish in order to judge color relationships. He also found it impossible to repair simple scratches—to match the tone created by the gradual sinking in of the colors. Albers then tried alkyd (resin) enamel, a nonabsorbent ground. (This was a type used for housepainting, not the new Winsor & Newton product.) Alkyd enamel presented opposing problems: it was so resistant that it greatly prolonged drying time; and colors that took a lot of oil in grinding, such as ivory black, produced a very slick surface. Albers countered the excess oil by adding to the black pure calcium carbonate (whiting), which does not affect color. He even dried out the oiliest of colors on a blotter before use. Ultimately, Albers settled on acrylic emulsion gesso (Liquitex), which he felt to be the ground that yielded color with full brilliance. A pure white ground, first of all, displayed every color to its greatest intensity. Secondly, as the oil film became thinner with aging, it reflected the white undercoat, thereby adding to the luminosity.

Albers avoided mixing colors whenever possible, believing that the process reduced color or light intensity, and often both. Only in mixing blues and pinks did he

add white to his colors. To give himself a real choice of color, Albers had to acquire a large collection of tube paints. Since similarly named colors differ from manufacturer to manufacturer, he was able to collect, for example, up to six different shades of cadmium yellow medium. With this rich and subtle range of color at hand, Albers proceeded to apply the paint in one primary coat with a palette knife. Needless to say, he rejected all painting media, for he observed that additional oil modified the color value—something you have already seen in the experiment described at the beginning of this chapter. Albers allowed the texture of the masonite to show through only when transparent or semitransparent pigments made such an effect unavoidable. For this reason he asserted that tactility was only an incidental product of his art.

When his paintings were thoroughly dry, Albers varnished them with a polyvinyl acetate spray similar to Magna varnish or one made up of Elvacite thinned with xylene. The final varnish, he felt, was a necessary protection for an oil film.

Albers also pondered the relationship between color and the external source of light, a problem that every painter faces. He began with the old rule that landscape paintings begun outdoors should be finished indoors, because it is there that they will be shown. While not in any way binding for the individual painter, the precept does acknowledge the difference between outdoor light and indoor light, and its consequent influence on color. Indoor light changes a great deal throughout the day. Generally warmer than outdoor light, indoor light becomes relatively cooler toward evening, since outdoor light turns warmer late in the day. Albers noted that as a result of these shifts the reds in a painting dominate during the daytime, while in twilight the blues become more active. Still more modifications occur later in the evening with artificial light. Today, the artist must remember that far more people now view paintings in artificial light than in natural illumination, particularly because an increasingly large number of galleries and museums prefer cold and warm artificial light to constantly changing natural light.

In the end, Albers decided that his goals were best accomplished under artificial light. He chose a fluorescent source for its combination of warm and cool, just as in good galleries. Occasionally, he did switch to the warm incandescent light when he wanted to compare warm colors. Albers thus saw no reason to depend upon daylight, which continually changes in both its light and its color intensities. "The very famous north light for ateliers," he concluded, "though it provides reflected light and protection from direct sunlight, seems not only superfluous, but unnatural and more artificial than all truly artificial light."

For the sake of consistency and expedience, Albers taught his course, "Interaction of Color," without using paint. Instead, the students arranged silkscreened sheets of colored paper, known as Color-Aid and sold in sets at art supply stores, in a variety of compositions. These exercises in cut paper, born of Albers' vision as a painter, were exciting to observe. Making hard edges seem to melt, cool tones advance and warm ones recede (contrary to what was previously taught), turning opaque into transparent—all these optical effects and more created a stimulating visual tonic. Students with previous painting experience, as well as those taking painting courses simultaneously with the color course, thus could apply the results of the exercises to their own work.

Some of the students who had to translate such conceptual information into painting at a later date initially found it very difficult. Gone were the premixed, flat, and even tones of the silkscreened Color-Aid sheets; instead, they confronted colors with strange new names and, worst of all, pigments that varied in opacity. Even these problems could not diminish the value of the course. Students emerged with a profound understanding of the remarkable dynamics of color.

187. Adolph von Menzel.
Wall of the Studio. 1872.
Oil on canvas.
Kunsthalle, Hamburg.

Color as Light:
Gauguin and Van Gogh

The somewhat didactic nature of Albers' *Interaction of Color* makes it a fundamental
study for beginning painters. Albers himself acquired his passionate interest in color
from earlier artists. As a student, he was exposed to the color theories of the late-
19th-century Munich School, where the painters began with a Venetian red ground
and, following Rembrandt, made all the shadows warm and the lights cool (Fig. 187).

This interaction of complementary color values characterizes the work of other artists who influenced Albers and who continue to influence painters of widely divergent aesthetic postures. Among the most important are Gauguin and Van Gogh. Gauguin produced his original and, at times, exotic orchestrations in the service of an aesthetic that released color from its descriptive function. By applying color in broad, flat areas, he rejected its traditionally crucial role in the articulation of plastic forms (Pl. 7, p. 211). Gauguin's individual approach to color led him, rather unjustly, to criticize Van Gogh for being a one-note colorist who created only a single color sensation—the vibration of complementary colors. In truth, Van Gogh's color extended beyond the complementaries to the use of subtle, close-keyed harmonies (Pl. 8, p. 212).

Whatever the differences between them, both Van Gogh and Gauguin treated color in a manner entirely new in Western art. They revealed for the first time that light could be produced by *color areas* rather than by the mere contrast of light and dark. The pink sand in Gauguin's *Riders on the Beach* (Pl. 7, p. 211) illuminates the shallow picture space, all the while that it emits a light that advances towards the viewer. Color-created light also radiates from Van Gogh's *Portrait of a Peasant* (Pl. 8, p. 212), where the yellow hat, no less than the bright blue background, gives off energetic vibrations. (This is just the kind of complementary combination that Gauguin found too obvious.) Van Gogh also designed dissonant color relationships, as in *View at Arles with Blooming Trees* (Pl. 9, p. 213). The tree, a clashing note of cobalt violet, startles the large color field of heavy green. This painting underscores a concept shared by Van Gogh and Gauguin: that light can be produced by a flat zone of color, and that this color becomes the light source.

Matisse

For Henri Matisse, one of the great colorists of the 20th century, color again served as the primary source of light. In his 1911 work, *The Red Studio* (Pl. 10, p. 214), although objects and line do establish a light-dark contrast against the ground, the Venetian red surface that covers the picture plane actually creates most of the light.

Matisse employed other color ideas in his long career, each of which has a foundation in pictures painted between 1899 and 1911, his early period.

In *L'Algérienne* of 1909 (Pl. 11, p. 215) Matisse packed opposing aggressive colors and patterns together to bring about a series of explosions. These opposing energies cooperate in a dangerously balanced unity, for Matisse believed that colors should evolve into a "living harmony of tones"—a concordance in which, like a musical composition, "both harmonies and dissonances of color are agreeable." Nine years before *L'Algérienne,* Matisse struggled with complementary color accents placed on top of heavily painted slabs filled with broken color, rather than continuous or modulated hues (Pl. 12, p. 216). By means of this system, Matisse used the color logic of Gauguin and Van Gogh, as well as Cézanne, to build his own color vocabulary. Early in his professional career, Matisse had explored Seurat's *pointillist* technique. He broke up the surface into dots and spots of color that interact to create a third, optical color. But in *Buffet and Table* (Fig. 188), Matisse did not imitate Seurat's touch. Rather, he painted in a broader, looser way, with longer and more irregular patches.

Optical Mixture: Seurat

Seurat himself is often misunderstood by young painters, because his dot technique is too easy to classify, and the catchwords *Pointillism* or *Divisionism* replace careful

188. Henri Matisse. *Buffet and Table.* 1899.
Oil on canvas, 26⅜ × 32⅛″ (68 × 83 cm).
Dumbarton Oaks Collection, Washington, D.C.

looking. In fact, as Matisse well understood, Seurat treated colors as optical mixtures—an additive principle whereby, in visual terms, one color blends with a second to produce a third. The process is easily illustrated by *Gravelines* (Pl. 13, p. 217). Here, when viewed at a distance, the blue and red dashes form a third color, violet. This small painting also invites close inspection for the magnificent handling of paint. Note how the red and blue strokes are being melted by the large white ones that receive them in a wet-on-wet technique.

Seurat used the principle that color 1 plus color 2 equals a new color (3) only when his theme demanded it. He began with small, directly brushed sketches from nature that served as studies for his large, ambitious paintings. In these one-session studies Seurat did not always incorporate the optical mixture formula, since his main goal was to gather visual information for the final work. Even so, Seurat could become

committed to making a complete statement. In *Lisière de Bois au Printemps* (Pl. 14, p. 217), he dragged, scraped, and pressed into the surface a warm-cool color relationship without the dot technique, but with great textural variety and a combination of relatively dry and wet paint. Clearly, the demands of the particular motif engendered Seurat's textural and color choices, in this case, warm against cool, yellow against blue—but with great modulation. In the bottom blue area, greens and blues intermingle, while in the single vertical tree on the right, the blue moves toward violet. The white-blue sky also has touches of cobalt violet.

So successful was Seurat's reconciliation of method and pictorial invention that we are not necessarily aware of the famous pointillist technique. In *Une Baignade, Asnières* (Fig. 189), one of his finest compositions, the blinding magic light of this silent monumental painting dominates the viewer's response. Once you see this light from a distance, you must examine the image up close—only to discover that the pointillist optical mixture principle is used gently and sparingly, woven into the form's allover surface. Of course, the effect can be isolated here and there, but it is neither the artist's overriding concern nor the hidden subject of the painting. As in surface handling, Seurat's color vocabulary is dictated by the picture's thematic needs, not by a preconceived technique.

189. Georges Seurat. *Une Baignade, Asnières.* 1883–84. Oil on canvas, 6′7″ × 9′10½″ (2.01 × 3.01 m). National Gallery, London (reproduced by courtesy of the Trustees).

7. Paul Gauguin. *Riders on the Beach.* 1902. Oil on canvas, 25⅝ × 30″ (66 × 76 cm). Folkwang Museum, Essen, West Germany.

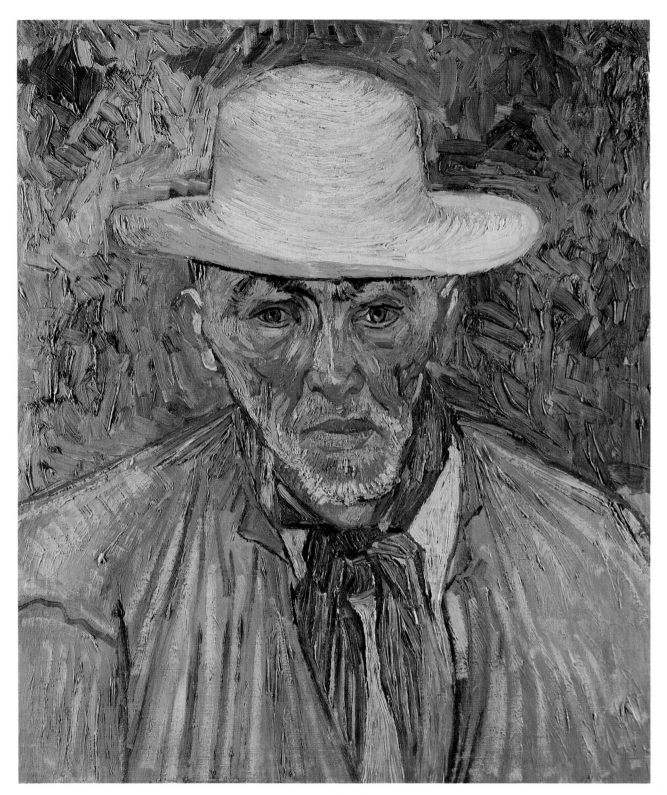

8. Vincent van Gogh. *Portrait of a Peasant, Patience Escalier.* 1888.
Oil on canvas, 25⅜ × 21½″ (65 × 55 cm). Norton Simon Inc. Foundation, Los Angeles.

9. Vincent van Gogh. *View at Arles with Blooming Trees.* 1888.
Oil on canvas, 21 × 26″ (50 × 65 cm). Rijksmuseum Vincent van Gogh, Amsterdam.

10. Henri Matisse. *The Red Studio.* 1911. Oil on canvas, 5'11¼" × 7'2¼" (1.78 × 2.16 m). Museum of Modern Art, New York (Mrs. Simon Guggenheim Fund).

11. Henri Matisse. *L'Algérienne.* 1909. Oil on canvas, 32 × 26″ (81 × 65 cm).
Musée National d'Art Moderne, Paris.

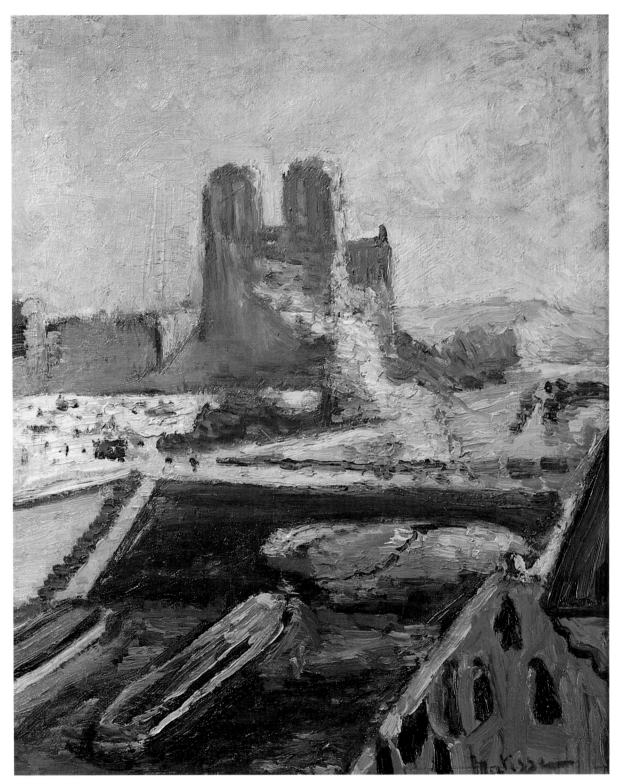

12. Henri Matisse. *Notre Dame.* c. 1900.
Oil on canvas, 18⅛ × 14⅞″ (48 × 37 cm). Tate Gallery, London.

above: 13. Georges Seurat. *Gravelines.* 1890. Oil on wood (cigar box lid), 6¼ × 9¾″ (16 × 24 cm). Courtauld Institute Galleries, University of London.

below: 14. Georges Seurat. *Lisière de Bois au Printemps.* c. 1882. Oil on canvas, 18 × 10¼″ (46 × 26 cm). Jeu de Paume, Paris.

above: 15. Francesco Guardi. *Laguna Grigia.* c. 1780.
Oil on canvas, 9¾ × 15″ (25 × 38 cm). Museo Poldi Pezzoli, Milan.

below: 16. Jean Baptiste Camille Corot. *Le Port de La Rochelle.* c. 1851.
Oil on canvas, 19⅞ × 28″ (50 × 70 cm). Yale University Art Gallery, New Haven, Conn.

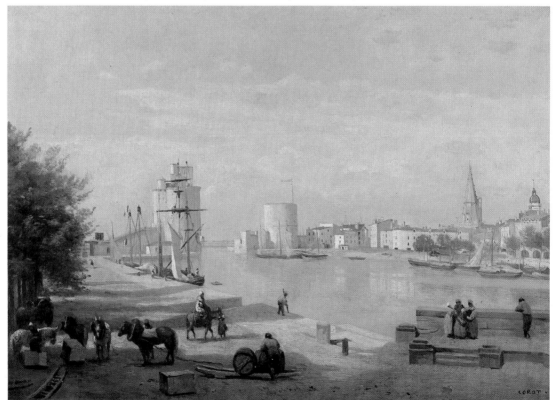

17. Joseph Mallord William Turner. *Sun Setting Over a Lake.* c. 1840. Oil on canvas, 2'11⅞" × 4'4" (.91 × 1.23 m). Tate Gallery, London.

18. Mark Rothko. *Earth Greens.* 1955.
Oil and magna on canvas, 7′6″ × 6′1″ (2.31 × 1.87 m). Courtesy Galerie Beyeler, Basel.

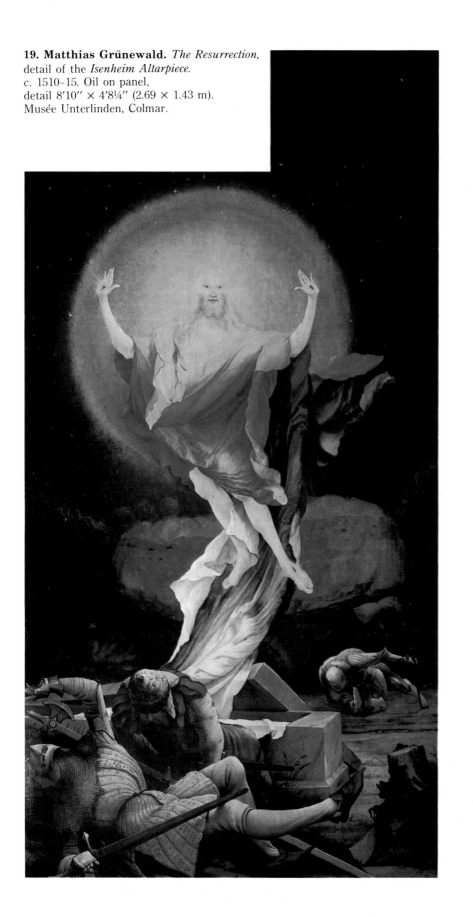

19. Matthias Grünewald. *The Resurrection,*
detail of the *Isenheim Altarpiece.*
c. 1510–15. Oil on panel,
detail 8'10" × 4'8¼" (2.69 × 1.43 m).
Musée Unterlinden, Colmar.

20. Odilon Redon. *Woman with Flowers.* 1903.
Pastel, 26 × 19¾″ (65 × 49 cm). Collection David A. Schulte, New York.

Optical Mixture: Rubens

The Old Masters employed different kinds of optical mixtures. Rubens, for example, relied on a visual blend of superimposed colors, rather than adjacent ones. As part of his characteristic painting style (p. 175), he applied flesh tones over a thinly painted neutral gray ground. These layers of pink, ochre, and white—all components of his roselike flesh tints—force the gray underneath to produce a third tone, an optical blue-violet iridescence, as if the veins were showing through the pink flesh. Unfortunately, the effect is difficult to reproduce, since translucent oil films do not photograph well. You can test the method by placing some strokes of pink pastel on gray paper.

The Limited Palette

Experimenting with a limited palette is another way of learning how to attain a variation that fools the viewer into believing that many colors are present. Whistler was a master at painting within a narrow color range (Fig. 170). Indeed, he could make a grayish-green painting appear color saturated by applying layers of variant tones to different parts of the painting. Likewise, Guardi's *Laguna Grigia* (Pl. 15, p. 218), has its vast space created with little more than one modulated color representing water and sky.

Value and Color

A painter cannot make a distinction between the light effect of a color and the color itself. To put it another way: value and color are one. Corot had two methods of applying paint, each with a different color-light effect. In the first manner, usually reserved for small landscapes and works from models, he used a direct paint approach. As in *The Roman Campagna, with the Claudian Aqueduct* (Fig. 190), he toned down any color without ever letting it appear muddy. When working with this process, Corot

below: 190. Jean Baptiste Camille Corot. *The Roman Campagna, with the Claudian Aqueduct.* c. 1826–28. Oil on canvas, 8½ × 13″ (22 × 33 cm). National Gallery, London (reproduced by courtesy of the Trustees).

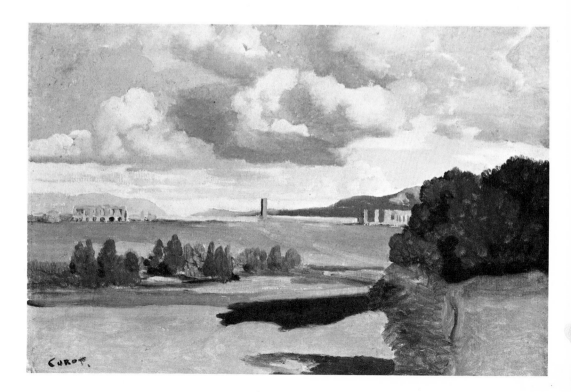

191. Rembrandt. *The Stone Bridge.* c. 1638.
Oil on panel, 11½ × 16½″ (30 × 43 cm).
Rijksmuseum, Amsterdam.

had the remarkable ability to apply, seemingly in one coat, the exact tone in the color-value scale to each of the forms depicted. Even Corot's darkest darks, his murkiest tones, have a definite warm or cool character, so that the deepest shadows, toned-down ochres, and raw siennas still give off light. This is the test that determines whether a tone is "alive," for if you cannot tell whether it is warm or cool, it is not giving off light and is, therefore, a dead area.

In Corot's second method the manner of creating the light and applying the pigment is hard to discern (Pl. 16, p. 218). The whole surface of *Le Port de La Rochelle* emanates an opalescent golden glow, as if separate, thin films of paint interpenetrate. Corot seemed able to paint two layers at the same time. One coat addresses itself to the manipulation of the exact light value of each section, keeping it in perfect balance with all the values on the surface. The second coat addresses itself to the total glow of the surface. This interpenetration of effects parallels the imagery where sky and water reflect each other.

Light and Space

Color in the art of painting includes not only light coming from color (Van Gogh), color vibrations producing light (Seurat), and other phenomena, but it may also include light in space—that is, pigments creating light inside the picture plane. In *The Stone Bridge* (Fig. 191) Rembrandt manipulates the pigment so as to contrast tonal values, transforming pigment into light. This light, deep inside the painting's space, seems to be more than the product of pigment on canvas. Rather, it has an inner glow, as if it were artifically illuminated.

Turner also engineered the effect of internal illumination in *Rockets and Blue Lights* (Fig. 192). At the same time, he entraps us by constantly spinning the large end

192. J. M. W. Turner.
Rockets and Blue Lights. 1840.
Oil on canvas, 3′⅛″ × 4′⅛″ (.92 × 1.22 m).
Sterling and Francine Clark Institute,
Williamstown, Mass.

of a funnel-like arc of light-energy out of the space. Our physical reaction is either to feel pulled into the space or to want to pull back and away. In *Sun Setting Over a Lake* (Pl. 17, p. 219), Turner created another, related kind of sensation, one that inspired the Impressionists—atmospheric pigmentation. Using layers of thick and thin paint films, Turner released a colored, weighted mist into the air. Miraculously, he projected this atmosphere into a controlled space, but one in which circles of light, moving gently in slow motion, tend to pull us into his invention, his concoction of light and air.

Paint and the Canvas

Atmospheric effects can be produced even with thin washes of paint. Rothko used Magna colors diluted with turpentine (Fig. 116; Pl. 18, p. 220). Thinning his paint almost to a stain, he left just enough opacity to cover the simple shapes with a consistent color, a frontal film that radiates like an atmospheric glow. These thin coats of paint create a silent aura of light, an expanding atmosphere. The paint's texture cannot be seen; all we see is the weave of the canvas. In other words, the paint and the canvas are one.

Glazed Light

Glazed light is yet another color effect. The light created by Grünewald's brilliant, deep-glazed surface is too dense to conform to the traditional definition of a glaze—a thin film of transparent paint placed over an opaque, lighter color. Grünewald's enamel-like surfaces emanate a dense color-light unlike any other. This light is so fiery, so deep, that it seems to penetrate the support (Pl. 19, p. 221). In the detail reproduced here, the blinding light engulfing the Christ figure melts his face and transforms it into pure light. Seen at a distance, the glow spreads out to cover the whole surface. Although this painting was finished 460 years ago, the feeling of color-light is so fresh that one feels as if the painter has just recently applied the last brushstroke.

Light from Dry Pigment

Light also can be created by the special brilliance of dry pigment or its compressed equivalent, pastel. The wetness of oil, as noted in Chapter 3, darkens blues and blue-greens and tones down the intensity of high-keyed colors. Similarly, waterbase media tend to flatten all the tones slightly. After accepting the fact that pastel gives us the full brilliance of pigment in its dry state, the real question is what do you do with it? Redon found an answer (Fig. 131, Pl. 20, p. 222). He used unconventional harmonies and dissonances with surprising resonance—blues that exist in no other media, and pink, violet, green, and golden accents that, by employing the medium in an innovative way, open up a whole new color world.

This brief catalogue of color thinking has touched on some of the principles and ideas you will have to understand in order to use the inherited body of possibilities to make choices, in the same way that you select grounds and media or choose to handle the surface. Your vision will find the proper color language to fill its needs.

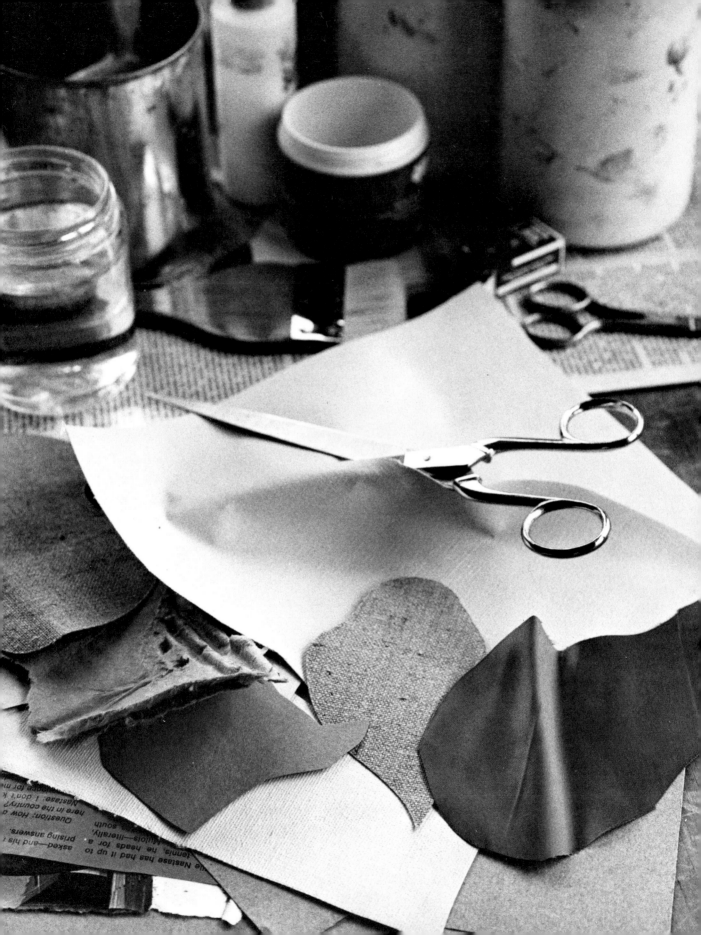

Collage

Collage with Paper

Highly skilled French housepainters, working in oil paints, can paint remarkably convincing marble veining on a wooden facade. It was this training to which Georges Braque was exposed when he served as an apprentice housepainter eighty years ago. Not surprisingly, Braque always retained a sensitivity to the illusionistic play of textures. His textural modes range from the purely physical textures of the sand in oil paintings produced during the 1920s to the imitative textures achieved fifteen years before by cutting and gluing papers with printed designs, sometimes in combination with actual textures. It was in these earlier works that Braque, together with Picasso, invented the collage form itself.

The actual overlapping of pasted papers was Braque's way of creating a spatial construction (Fig. 193). In addition to this, he obtained a vivid textural sensation by playing with different paper surfaces: printed wood texture, gray wrapping paper (in the back plane), various open-weave papers, deckle-edged watercolor paper, a black paper resembling construction paper, and corrugated cardboard, which provides a sculptural contrast to the other papers. Notice how the corrugated cardboard form disappears under its top neighbor (the guitar) and reappears on the other side.

Matisse, the other great 20th-century innovator in collage, used the technique in a new way and for a different purpose. At the very end of his career, when he was in his eighties, Matisse cut colored paper in a process that he described as "carving with

color" (Fig. 194). In the background of the studio photograph, a pair of scissors rests on sheets of paper prepainted with gouache. (Matisse worked in Linel gouache—a French product that used his name, by permission, in advertising during the late 1940s.) From his sickbed or in a wheelchair, Matisse directed the placement of his cut-out shapes.

L'Escargot (Fig. 195), a huge picture more than 9 feet high, is one of the products of Matisse' version of the collage technique. This work, unlike Braque's, has no interaction of various paper textures. The brushstrokes that applied the gouache hardly show. Instead, shapes that barely overlap create a movement of color—forms that pivot, swing around a central viridian shape, and then come to a perfect equilibrium. Comparing *L'Escargot* to Braque's collage is an excellent demonstration of how the artist's personal vision transforms a technique or material.

193. Georges Braque. *Musical Forms* (or *Guitar and Clarinet*). 1918.
Pasted paper, corrugated cardboard, charcoal,
and gouache on cardboard; 30⅜ × 37⅜″ (77 × 95 cm).
Philadelphia Museum of Art (Louise and Walter Arensberg Collection).

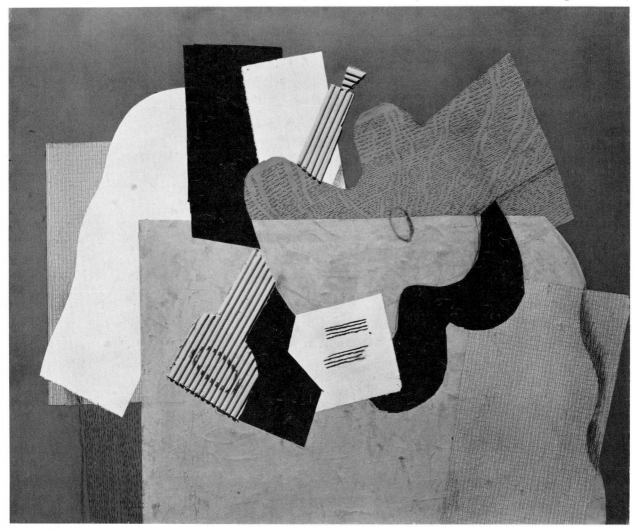

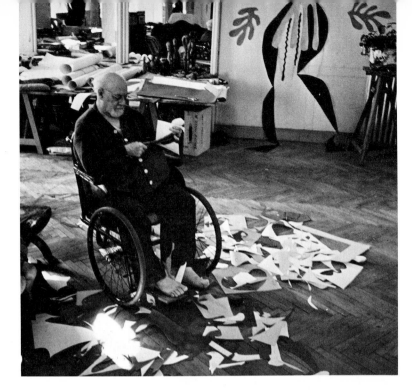

left: 194. Henri Matisse cutting papers in his studio in Nice, 1953.

below: 195. Henri Matisse. *L'Escargot.* 1953. Cut paper coated with gouache, 9'4¾" × 9'5" (2.86 × 2.87 m). Tate Gallery, London.

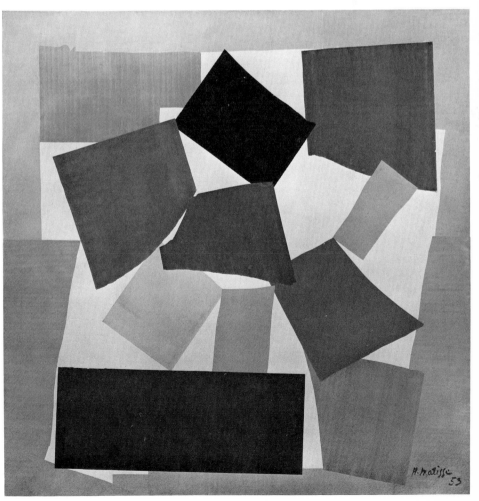

The early paper collages of Braque and Picasso are still in good condition, for the artists knew their materials. By contrast, collages of the Dadaists—for whom permanency was irrelevant—have either completely disintegrated or have acquired an allover patina. Today, an artist working with paper collage still can find little information that will aid in the selection of permanent materials. Hence, you must investigate the composition of each paper, its manufacturing process, and the cause of its deterioration. Prepared colored paper also should be tested or, better yet, made in the studio. Having found your papers, you must then find a glue that will not damage them in any way.

Paper The rag content of a paper, as noted in the discussion of drawing (p. 53), is an important factor in its permanence. Newspapers made a hundred years ago on rag paper seem to be in perfect condition compared to those printed just ten years ago on mechanical wood paper, which have acquired a pale burnt sienna stain. The causes of deterioration in the wood paper include chemical residues from manufacturing, certain fungi which cause foxing (brown spots), the addition of mineral matter, and, the greatest menace of all, over-acidity, often the result of the faulty removal of residue during the bleaching process.

Rag paper, made from cotton and flax, contains the greatest percentage of pure cellulose—one key to permanency. Papermaking materials, in order of their cellulose proportion, are cotton, flax, mulberry, hemp, esparto, straw, and mechanical wood. Yet more than the initial choice of the fibers themselves, manufacturing processes will ultimately determine a paper's permanence. Even mechanical wood, if properly processed, can produce a durable paper. Whatever the material, the procedure involves reducing it to a fibrous state, bleaching, beating to a pulp with water, and, lastly, converting the pulp into paper.

What are the relative merits of handmade paper as opposed to the machine-made variety? The manufacturing procedures are the same, except that handmade paper is produced sheet by sheet instead of on a continuous web of woven wire. But handmade paper has two advantages: it is less likely to have harmful additives, and it is constructed with equal stress in both the horizontal and vertical directions. To distinguish handmade from machine-made paper, tear the paper rapidly from all sides. If it resists more on one side than the other, it is machine-made. In addition, machine-made paper will spread primarily in one direction if wet and pressed between blotting papers. When you purchase paper, therefore, look for the following six specifications, which should be printed on the cover of block paper or available from your art supply dealer.

1. handmade
2. 100 percent rag—new linen, cotton, flax, or hemp—undyed and unbleached
3. no added filler or color
4. free from starch, resin, or any mineral matter
5. sized with animal gelatin
6. relatively acid-free

If these criteria seem extremely rigid, remember that a collage is only as permanent as its most perishable paper. And any weaknesses in paper are often communicable to other papers.

Coloring The coloring of the paper should be discussed next. If you test the light-fastness of commercially prepared silkscreened papers, such as Color-Aid (p. 206), you

will find that most of the colors do not fade except the brightest ones, which do show definite signs of fading after only two weeks. To make your own tests, cut a 3- or 4-inch square of the paper to be examined. Place a 1-inch square of heavy black paper in the center to protect this area from light. Expose the paper to direct sunlight for two weeks, and then compare the exposed and protected areas.

The safest and most satisfying solution is to follow Matisse' example and prepare your own paper. Matisse used gouache, but this has a tendency to become brittle with age. Acrylic emulsion colors—unavailable to Matisse—have a strong and flexible glue action. They become one with the paper and, consequently, are not as likely to chip or wrinkle as much as gouache. To avoid wrinkles during the drying process, tape the paper (with a tan paper tape) to a board, a wall, or even to the floor. Simply cut inside the tape's edge when the paper has dried completely.

Oil paint is very difficult to use on paper unless you are willing to size both sides of the paper with a thin rabbitskin glue or gelatin (p. 74) in order to keep the oil from staining and damaging the paper. Turpentine, too, contains acids that will cause paper to be damaged.

Glue Emulsified polyvinyl acetate (p. 116) is a possible choice for the glue, if you thin it 50 percent with water. Watch for wrinkling, since p.v.a. glue is strong.

Acrylic emulsion gels, such as Aquatex gel, seem to work best with paper, as well as with canvas. Be sure to press out the wrinkles and remove the excess gel from the edges. Acrylic emulsion medium could also be used, but it is not so easy to manage because of its thinner body and the need to wet the paper before applying. An overcoat of the medium in either the mat or shiny variety can be used to protect papers that by their very nature will disintegrate. Such a process, however, will not keep a wood pulp paper from cracking and becoming very brittle, nor protect it from changing color.

David Davis sells a cellulose, plastic-base powdered glue, soluble in water, called Low pH Glue. This glue will not wrinkle thin tissues, but you must experiment with the amount of glue needed by thinning it. Thin the glue until no wrinkles appear when the paper is dry.

Avoid rubber cement, which yellows badly, as well as all household glues, which are not permanent. So-called "library paste" has too high an acid content for collage. Finally, make sure the collage does not touch glass. There must be air space between glass and all works on paper, for contact initiates a chemical reaction that ultimately destroys the paper.

Collage with Canvas

Conrad Marca-Relli, an artist who began to produce masterful canvas collages in 1952, felt that collage, like all media, could easily be abused. If you focus on the technique before you see the interaction of shape, line, color, and so forth, then the medium remains solely a method. In short, the materials must be transformed by the artist's pictorial vision.

Marca-Relli's initial use of collage was a logical development from his earlier white-on-white paintings, which also contained large flat shapes. The step from painting to collage, then, did not force a radical change in his formal language. Marca-Relli took up collage in order to expand his vocabulary of interlocking and overlapping shapes. In addition, he produced lines with the edges of the shapes by coating the back of each cut-out with a dark color that stained the edges. These edges

created a network of alternately continuous and broken lines that defined the forms and stressed the tensions of the overlaps (Fig. 196).

Despite Marca-Relli's emphasis on line and interlocking shapes, some critics have related his work to texture study. Perhaps because Braque's collages represent a wide variety of textural surfaces, all collage is automatically linked to texture. A good example of collage as a textural study is Anne Ryan's *Oval* (Fig. 197). On a ground of handmade paper, she compactly overlaps pieces of various fabrics to create a harmonious relationship of woven fabrics.

Marca-Relli's concern, however, was with color as well as with texture, texture being a by-product of the pasting technique, the working method. In his first collages, he used primed and unprimed white canvas, the interaction of which created a play of transparency and opacity. Marca-Relli gradually added natural-color tan linens to the collages. When he felt the need to widen his color range, he began to paint in combination with collage—large broad areas of reds, blues, and mustard yellows.

below: 196. Conrad Marca-Relli. *The Battle.* 1956. Collage with oilcloth, toned canvas, enamel and oil paint on canvas; 5′10½″ × 10′10½″ (1.79 × 3.31 m). Metropolitan Museum of Art, New York (Arthur H. Hearn Fund, 1956).

opposite: 197. Anne Ryan. *Oval.* Collage on paper, 6¾ × 5⅛″ (16 × 12 cm). Collection Mr. and Mrs. John de Menil, Houston.

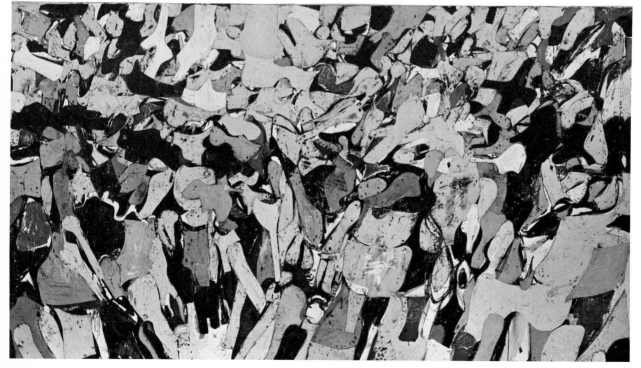

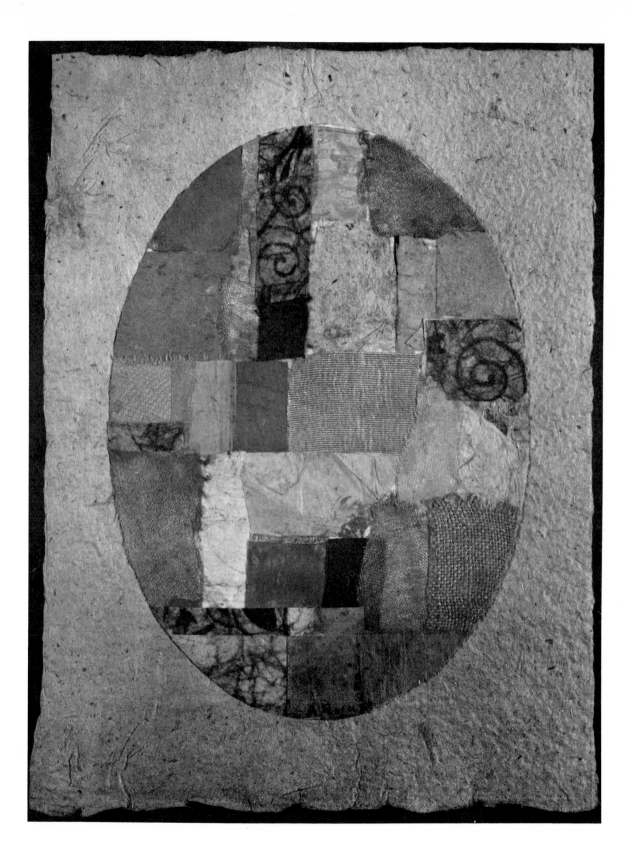

198. John Walker. *N.Y.C. III.* 1974.
Collage with acrylic on canvas, 10 × 8′ (3.05 × 2.44 m).
Courtesy Cunningham Ward Gallery, New York.

Marca-Relli does not precut shapes to fit a predetermined arrangement, nor does he measure the area to be worked. The table on which he cuts out the shapes stands about 10 feet away from the painting. His only preparations are drawings that explore the rhythm of the particular type of interlocking. In this way, Marca-Relli can work directly, but without being dependent solely upon accident or the emotional moment. Collage gives Marca-Relli a method of working simultaneously on many levels: he is free to change the form relationships immediately; and he can blot out darks with a fresh white surface, paint and cover over and over again, correcting the relationships until he finds the desired clarity. At the same time, Marca-Relli acknowledges, collage has its pitfalls. The ability to make rapid changes also makes him wary of destroying relationships too quickly. The power to destroy or construct in an instant is thus inherent in the collage medium. Over the years, the character of Marca-Relli's compositions changed, and in the mid-1960s he expanded his idea of the collage form to include sheets of plastic, metal, and other materials from the industrial world. But he has never lost interest in pasted canvas collages. Marca-Relli developed the technique so successfully that he became the first artist to execute mural-size collages such as *The Battle* (Fig. 196) with ease.

Marca-Relli first used roofing tar as a glue. But this material runs in very hot weather and so had to be abandoned. He has also employed lead white, for lead has a strong glue action. If you experiment with lead, be sure the surface that touches the lead is sealed, for otherwise the lead will rot the canvas. A mixture of heated wax in turpentine combined with dammar varnish that Marca-Relli tried should be avoided, since it is highly flammable. Marca-Relli finally settled on polyvinyl acetate emulsified in the form of Elmer's or the Italian equivalent, Vinavil, preferring the plastics because they minimize shrinkage.

Another artist who has managed to work on a large scale with collage is the young English painter John Walker (Fig. 198). His studio overflows with huge cut-out geometric-shape pieces of colored and textured canvas taped to the walls or lying on the floor, plus large open bags of dry pigment and marble dust, large containers of acrylic emulsion medium and acrylic gel, large rolls of cotton canvas (No. 10), and boxes of charcoal.

After much experimentation, Walker found acrylic gels, purchased in drums, to be the ideal glue. With a large spatula, he applies the gel on the canvas to be glued. When it is in place, he presses and smoothes the surface carefully, so that the liquid spreads evenly and no air bubbles survive. Remember that you do not have to size canvas or paper before applying acrylic gel, for it does not damage these supports.

Walker also uses the gel to float dry pigments or marble dust, applied during all stages of constructing the collage, until the individual shapes, indeed the whole surface, appear to be made out of porous stone, steel sheets, or even, as one critic saw it, the sides of old leather.

The other materials Walker employs in his color-texture buildups are acrylic paints, acrylic medium (used as another vehicle for floating dry pigment and marble dust), and *perlite,* an industrial thickener that merges with acrylic products to add weight and texture. Finally, he draws on the surface with charcoal as an added graphic element and to outline changes, spraying charcoal lines he wishes to preserve with acrylic mat medium.

When viewed from a distance, Walker's large works have a density, weight, and textural crust that suggests the patina of aging material. These collages, although maintaining the two dimensions of the painting tradition, evoke the presence of heavy sculptured relief. In Walker's art, collage is transformed into bas-relief. In contrast,

flat, shallow space is created in Bearden's *Interior with Profiles* (Fig. 199) by a minimum of overlapping shapes of papers, photographs, and magazine cut-outs.

Kurt Schwitters' collage *47.14 De Stijl* (Fig. 200) suggests still another artistic form—manipulation and interruption of structures or patterns. Stamps, cardboard, and textured and colored papers combined with paint produce an interrupted surface, a constantly surprising interaction of structured patterns.

The physical acts of cutting, pasting, arranging, and rearranging make collage an appealing alternative or addition to the painter's language, a technique that facilitates a wide variety of form invention. The sensation of planar overlapping can be combined with an interaction of textures (Braque), an interaction of shapes and color (Matisse), or as in Schwitters' work, an interruption and layering of structures. For contemporary painters who use collage as their primary medium, it can serve figure compositions as well as abstractions (Marca-Relli, Bearden). And, as in Walker's work, a textured collage can suggest sculptural experience, or as in Ryan's, a union of different textures. Thus, despite its relatively short history, the medium has endless possibilities. With patient exploration of materials, you can make collage permanent.

199. Romare Bearden. *Interior with Profiles.* 1969. Collage, 3′3¾″ × 4′1⅞″ (1.01 × 1.27 m). Collection First National Bank of Chicago.

200. Kurt Schwitters. *47.14 De Stijl.* 1947.
Collage, 10⅞ × 8¼″ (28 × 22 cm).
Courtesy Marlborough Gallery, Inc., New York.

Studio Tools

Light Sources

If you ask two painters about the ideal studio light, the answers may range from Josef Albers' claim that paintings should be painted in the light in which they will be exhibited (p. 206), to Edwin Dickinson's advice that only under north light can a painter learn to see true tonalities. Advocates of natural light still complain bitterly when museums exhibit paintings executed outdoors in artificial light. In the studio, some painters prefer a light source coming in from a single window, others from several windows, and yet others from a skylight. Clearly, the best light is that which suits an artist's personal taste. Even here, the argument can be purely hypothetical because more often than not circumstance dictates the painting light. There have been artists who can afford the ideal light, and yet prefer a cramped, familiar, lived-in environment. The light source, in other words, is important, but poor conditions should not inhibit you. Figure 201 shows the corner of a hotel room where Bonnard spent his last summers. Can *you* imagine painting against that floral wallpaper?

Tools

The choice of studio tools and supplies—brushes, painting knives, palettes, canvas—does not present the same problems. The only difficulty is finding suppliers who carry a wide range of materials, so that you have a real choice. If your art supplier has only

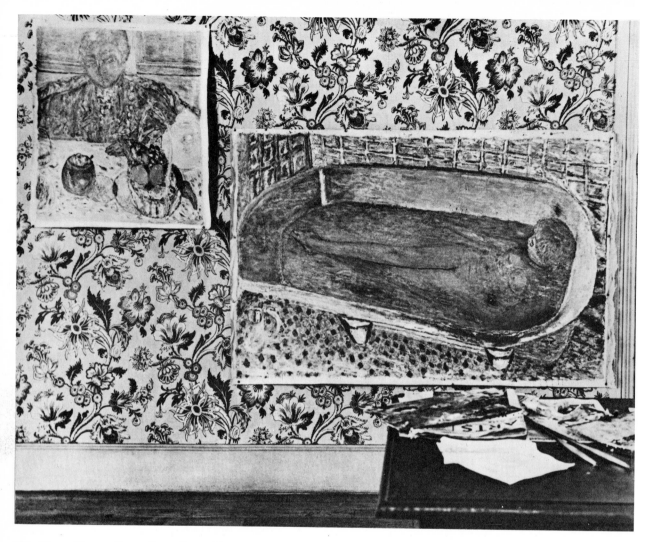

201. Pierre Bonnard's studio at Deauville. c. 1945.

a small variety, ask to look at the catalogues. Chances are you will find what you want, and the supplier will be glad to order items for you. Furthermore, at least two mail-order art suppliers send out free catalogues–Dick Blick in Chicago and Utrecht Linens in New York.

Brushes The production of brushes is a much more complicated procedure than might be imagined. Upon entering a brush-making factory, you confront a complicated machine, with belts revolving on two levels, that blends, combs, and cleans the assorted bristles and hairs used in brushes. Skunk, squirrel, and ox hairs in various combinations are thoroughly mixed to produce one uniform color and texture.

Red-sable brushes are hand-produced in a series of delicate operations. Tufts of hair, shaved from the tails of red sables (*Tartar martens*), are graded according to five or six sizes. The tips of the tails have the longest hairs, but the best points come from the center. After grading, the hairs are submerged in water, allowed to dry, and then

left: 202. In making brushes by hand, small tufts of hair are inserted in the appropriately sized metal cup.

below left: 203. The tuft of hair (which has been bound together) is moistened and inserted tip-first into the ferrule until the desired length is exposed.

below right: 204. Cement is poured into the ferrule, and the brush tip is attached.

baked in an oven for 36 hours at 200 degrees, a process that stiffens each hair. The last operation in preparing a brush point is called *knifing*. Small bundles of hair are tested for resilience with a steel comb; those that are too wild or unmanageable are extracted with a knife (Fig. 202). In this way, more than half of the hairs are discarded, leaving only the soft tips.

Small metal cups, whose inner shapes correspond to the exact negative of the desired brush, serve to form each of the various types. These negative shapes range from long and pointed to flat and stubby. The groups of hairs thus molded are snapped into metal ferrules (Fig. 203). These brushes, as yet without handles, are transported to another section of the factory, where resin (Nylox) is poured into the ferrules to glue the tops of the hairs together (Fig. 204). To ensure adhesion, the glue is set by heat, the brushes being baked again, this time for four hours at 375 degrees. The final procedure, *crimping,* involves the fastening of wooden handles to the ferrules by a machine that firmly stamps the metal ferrule around the wood.

Figure 205 illustrates the various shapes of hog hair and sable brushes manufactured for use with oil. Which are the best types? Again, few painters will agree, although many are adamant about their personal choices. Some refuse to use sable brushes with oil paints; some find particular shapes more useful than others. One painter believes that the secret of Spanish brushwork (Velázquez, El Greco, and Goya) was to be found in the painters' use of extra long, floppy bristles. The long-handled French bristle brush also has its adherents, as do all the types illustrated. And housepainters' brushes, some very expensive and expertly made, must certainly be added to your list. No matter how experienced they are, painters always look for a magic brush. In reality, because artists imagine future works in terms of chosen tools and materials, a new brush broadens the imagination. You should, therefore, buy samples of all the brush types. Play with them in order to discover whether a particular type is useful to you. Remember, too, that tools that you do not know how to use or dislike today may be your favorites in a year's time.

Finally, a word about quality in brushes—cheap brushes are no bargain. They do not hold their shape and fall apart in short order. Comparing an imitation sable, made from ox hair and tinted to match red sable, with the genuine product is a revealing experience. The real sable is more obedient to the touch, and snaps back to its original shape after each stroke. The ox hair, by contrast, tends to resist, making it harder to maneuver on the canvas or paper. In the end, it is cheapest to buy the best quality, for performance can only be guaranteed with good brushes.

The Care of Brushes If properly cared for, good brushes will last for years. The best treatment is to wash them at the end of your painting day. Following is a list of dos and don'ts for oil brushes.

- *Don't* let paint dry on the hairs. The strong solvents needed to dissolve dry paint weaken the brush.
- *Don't* let brushes rest on their bristles for days at the bottom of your turpentine jar. They will become misshapen—a problem difficult to cure.
- *Don't* allow brushes to stand in turpentine with the level of liquid higher than the top of the metal furrule. The wood will become impregnated with the turpentine, which will eventually loosen the bond between the metal and wooden parts.
- *Don't* wash brushes in hot water. This will loosen the resin that holds the hairs together. Cool water is best.
- *Don't* store brushes in a closed paint box until they are absolutely dry, for otherwise mildew will appear.
- *Don't* push the bristles into the bar of soap. Be gentle.
- *Do* wipe the brush clean of paint first.
- *Do* clean next in turpentine or paint thinner, then wipe clean again.
- *Do* follow this step by washing with ordinary household or laundry soap.
- *Do* work the lather into the bristles on the palm of your hand.
- *Do* repeat soaping until the brush is clean.
- *Do* shape the brush when you finish.

Small, discarded pieces of soap can be stored in a closed jar half filled with water. As the pieces dissolve, they produce a strong, soapy syrup that is excellent for washing brushes. When it comes to shaping brushes, do not—as some earlier painters did—shape them in your mouth. This is a dangerous practice because of the possibly poisonous content in some of the pigments.

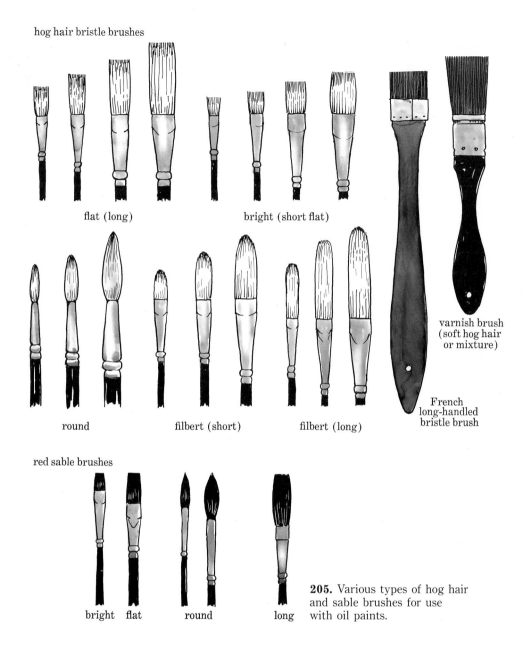

hog hair bristle brushes

flat (long)　　　　　bright (short flat)

round　　　filbert (short)　　　filbert (long)

varnish brush
(soft hog hair
or mixture)

French
long-handled
bristle brush

red sable brushes

bright　flat　　round　　　long

205. Various types of hog hair
and sable brushes for use
with oil paints.

Brushes for Acrylics　　Follow the same procedure as for oil brushes, substituting water for turpentine. But be especially careful not to use hot water, for heat makes the acrylic paint coagulate.

Brushes for Watercolor　　Do not use soap. Clean only with cool water, and shape very carefully.

A contemporary painter who favors watery stains might be amazed to find art students still at work with painting knives, or palette knives as they are also called. In addition, the idea of painting with a knife is commonly associated with those dollar

Painting Knives

books addressed to hobbyists. Albers, however, painted exclusively with a palette knife. The point is that in an Albers painting you react first to the image, not to the use of the knife. But in an amateur work inspired by how-to books, no matter what is depicted, the subject is really the use of the knife.

If you look hard, you can see the marks of the palette knife in the works of Courbet and, perhaps, Rembrandt or Soutine (Figs. 153, 139, 158). Among today's leading painters, some smooth out their large areas with a long spatula (Fig. 206), a tool generally used for applying grounds (p. 70).

For convenience of reference, the straight blade in Figure 206 is called a palette knife because it, along with the trowel-shape one, is handy for mixing colors on the palette. As always, you should experiment with all the shapes to see which ones suit your style or stimulate your imagination. Study the construction of each knife

206. Various types of painting knives.

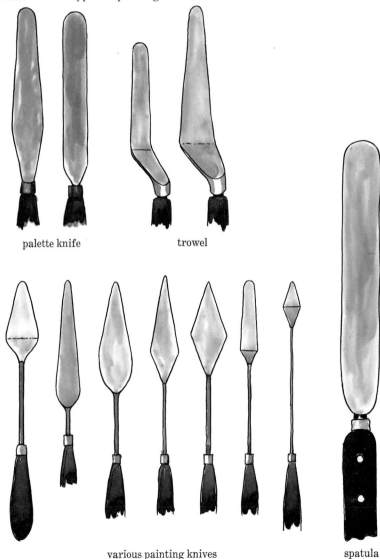

palette knife trowel

various painting knives spatula

207. Wooden palettes come in several shapes.

carefully. Certain Italian painting knives, for example, have a design that makes them difficult to manipulate. Tiny bolts are used to fasten the blade to the long handle. These bolts appear on the top of the area that touches the paint. But as you mix, the bolts keep gathering paint, making it impossible to clean the knife properly. Avoid, therefore, any painting knife that has visible bolts. Apart from such technical matters, remember that if the use of the knife is more apparent than your form invention, you are featuring the knife and not your vision.

Bonnard's palette (Fig. 201) was of the simplest wooden variety, but he also used other surfaces in a highly personal method of mixing and preserving color combinations. On inexpensive china, Bonnard placed combinations that he found attractive on his palette. He made a big collection of these plates, a library of color orchestration. Jacques Villon, by contrast, kept separate palettes for different paintings, since he was in the habit of having several works in progress at the same time. For this purpose, he employed pads of tracing paper, one for each painting. Picasso often let old newspapers serve as his palette—a practice not generally recommended. Old muffin tins are excellent for mixing colors. At the end of the painting session, you can cover the oil paint with water, thus preventing air from drying the colors.

The Palette

The best palette for you is the one that suits your painting habits. If you like to work directly in front of the canvas without stepping back to get the paint on your brush, a wooden palette (Fig. 207) may be the most practical.

In terms of gauging color, the most useful palette is one that has a white background that matches the ground of the canvas. White plastic palettes and smooth paper peel-away palettes are now made in most of the shapes of the wooden models. However, a plate glass palette with a white piece of paper underneath is easiest to clean. Make sure to tape the edges of the glass to avoid cutting yourself. Clean it with a commercially made paint scraper, the kind in which you insert a single-edged razor blade (available in hardware stores). This glass palette is best left stationary, although taping a piece of masonite on the bottom will reduce the risk of breakage.

The small metal palette cups that fasten onto wooden, white plastic, or paper palettes are handy. Do not leave the medium in these cups uncovered at the end of the day, for it will slowly dry, becoming sticky and useless.

Repairs

You should learn to repair cuts, tears, or holes in your canvas. Try to practice on old, damaged paintings, often sold cheaply in junk stores. In this way, you can take chances that you would not take on your own work.

To begin, put the painting face down on waxed paper, using newspapers as a slight cushion underneath. Take a piece of raw canvas, cut to just overlap the tear or hole. Spread some acrylic gel evenly on the cut raw canvas and place it on the area to be repaired. Now check the face of the painting to see that the patch is lined up. There should be no flaps or wrinkles. Turn the painting on its face, cover the patch with another piece of waxed paper, and put some weights on top. In a few hours the gel will dry. If there are some valleys or ridges left around the tear, cover them with a thin coat of acrylic gesso or a coat of rabbitskin glue (p. 73). For an acrylic painting, fill in the ridges with the aid of a palette knife, and keep filling, one coat at a time, until the surface is even. For an oil painting, the final coats may be of flake white instead of gesso. When the flake white is dry, sand or scrape it gently with a razor blade. You are now ready to touch up the surface. With a little practice, the procedure is easy.

Far simpler is to remove a bulge caused by hitting the canvas against an object. Wet (but do not soak) the back of the bulge with water. Then, as above, place the painting under weights.

Care of Paintings

Your completed works should receive as much careful attention to technical matters as do those in progress. To preserve your paintings in good condition, follow this list of dos and don'ts.

- *Do* let paintings dry in light.
- *Do* roll a painting face out. The larger the roll the less likely it will crack.
- *Do* wait until a painting is dry for a month or more before varnishing—and the longer the better. Premature varnishing traps moisture between the paint film and the layer of varnish, resulting in a foggy film known as *blooming*.
- *Don't* rub in oil on the surface to take out dry spots.
- *Don't* wash a painting with a strong solution of soap and water. To remove dirt, use only a few drops of detergent to a cup of water. Do not let the surface stay wet.
- *Don't* store paintings in a cold place. Cold causes cracks.
- *Don't* use acrylic paints with oil brushes. Use only nylon brushes for acrylic. (Acrylic paints tend to damage oil brushes.)
- *Don't* clean a painting with a slice of potato. This is an old wives' tale.
- *Don't* hang paintings over a heat source.
- *Don't key* a painting too much after it is dry. This will produce cracks. (Keys are wooden, triangular pegs which are placed into the corner slots on the back of a commercial stretcher to tighten the canvas.)

Manufacturers and Suppliers

The companies listed below either manufacture products referred to in the text, or are authorized distributors of these products. You can write directly to the companies for information on stores in your area that sell the products.

Mail Order Art Suppliers (General)
Dick Blick
Sherwin Williams, Canada
Utrecht Linens

Canvas
David Davis
Gwartzman's Canvas & Art Supplies, Canada
New York Central Supply Company
Utrecht Linens
Winsor & Newton

Dry Pigments
Bocour Artist Colors
David Davis
Sherwin Williams, Canada

Electric Engraver
Dremel Electric Engraver

Turkey Feathers (Quill Pens)
Finnysports
M. Schwartz & Son, Inc.

Gummed Linen Tape (For Matting)
Dennison Manufacturing Company
Gane Brothers & Lane, Inc.
Gaylord Brothers, Inc.

Jet Pack Sprayer
Ambroid Company

Oil-Wax Crayons
Markal Company

Paper
Aiko's Art Materials Import
Andrews, Nelson, Whitehead
David Davis

Heinz Jordan & Company, Canada
New York Central Supply Company
Process Materials Corporation
Strathmore Paper Company

Wooden Stretchers
Craft-Cut
David Davis
James J. Lebron
Utrecht Linens

Synthetic Media and Varnish
Acrylic Varnish Spray Cans (Synvar and Univar)
F. Weber Company

Acryloid F10
Röhm & Haas

Alkyd Colors, Media
Winsor & Newton

Elvacite 2044
Almac Plastics (small amounts)
E. I. DuPont de Nemours & Company (manufacturer)

Magna Colors and Varnish
Bocour Artist Colors

Rhoplex 234 and Additives:
Acrysol G110, Acrysol Gs, Triton CF10
Röhm & Haas

Soluvar (Varnish for Acrylic Emulsion)
Permanent Pigments

Vinyl Emulsion (p.v.a.)
Borden Chemicals Company
Polyco Department

Venice Turpentine
F. Weber Company

Addresses
Aiko's Art Materials Import, 714 N. Wabash Avenue, Chicago, Ill. 50511
Almac Plastics, 47-42 37th Street, Long Island City, N.Y. 11101
Amboid Company, Taunton, Mass. 02780
Andrews, Nelson, Whitehead, 7 Laight Street, New York, N.Y. 10013
Dick Blick, P.O. Box 1267, Galesburg, Ill. 61401
Bocour Artist Colors, 1 Bridgewater Street, Garnerville, N.Y. 10932
Borden Chemical Company, Polyco Department, 511 Lancaster Street, Leominster, Mass. 01453
Craft-Cut, Route 2, Box 198-X, Santa Fe, N.M. 87501
David Davis, 539 La Guardia Place New York, N.Y. 10012
Dennison Manufacturing Company, Coated Paper Division, 300 Howard Street, Framingham, Mass. 01701
Dremel Electric Engraver, 4915 21st Street, Racine, Wis. 53406
E.I. DuPont de Nemours & Company,

Electrochemical Department, Wilmington, D. 19898
Fezandie & Sperrle, Inc., 111 Eighth Avenue, New York, N.Y. 10011
Finnysports, 2910 Glazman Road, Toledo, Ohio 43614
Gane Brothers and Lane, Inc., 1335 West Lake Street, Chicago, Ill. 60607
Gaylord Brothers, Inc., P.O. Box 61, Syracuse, N.Y. 13201
Gwartzman's Canvas & Art Supplies, 448 Spadina Avenue, Toronto, Ont. M5T 2G8, Canada
Heinz Jordan & Company, 42 Gladstone Avenue, Toronto, Ont. M6J 3K6, Canada
James J. Lebron, 31-36 58th Street, Woodside, N.Y. 11377
Markal Company, 3052 West Carroll Avenue, Chicago, Ill. 60615
New York Central Supply Company, 62 Third Avenue, New York, N.Y. 10003
Permanent Pigments Company, 2700 Highland Avenue, Cincinnati, Ohio 45212
Process Materials Corporation, 329 Veterans Boulevard, Constadt, N.J. 07072
Röhm & Haas Company, Independence Mall West, Philadelphia, Pa. 19105
M. Schwartz & Son, Inc., wholesale dealers, 45 Hoffman Avenue, Hauppauge, N.Y. 11787
Sherwin Williams, 13 Clapperton Road, Barrie, Ont. L4M 3E4, Canada
Strathmore Paper Company, Westfield, Mass. 01085
Utrecht Linens, 33 35th Street, Brooklyn, N.Y. 11232
F. Weber Company, Wayne & Windrin Avenue, Philadelphia, Pa. 19144
Winsor & Newton, 555 Winsor Drive, Secaucus, N.J. 07094

Index

Photographic Sources